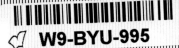

TAB. LXVIII.

Fig. 2.

Fig. 10.

Fig. 3.

Fig. 6.

Fig. 9.

Fig. 11.

Fig. 14.

THE BIRD
ILLUSTRATED
1550–1900

HARRY N. ABRAMS, INC.,
PUBLISHERS, NEW YORK

THE BIRD
ILLUSTRATED
1550–1900

■

From the Collections of
The New York Public Library

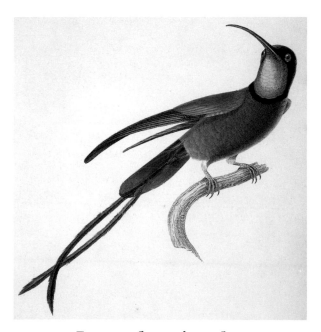

Introduction by
Roger Tory Peterson

■

TEXT BY
JOSEPH KASTNER

■

with commentaries by
Miriam T. Gross

Editor: Ruth A. Peltason
Designer: Elissa Ichiyasu

Photographs by Philip Pocock

Endpapers:
Nests. [Plate 68.] Etching. In *Locupletissimi rerum
naturalium thesauri . . .* by Albert Seba (1734–65).

Page 6:
Frontispiece. Hand-colored engraving with etching.
In *Nederlandsche vogelen . . .* by Cornelius Nozeman and
Martinus Houttuyn (vol. 5, 1770–1829).

Page 9:
"Lascaux: The Scene in the Shaft." In *Treasures of
Prehistoric Art*, by André Leroi-Gourhan. Translated by
Norbert Guterman. New York: Abrams, 1967, page 176.

Page 11:
Falconry. In *Die Falkenjagd: Bilder aus dem Falkenbuch
Kaiser Friedrichs II*, mit Einem Geleitwort von Carl A.
Willemsen. Leipzig: Insel-Verlag, 1943. Illustrations from
Frederick II's "De arte venandi cum avibus . . ."

Page 114:
Eggs. [Plate 32.] Hand-colored engraving with etching.
In *Histoire physique, politique et naturelle de l'Île de
Cuba . . .* by Ramon de la Sagra (1839–61).

Library of Congress Cataloging-in-Publication Data
Kastner, Joseph.
The bird illustrated, 1550–1900.
Bibliography: p.
1. Birds—Pictorial works—History.
2. Birds in art—History.
3. Ornithologists—Biography.
4. Zoological illustration—History.
I. Gross, Miriam T.
II. New York Public Library.
III. Title.
QL674.K37 1988 598'.022'2 87–17467
ISBN 0–8109–0746–1

CONTENTS

■

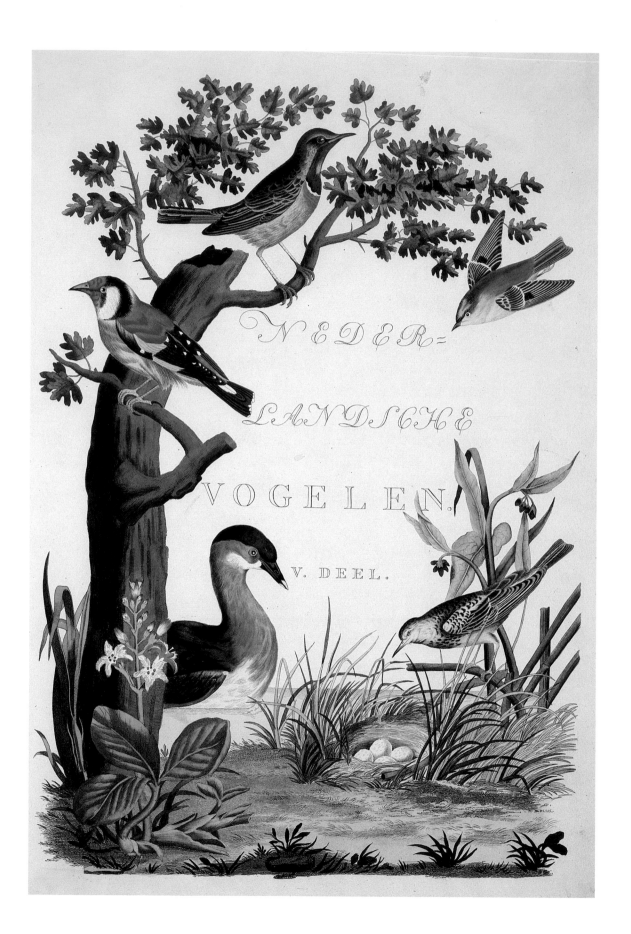

NEDER=

LANDSCHE

VOGELEN.

V. DEEL.

Few outside of the scholarly, artistic, and ornithological communities are familiar with more than a handful of the preeminent artists and naturalists who have played a part in the history of bird illustration. But the development of the depiction of birds is a fascinating story, related by The New York Public Library's wide-ranging and sumptuous collection of more than several hundred volumes, which include many of the most magnificent and bibliographically significant ornithological titles from the mid-sixteenth through the nineteenth centuries. *The Bird Illustrated,* which is published in conjunction with an exhibition at the Library, surveys the collection through examples reflecting the skills and techniques of artists from all over, who have illustrated birds found worldwide. Perhaps more significantly, it delineates the connection between scientific discovery and artistic achievement in the evolution of ornithological illustration. ▪ The exhibition at the Library is the fruit of several years of work, initiated by a long-time staff member, Miriam T. Gross, Research Librarian in the General Research Division. As exhibition curator and as author of the descriptive commentaries and the historical bibliography in *The Bird Illustrated,* she has worked tirelessly to document the Library's holdings in this field. The Library owes her a debt of gratitude. Ms. Gross has been supported in her efforts by many other members of the Library staff, including members of the General Research Division, the Science and Technology Research Center, the Special Collections, the Conservation Division, the Exhibition Program Office, the Publications Office, the Public Relations Office, and the Office of Public Affairs and Development. The Library is proud that its efforts have made possible the opportunity to acquaint readers with the finest of bird illustrations. ▪ The Library acknowledges with gratitude the generous grants from Christian Dior and Parfums Christian Dior in support of the exhibition. Additional assistance has been provided by the National Endowment for the Arts.

FOREWORD

BY

VARTAN

GREGORIAN

▪

President and

Chief Executive Officer

The New York Public Library

Birds, the only other two-legged creatures on earth, have fascinated man since the Stone Age. The ancient hunters who decorated the walls of their caves made the earliest drawings of birds known to us, preceding even those on the tombs of the pharaohs. Bird art, if we may call it that, has a history that goes back at least five thousand years. ▪ The two or three centuries prior to 1900 embraced the era of princely patronage when many lavish books on birds were published. New species were constantly being discovered, named, and illustrated. It was the age of shotgun natural history, and at first most bird illustrations reflected this: they were stiff as though the birds had been stuffed and wired to a museum perch. But when Audubon and Gould arrived on the scene in the 1830s or thereabouts, all this changed—these great ornithologists took birds out of the glass case for all time. ▪ While John James Audubon is by far the best known of the early American ornithologists—indeed his name has become synonymous with birds—he was by no means the first to explore the avian trail in the New World. Charting the way was the transplanted Scot Alexander Wilson, commonly referred to as the "father of American ornithology," who published his own nine-volume work more than twenty years before Audubon produced his monumental *Birds of America*. However, Mark Catesby, an Englishman, was on the scene a century earlier than either of these men, having depicted 113 American birds for the first time in his *Natural History of Carolina, Florida and the Bahama Islands* (1731–43). ▪ Catesby's illustrations are typical in style of those done in eighteenth-century Europe—archaic, but meticulously executed, with little semblance of sound structural drawing or any feeling of the living bird. If we might call Catesby the "founder" of American ornithology, and Wilson the "father," then surely Audubon is the "patron saint." ▪ At about the same time that Audubon was taking bird portraiture to new heights in America, Englishman John Gould was doing the same for Europe, but with a difference. Whereas Audubon painted all, or nearly all, of his own birds, Gould relied heavily on his talented wife and several other artists. One of them, Edward Lear of nonsense-rhyme fame, might have become the brightest star in the galaxy of bird illustrators had he not turned to landscape painting in his twenties. But another of Gould's collaborators, Josef Wolf, the German, in the opinion of many was the finest portraitist within the time frame of this book. ▪ In his graceful text, Joseph Kastner introduces us to these pioneer bird illustrators and also many lesser practitioners, some of whom are all but forgotten. This pre-

INTRODUCTION
BY
ROGER
TORY
PETERSON

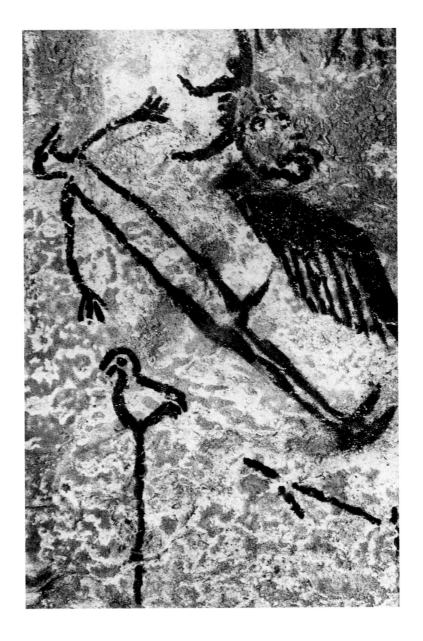

sentation from the collections of The New York Public Library stops short of 1900, at the cusp of the twentieth century, when bird painting was taking another leap forward. The turn of the century saw the emergence of Bruno Liljefors, whose oils graced the galleries of Sweden, and Archibald Thorburn of England, and Louis Agassiz Fuertes of America, who painted birds with more accuracy and feeling for form, character, and pterylography than any of their predecessors, with the possible exception of Wolf. ▪ Today there are literally thousands of men and women who paint or draw birds. Some are "painterly" illustrators inspired by Liljefors, playing with three-dimensional activity, mood, and light. Others are delineators following the tradition of Audubon or Fuertes. All are literal or "representational" in their approach; a naturalist in all honesty cannot paint or draw otherwise. ▪ *The Bird Illustrated* celebrates the old-timers who blazed the trail.

Four centuries ago, Ulysses Aldrovandus (or, Ulisse Aldrovandi), one of the first men of modern times to produce a comprehensive natural history of birds, tried to explain what it was that caused him to undertake his long and almost endless task. Doing it, he decided after some thought, "leads to honor and renown" and, he went on to say, "it is accompanied with the most exquisite gratification and astonishment." ▪ In the years that followed, many men took on Aldrovandi's task and their work is represented in this book. Some of them have indeed achieved honor and renown but only scholars know the others. The birds they drew or painted could be stiff and plain, or graceful and extravagant. Sometimes their art was awkward, sometimes deft. But what is glowingly evident in this gathering of birds is that the

AN AVIARY OF ILLUSTRATORS

artists and authors, marveling perhaps at what they were doing, must have felt that "exquisite gratification" at having done it. ▪ It is an effect birds always seem to have had on mankind. There have been many efforts to explain why people become fascinated, even obsessed, by birds. It may be the feeling of freedom that birds impart, or an aesthetic appreciation of their beauty, or an acute identification with nature that they provoke. ▪ Whatever it is that touches them, men have watched and portrayed birds for millennia. Drawings of birds, vivid in their bare outlines, are found scratched on the walls of prehistoric caves in France and Spain, and there are recognizable swans, eagles, owls, and ravens carved on Paleolithic stones and bones. Paintings in ancient Egyptian tombs are alive with waddling geese and stately cranes. ▪ In early manuscripts, birds appeared as religious symbols or as accompaniment to stories—to illustrate Aesop's fables, for example—or simply to provide familiar detail for scenes of daily life. It was not until the Renaissance that birds were portrayed as themselves, as creatures to be recognized and classified. They had been studied and classified long before, of course, by Aristotle but his work had become so encrusted with error and the interpolations of fusty pedants that it had to be done all over again. When Renaissance men looked around with opened eyes at their world, they began to see it—and to show it—as it really was, not as outmoded teaching told them it should be. ▪ The Renaissance impulse to learn all there was to know was joined by an ambition to set this knowledge down. Within a century after the first use of movable type, books on birds appeared. Many of the books that have been printed since are in the collections of The New York Public Library. There, among all the many habitats of ideas and images that the Library encompasses, is the bibliographic aviary whose denizens fly, hop, strut, swim, and perch on these pages. ▪ The first ornithologies were printed in the middle of the sixteenth century. In 1551 in Zurich Conrad Gesner, a Swiss physician and naturalist (who was also a pioneer in bibliography and comparative linguistics), began publishing his encyclopedic *Historiae animalium*, an account of all that

was known about the animal world. One 800-page volume was given over to descriptions of birds—their anatomy and habits, and the myths about them. The text was livened with more than two hundred illustrations and largely because of the illustrations, Gesner's book achieved an enduring popularity. *Historiae* went into a second Latin edition as well as three printings of a German edition, while a one-volume digest of the bird section remained for two hundred years a standard household reference. ▪ At the same time, a widely traveled French botanist and ornithologist, Pierre Bélon, published his *Histoire de la nature des oiseaux*, with portraits of some two hundred birds, including species from the Americas. It was less inclusive than Gesner's book though its observations were often more original. ▪ Meanwhile at the University of Bologna, Aldrovandi was laboring away, but it was not until a few years before his death around 1605 that he published his three-volume, 2,600-page *Ornithologiae*. Aldrovandi called himself the "illustrator of nature" and employed the best artists he could find. One painter worked for him for thirty

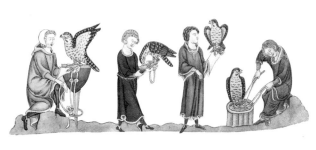

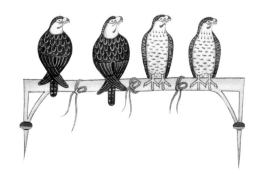

years at a handsome salary of two hundred gold pieces a year. ▪ Aldrovandi anticipated modern procedures by going out on bird walks "accompanied," he wrote, "by my draughtsmen and amanuenses" to make sketches and take notes on the master's field observations. He was infinitely painstaking, giving every bird's name in Greek, Latin, Hebrew, Arabic, and Italian, recording their uses as "images in sacred and profane mythology, on coins, in proverbs and hieroglyphics," so that he could claim that "whatever can be usefully said upon birds may be found here." ▪ As anyone bearing the name of Ulysses should be, Aldrovandi was a very wise man. If what he said about birds has not turned out to be altogether useful today, what he said about studying birds rings as true now as it did when he said it more than four hundred years ago. Expressing the awe and reverence that in one way or another every true student of nature must feel, he remarked that he had reached the richest of rewards for, through his work, he had "become acquainted with those matters with which the Almighty alone seems to be familiar."

Put most simply, the ornithological purpose of depicting a bird is to provide a recognizable likeness by which that bird can be identified. To do that, the bird and its actions must be known accurately and in detail. The men who came to understand birds best were the falconers who, in using hawks for hunting, learned intimately how their wings and bodies worked, how their minds or instincts acted, how they hunted, and how their prey behaved. Hawks and other predatory birds were favorite subjects of early artists. In fact, the first modern work of ornithology was done by an extraordinary falconer, Frederick II of Hofenstaven, Holy Roman Emperor, King of Sicily and Jerusalem—a prodigious monarch whom an admiring contemporary called Stupor Mundi, Amazement of the World. ▪ Frederick, who lived from 1194 to 1250, fought wars from Germany to the Holy Land, quarreled with several popes and was twice excommunicated by them, and was assigned by Dante to the Sixth Circle of Hell for his heresies. Somehow Frederick found time to attend to his hundreds of falcons, studying them not just with the eye of a huntsman but the curiosity of a scientist. He compiled *De arte venandi cum avibus* (The Art of Hunting with Birds), whose understanding and depiction of the mechanics of flight and the behavior of birds presaged the course of ornithology. ▪ In *De arte venandi* and in the books that followed, illustrations were reproduced by the simplest process, the woodcut. In this method, a drawing was made on a plank of hard wood and the wood cut away around it, leaving a raised image on the block. The woodcut was simple and inexpensive but it had its limitation. It could rarely reproduce subtle shadings or differences in emphasis. ▪ Woodcuts were gradually displaced by metal engravings. Here the image was cut into a steel or copper plate. Ink settled into the grooves and the image formed by the grooves would be transferred to paper. It was far easier to cut fine lines into metal than to carve them out of wood and the engraving provided a truer and more elegant picture. A somewhat similar process, the etching, came into more limited use. ▪ In the nineteenth century the engraving gave way to the lithograph. The image was drawn on a flat stone with a grease pencil. Greasy ink applied to the dampened stone would adhere only to the drawn image and so be transferred to paper. The lithograph enabled the artist himself to draw directly and freely on the stone, instead of giving his work to an engraver who would painstakingly cut it into metal. It was the relative ease and inexpensiveness of the lithographic process that led to the great expansion of illustrated book publishing in the nineteenth century. ▪ Each of these methods produced a basic black-and-white image. Colors were almost always applied by hand afterward and hand coloring became a cottage industry, done for the most part by overworked wives or anonymous spinsters or young ladies with an artistic bent. The colorers got little pay—three to nine pence per page—and less credit, although one author was gracious enough to acknowledge that "the coloring of the plates has been executed by Miss Bertha Sharpe and Miss Dora Sharpe with the occasional help of their sisters Emily and Eva," all of whom happened to be the author's daughters.

PREDATORS

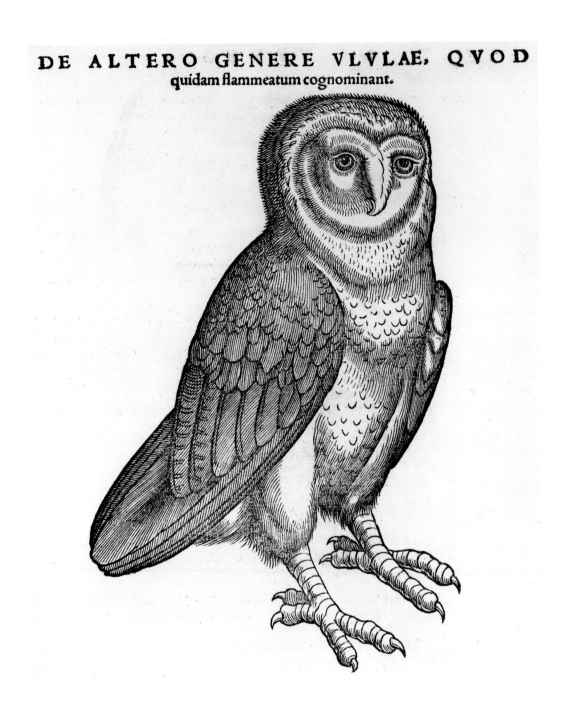

DE ALTERO GENERE VLVLAE, QVOD
quidam flammeatum cognominant.

1 ▪ SHORT-EARED OWL *Asio flammeus*

"De Altere Genere Ululae." Woodcut, from drawing by Lukas Schan. In *Historiae animalium. Liber III qui est de avium* by Conrad Gesner (1555). ▪ This woodcut was made for one of the earliest European ornithologies, the bird volumes, published in 1555, of Conrad Gesner's massive *Historiae animalium*. The artist, Lukas Schan of Strasbourg, knew his birds well; he was also a fowler, a professional bird hunter.

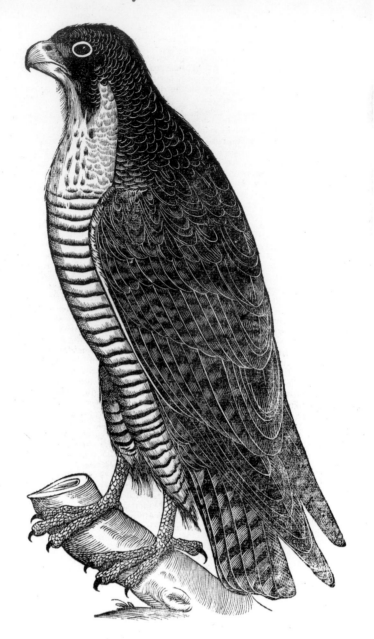

2 ▪ PEREGRINE FALCON *Falco peregrinus*

Woodcut, by Cristoforo and G. B. Coriolanus. In *Ornithologiae hoc est de avibus historiae libri XII* by Ulisse Aldrovandi (Ulysses Aldrovandus) (1599–1603). ▪ The Peregrine Falcon, long called the Duck Hawk, has always been a favorite of artists and huntsmen. Its fierce and arrogant bearing has made it a striking model for paintings—this early woodcut from Aldrovandi's pioneering *Ornithology* catches its haughty attitude. Falconers use the hawk's power and speed—its dives have been clocked at two hundred miles per hour—to hunt and bring down game birds.

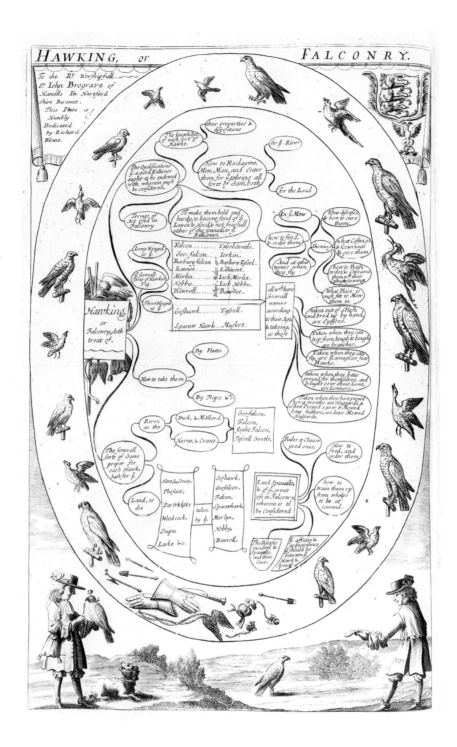

3 ▪ "HAWKING OR FALCONRY"

Etching, from drawing by Francis Barlow. In *The Gentleman's Recreation . . .* by Richard Blome (1686). ▪ *The Gentleman's Recreation* is both an encyclopedia of the art and science of falconry and a how-to work on hawking, hunting, horsemanship, fowling, fishing, agriculture, and cock-fighting. The vignettes in the bottom corners of the elaborate frontispiece show gentlemen hawking. The central oval depicts nine predatory birds with nine of their victims, along with assorted hawking paraphernalia.

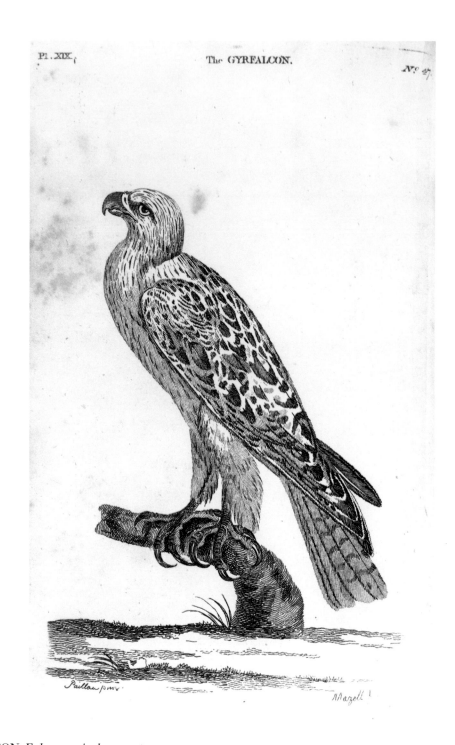

Pl. XIX. The GYRFALCON. Nº 47

Paillou pinx.

Mazell f.

4 ▪ GYRFALCON *Falco rusticolus*

"Gyrfalcon." Etching, by Peter Mazell from drawing by Peter Paillou. In *The British Zoology* by Thomas Pennant (4th ed., 1776–77). ▪ Thomas Pennant was a patriotic English naturalist who felt that his country's ornithology was lagging behind the rest of Europe's. "We are unwilling," he wrote, "that our island should remain insensible to its particular advantages," so in 1761 he published *British Zoology*, the most complete work then of its kind, and the first British book to contain color illustrations of birds. Though the book is called a zoology, 121 of its 132 illustrations are of birds. Tireless, Pennant kept revising and adding. This illustration is from the fourth of five editions.

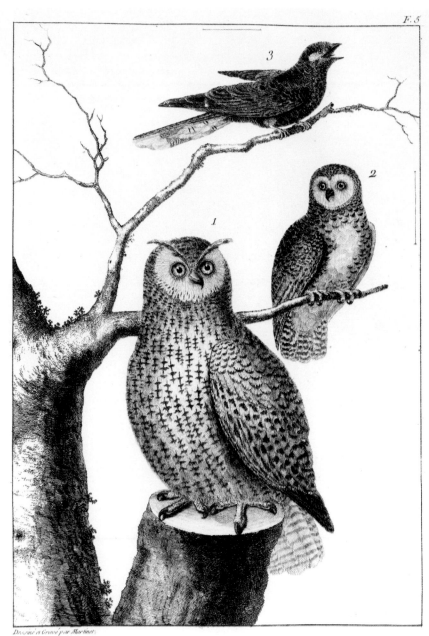

1. Grand Duc 2. Chat-huant 3. Tette chèvre.

5 ▪ EAGLE OWL *Bubo bubo* ▪ TAWNY OWL *Strix aluco* ▪
EUROPEAN NIGHTJAR *Caprimulgus europaeus*

"1. Grand Duc; 2. Chat-huant; 3. Tette-chèvre." Etching, by François Nicholas Martinet from his own drawing. In *L'Histoire naturelle, éclaircie dans une de ses parties . . .* by John Ray (1767). ▪ John Ray, the son of a blacksmith, and Francis Willughby, a wealthy aristocrat, were ornithological collaborators. They made a three-year birding trip through Europe in the 1660s and, after Willughby's early death, Ray published the findings in landmark works of natural history and classification. This illustration is from a French translation that applies colorful descriptive names—*Grand duc* suggests the demeanor of the Eagle Owl, *Chat-huant*, the hooting of the Tawny Owl.

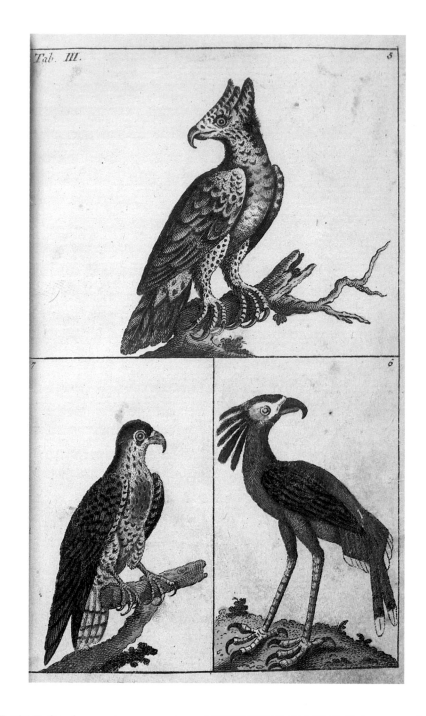

6 ▪ CROWNED EAGLE *Stephanoaetus coronatus* ▪ PEREGRINE FALCON *Falco peregrinus* ▪
SECRETARY BIRD *Sagittarius serpentarius*

"Der Heiducken-Adler; Der Sekretar; Der Edelfalke." Hand-colored engraving, by Gottlieb Tobias Wilhelm from his own drawing. In *Unterhaltungen aus der Naturgeschichte . . . Vögel* by Gottlieb Tobias Wilhelm (1795). ▪ Although these fancifully colored illustrations from Wilhelm's early natural history encyclopedia are crudely drawn, they are identifiable. The odd-looking figure on top is a Crowned Eagle, sporting a head crest that gives this species its name. The Peregrine Falcon, lower left, is identifiable by its facial pattern. The Secretary Bird, lower right, with its unmistakable long legs and shaggy head quills, is actually a most unhawk-like hawk.

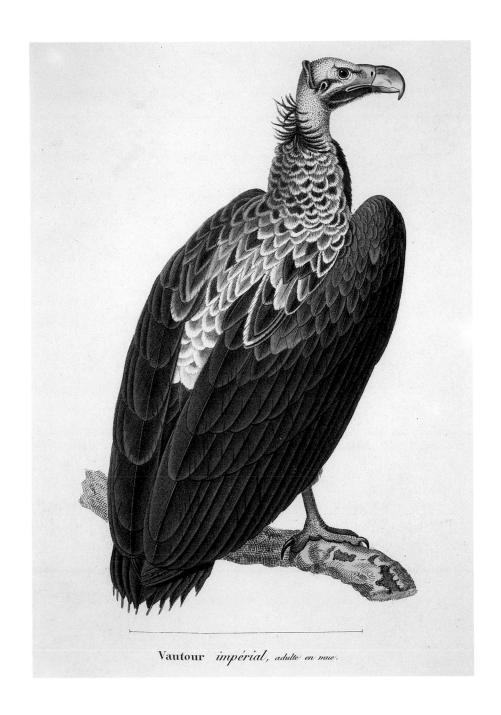

Vautour *impérial*, *adulte en mue*.

7 ▪ LAPPET-FACED VULTURE *Torgos tracheliotus*

"Vautour Imperial." Hand-colored engraving, with etching, from drawing by Nicolas Huet. In *Nouveau recuil de planches coloriées d'oiseaux . . .* by Coenraad Jacob Temminck and M. Laugier de Chartrouse (1820–39). ▪ Coenraad Jacob Temminck inherited a fortune from his Dutch merchant father and spent it freely to support works of other ornithologists, to acquire what was then the world's largest collection of birdskins (more than four thousand), and to publish handsome and useful bird books. Vultures, among the oldest groups of birds dating back some twenty million years, were called "Pharaoh's chickens" in ancient Egypt and represented parental love.

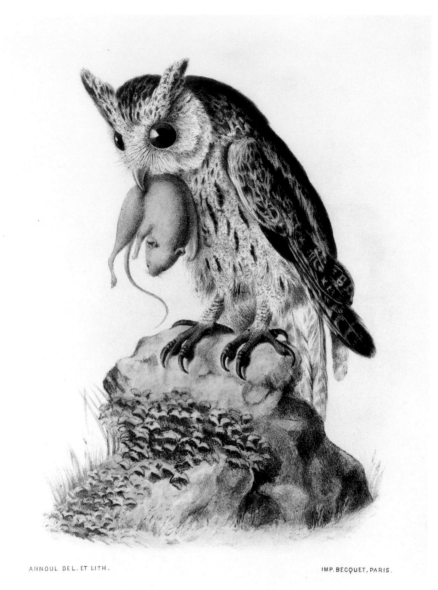

LEMPIJUS GLABRIPES.

8 ▪ COLLARED SCOPS OWL *Otus bakkamoena*

"Lempijus Glabripes." Hand-colored lithograph, by H. Arnoul. In *Les Oiseaux de la Chine* by Armand David and Emile Oustalet (1877). ▪ Father Armand David, a French priest, was the first westerner to study and describe the botany and zoology of China under the auspices of the government. He is memorialized in zoology as namesake to the rare Père David deer and remembered in ornithology for his *Birds of China*, the first important work on the subject. Scops, or screech, owls, are "eared" owls, with tufts of feathers resembling ears.

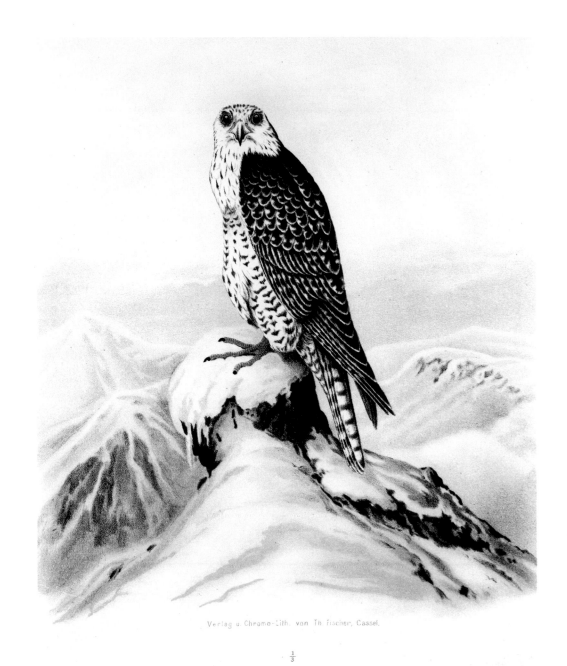

Verlag u. Chromo-Lith. von Th. Fischer, Cassel.

$\frac{1}{3}$

FALCO ARCTICUS, HOLBÖLL.
Grönländischer Jagdfalke.

9 ▪ GYRFALCON *Falco rusticolus*

"Falco Arcticus." Chromolithograph, by Theodor Fischer from painting by Oskar von Riesenthal. In *Die Raubvogel Deutschlands . . .* by Oskar von Riesenthal (2d ed., 1894). ▪ The Gyrfalcon lives in the Arctic and has always been sought after by falconers, mostly for its rarity and regal bearing since, as a hunter, it is less effective than the Peregrine. Ornithologists disagree over the origin of its name. Some say it means "sacred falcon," referring to the reverence in which hawkers held it. Others say the name means "greedy bird," a reference to its omnivorous appetite for gulls, ptarmigan, rats, and rabbits.

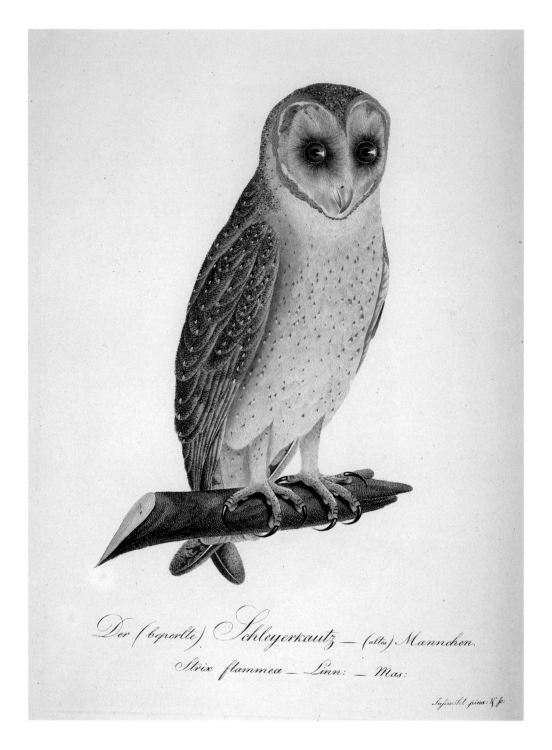

Der (beperlte) Schleyerkautz — (altes) Männchen.
Strix flammea — Linn: — Mas:

Susemihl pinx: & fe:

10 ▪ BARN OWL *Tyto alba*

"Der Beperlte Schleyerkautz." Hand-colored etching, by a member of Susemihl family from drawing by J. C. Susemihl. In *Teutsche Ornithologie . . .* by Moritz Borkhausen (1800–11). ▪ No one has ever really seen a blue-eyed Barn Owl—their eyes range from yellow to brown. Considering that, this depiction is not merely the colorist's fancy—even the text specifically mentions blue eyes. Moritz Borkhausen may have mistaken for the eye the blue nictitating membrane, which performs the functions of an eyelid.

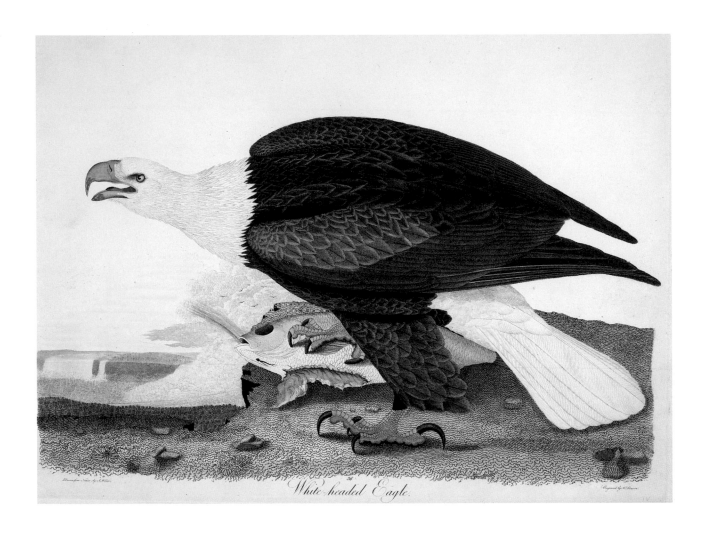

White-headed Eagle.

11 ▪ AMERICAN BALD EAGLE *Haliaeetus leucocephalus*

"White Headed Eagle." Hand-colored engraving, with etching, from drawing by Alexander Wilson. In *American Ornithology . . .* by Alexander Wilson (1808–14). ▪ Alexander Wilson is looked on by many as the "father of American ornithology" for writing and painting the first comprehensive work on American birds. It was Wilson's misfortune, however, to be overshadowed by his flamboyant contemporary, John James Audubon. On one of his many long trips, Wilson walked from Philadelphia to Niagara Falls and back again, watching birds along the way. Later he used the Falls as the setting for his painting of the American Bald Eagle.

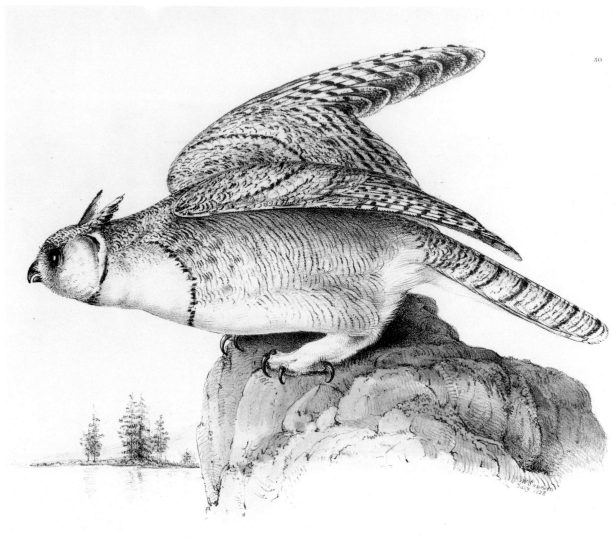

BUBO ARCTICUS.

12 ▪ GREAT HORNED OWL *Bubo virginianus*

"Bubo Arcticus." Hand-colored lithograph, by William Swainson. In *Fauna Boreali-Americana . . .* by John Richardson (1829–37). ▪ William Swainson was a versatile man—ornithologist, author, and artist, who both engraved birds and made lithographs of them. Collaborating with John Richardson, he wrote much of this work on the birds of northern America and also lithographed fifty bird portraits for it, using as his models specimens chiefly from the London Zoological Society and the Edinburgh University Museum. Richardson, who traveled the Arctic getting specimens, noted that this one had been "brought down with an arrow by an Indian boy."

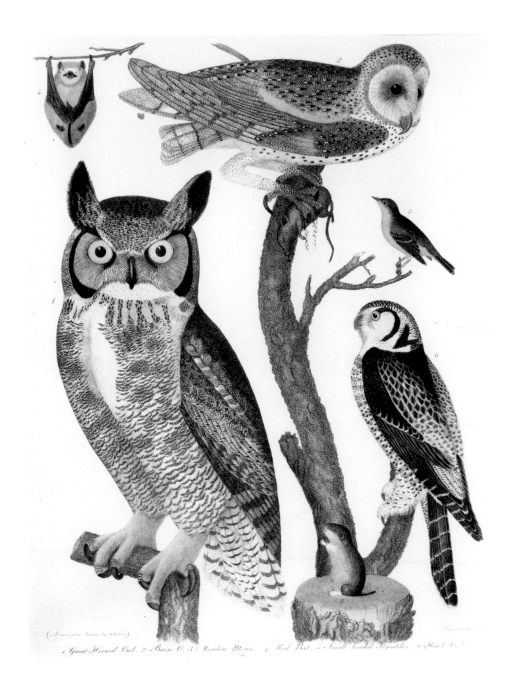

1. Great Horned Owl. 2. Barn O. 3. Meadow Mouse. 4. Red Bat. 5. Small headed Flycatcher. 6. Hawk Owl.

13 ▪ GREAT HORNED OWL *Bubo virginianus* ▪ BARN OWL *Tyto alba* ▪ FLYCATCHER *?species* ▪
HAWK OWL *Surnia ulula*

"1. Great Horned Owl; 2. Barn Owl; 3. Meadow Mouse; 4. Red Bat; 5. Small-headed Flycatcher; 6. Hawk Owl."
Hand-colored engraving, with etching, from drawing by Alexander Wilson. In *American Ornithology . . .* by
Alexander Wilson (1808—14). ▪ Before he turned to painting birds, Alexander Wilson was a poet, and his descrip-
tions are as vivid as any in all ornithology. "As soon as evening draws on," he wrote of the Barn Owl, "he sends forth
such sounds as seem scarcely to belong to this world . . . Waugh O! Waugh O! . . . and has other nocturnal solos one of
which resembles the half suppressed screams of a person suffocating or throttled." Because owls eat meadow mice
Wilson helpfully included one in this plate.

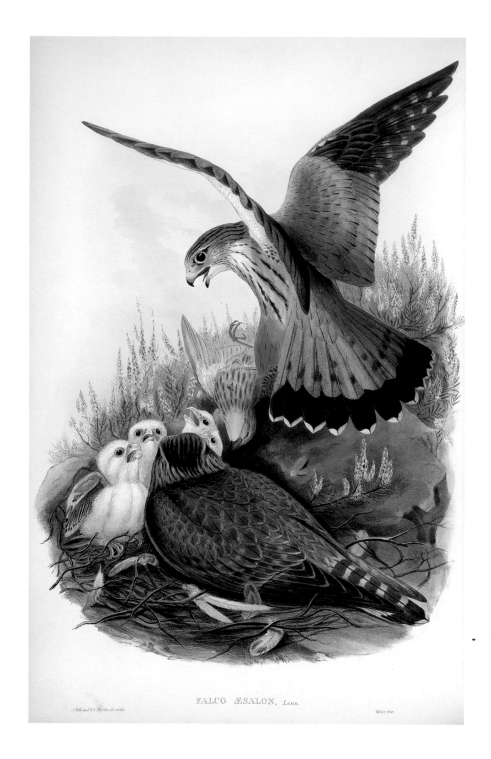

FALCO ÆSALON, *Linn.*

J.Wolf and H.C.Richter, del.et lith. Walter, imp.

14 ▪ MERLIN *Falco columbarius*

"Falco Aesalon." Hand-colored lithograph, by Josef Wolf and H. C. Richter. In *The Birds of Great Britain* by John Gould (1862–73). ▪ Josef Wolf, born in Germany, lived and worked mostly in England. Though he painted his birds from specimens in his studio he spent much time in the field, observing the lives, behavior, and surroundings of living birds. His habitats, therefore, are wonderfully detailed and convincing. Note in this painting of a Merlin the twig of a nearby flowering shrub and the loose feathers of a bird the young have been feeding on.

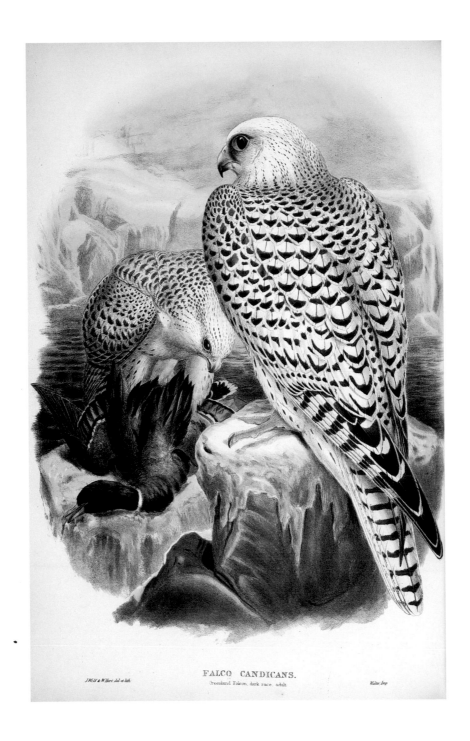

FALCO CANDICANS.

Greenland Falcon, dark race, adult.

J.Wolf & W.Hart del. et lith. Walter Imp.

15 ▪ GYRFALCON *Falco rusticolus*

"Falco Candicans/Greenland Gyrfalcon." Hand-colored lithograph, by Josef Wolf and William Hart. In *The Birds of Great Britain* by John Gould (1862–73). ▪ "We see distinctly only what we know thoroughly," wrote Josef Wolf, the nineteenth-century master of zoological illustration, and his own thorough knowledge is evident in his portrait of the Greenland Gyrfalcon, which seems alive as it crouches over the bloodied Mallard it has just caught.

From their earliest days, bird books were best-sellers—as they still are today. By the 1700s, advances in printing techniques made it feasible to produce large, lavishly illustrated books. Advances in the understanding of nature and the substitution of national languages for the scholar's Latin created larger and larger audiences for the books and led to the burst of interest in natural history that was a phenomenon of the eighteenth and nineteenth centuries. In many books, birds would be grouped into broadly descriptive categories—as "Seed Eaters, Berry Eaters, Insect Eaters" or as "Birds of Wetlands, Birds of Forests" and so on. Such classification was more convenient than scientific. But it served a popular purpose and the time-honored usage has been revived for *The Bird Illustrated.* ▪ Most books were piously intended to teach, not entertain, but in one way or another they managed to do both. Not everyone was impressed. "Most readers of natural history books," complained one scientist, go to them not for instruction but "as decorations because of their colored pictures." ▪ The grumpy critic was not too far off the mark. Whatever other value the books had, the illustrations gave them their popular appeal and the popularity grew as the illustrations improved. Sometimes the books were directed at special audiences, those on game birds, for example, at huntsmen and country gentlemen who took particular delight in Daniel Giraud Elliot's resplendent pheasants (plates 22, 23). By contrast, Bewick's simple *History of British Birds,* aimed at a general audience, went into six editions plus several small-scale versions. The never-ending volumes of Buffon's *Histoire naturelle générale* were spoken for almost before they were printed. ▪ Except in their enormous popularity and influence, these two men, Thomas Bewick and Le Comte de Buffon, could hardly have been more different. Bewick was a country boy who grew up with a feeling for nature that lasted through his life. More than any other book of its time, his beautifully illustrated *History of British Birds* opened the world of nature to people. The English critic William Henry Hazlitt spoke of it: "His volumes are loved and treasured and reverted to time after time; the more familiar, the more prized; the oftener seen, the oftener desired." ▪ John James Audubon once visited Bewick and found him in "a cotton nightcap, somewhat soiled by smoke. . . . Purely a son of nature." No one ever called Georges-Louis Leclerc, Le Comte de Buffon, a son of nature

GAME BIRDS

or found him in a soiled nightcap. The epitome of elegance and intellect, the count awed even the most illustrious of his contemporaries. "The mind of a sage in the body of an athlete" was the way Voltaire described him. As superintendent of the Royal Gardens in Paris, Buffon set out to publish a catalogue of its contents, which grew and grew into the forty-four-volume *Histoire naturelle générale et particulière.* It went into fifty-two editions in French, more than twenty in other languages, plus some three hundred abridged editions. A three-volume supplement, *Planches enluminées,* illustrated every known bird. Buffon's work always carried an air of omniscience, which in many ways it deserved. So, indeed, did Buffon who explained it—and himself— in his famous aphorism: "Style is the man."

16 ▪ DOMESTIC FOWL *Gallus domesticus*

"Cock." Wood-engraving, by Thomas Bewick. In *A History of British Birds* by Thomas Bewick (1797, 1804); restrike from original woodblock (1944).

17 ▪ RUFF *Philomachus pugnax*

"Ruff." Wood-engraving, by Thomas Bewick. In *A History of British Birds* by Thomas Bewick (1797, 1804).

Thomas Bewick's *A History of British Birds* was the nearest thing to a popular bird guide in its time. For his engravings, Bewick used the end-grain blocks of boxwood, the hardest wood he could find and so durable that some of his original blocks are still used to reprint his birds today. Only Holbein and Turner, said the critic John Ruskin, were more subtle in their drawing than Bewick. Bewick included domestic and wild birds in his book.

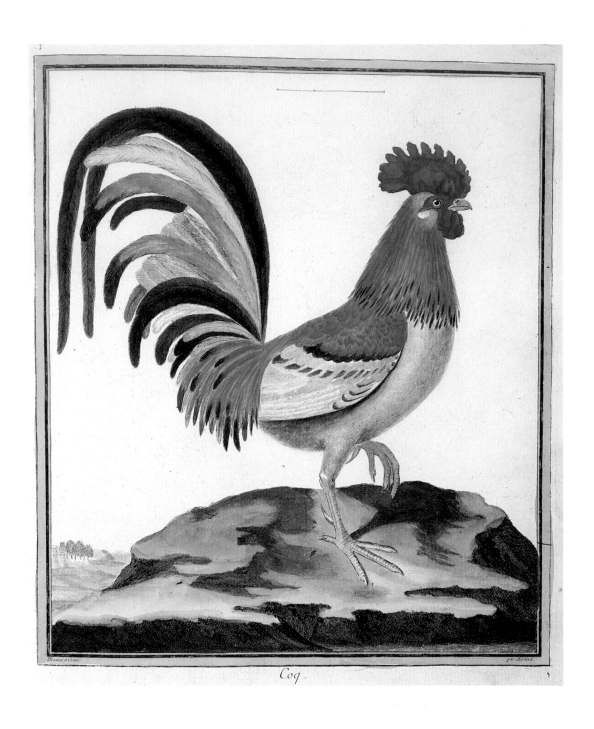

Coq.

18 ▪ DOMESTIC FOWL *Gallus domesticus*

"Coq." Hand-colored engraving, with etching, by François Martinet from his own drawing. In *Planches enluminées d'histoire naturelle par Martinet . . .* by Le Comte de Buffon (1765–83). ▪ François Martinet was an engineer by profession who turned artist and became one of the most prolific of all bird painters. For Le Comte de Buffon's work on the natural history of birds, he did just under a thousand engravings. It is interesting to compare this rooster to Bewick's (plate 16). Bewick's cock looks as if it were ruling a farmyard, Martinet's as if it were commanding a kingdom.

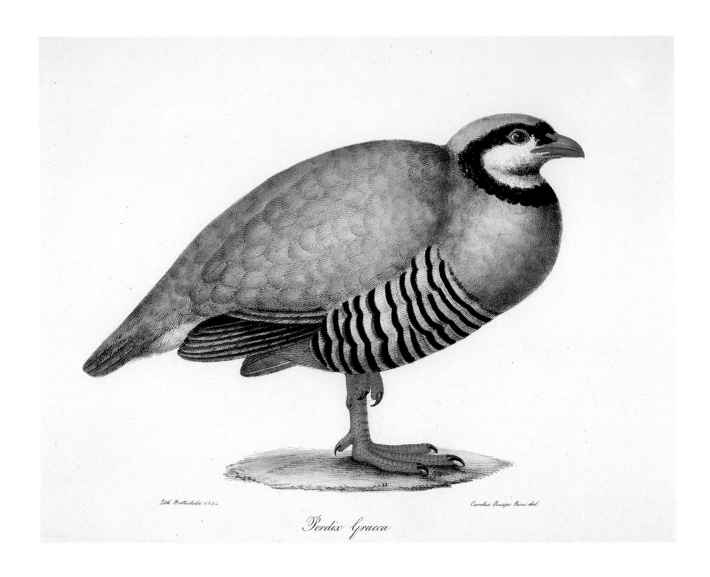

Perdix Graeca

19 ▪ ROCK PARTRIDGE *Alectoris graeca*

"Perdix Graeca." Hand-colored lithograph, by Battistelli from drawing by Carlos Ruspi. In *Iconografia della fauna Italica . . .* by Charles-Lucien Bonaparte (1832–41). ▪ Charles-Lucien Bonaparte was a nephew of Napoleon who gave him his title, Prince of Canino. But the Prince's considerable achievements as a naturalist were all his own doing. He spent his early years in the United States working on American ornithologies. Returning to Europe, he did a comprehensive work on Italian vertebrates, from which this illustration of the Rock Partridge is taken.

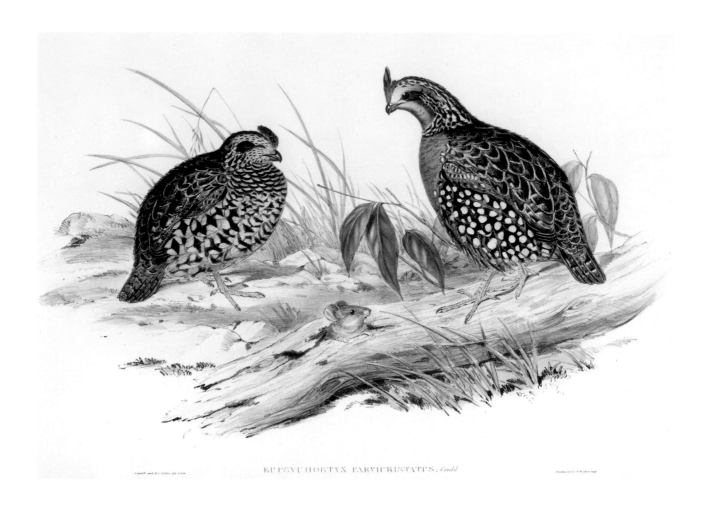

EUPSYCHORTYX PARVICRISTATUS; *Gould*

20 ▪ CRESTED BOBWHITE *Colinus cristatus*

"Eupsychortyx parvicristatus." Hand-colored lithograph, by John Gould and H. C. Richter. In *A Monograph of the Odontophorinae . . .* by John Gould (1844–50). ▪ John Gould, the great nineteenth-century producer of bird books, employed several artists but gave them all rigorous instructions on just what to do. A conscientious collaborator, H. C. Richter worked for Gould for forty years and followed orders down to the last detail, such as the inclusion of this winsome mouse peering out of the log in the foreground.

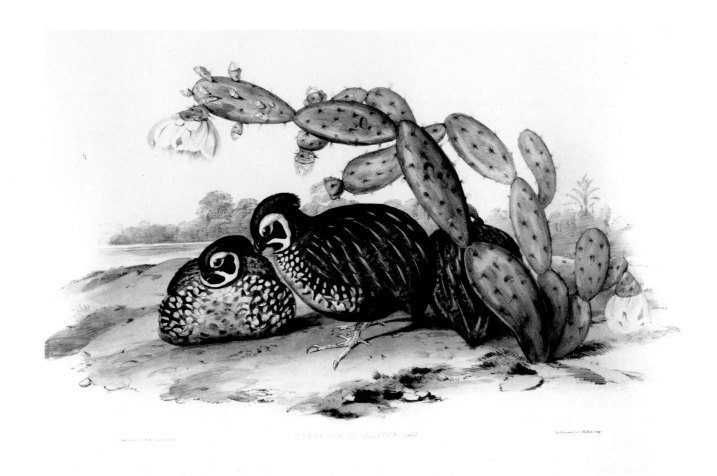

21 ▪ OCELLATED QUAIL *Cyrtonyx ocellatus*

"Cyrtonix Ocellatus." Hand-colored lithograph, by John Gould and H. C. Richter. In *A Monograph of the Odontophorinae . . .* by John Gould (1844–50). ▪ Although the flowering cactus here would seem to indicate that the Ocellated Quail is a denizen of the desert, its habitat is the grassy areas in and near pine-oak woodlands in Mexico and Central America. Himself the father of six, Gould took a domestic delight in including chicks whenever he could, keeping in mind, perhaps, the sentimental tendencies of Victorians.

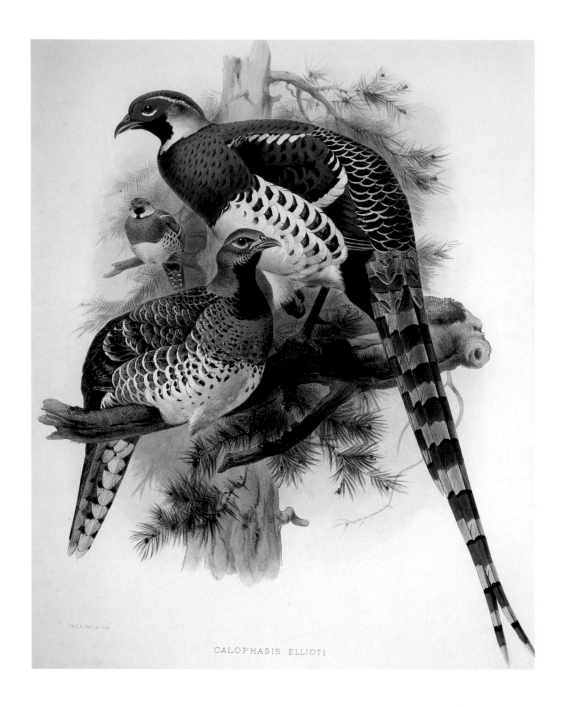

CALOPHASIS ELLIOTI

22 ▪ ELLIOT'S PHEASANT *Syrmaticus ellioti*

"Calophas Ellioti." Hand-colored lithograph, by Joseph Smit from drawing by Josef Wolf. In *A Monograph of the Phasianidae or Family of the Pheasants* by Daniel Giraud Elliot (1870–72). ▪ Daniel Giraud Elliot was a wealthy New Yorker who devoted much of his life to ornithological pursuits. His excellent private collection of birds formed the nucleus of the Department of Ornithology at the American Museum of Natural History in New York, and he acted as emissary to purchase further collections abroad. Although himself an artist of note, the paintings for his great pheasant monograph were done by Josef Wolf, to whom Elliot dedicated this volume. The discoverer of this Chinese bird honored Elliot by naming it after him.

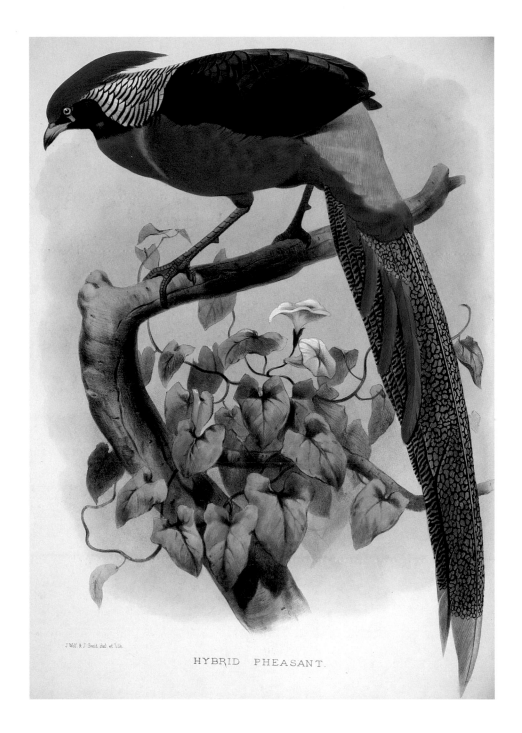

HYBRID PHEASANT.

23 • GOLDEN PHEASANT × LADY AMHERST PHEASANT *Chrysolophus pictus* × *C. amherstiae*

"Hybrid Pheasant." Hand-colored lithograph, by Joseph Smit from drawing by Josef Wolf. In *A Monograph of the Phasianidae or Family of the Pheasants* by Daniel Giraud Elliot (1870–72). ▪ Fellow naturalists admired Josef Wolf as "the most original observer of wild animal life" they knew. Wolf was able to make his observations of this pheasant in the convenient setting of the Zoological Garden at Regents Park in London. Though Elliot included this hybrid pheasant in his *Monograph*, he disapproved of hybridization. Pheasant fanciers, he advised, should keep "their birds as pure in blood as possible."

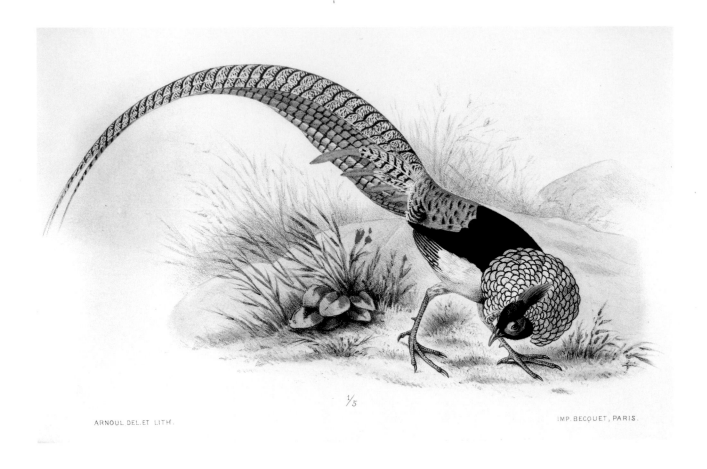

ARNOUL DEL.ET LITH.

¹⁄₅

IMP. BECQUET, PARIS.

24 ▪ LADY AMHERST PHEASANT *Chrysolophus amherstiae*

"Thaumalea Amherstae." Hand-colored lithograph, by M. Arnoul. In *Les Oiseaux de la Chine* by Armand David and Emile Oustalet (1877). ▪ The Lady Amherst Pheasant is one of sixteen members of the pheasant family depicted in this volume, and certainly one of the most beautiful. William Beebe, the famous naturalist, came upon a male of this species near an icy stream in the heart of Asia and declared that "the scarlet side feathers shone like shafts of rubies, and its eyes, matching its cape, gleamed with the very essence of the wilderness."

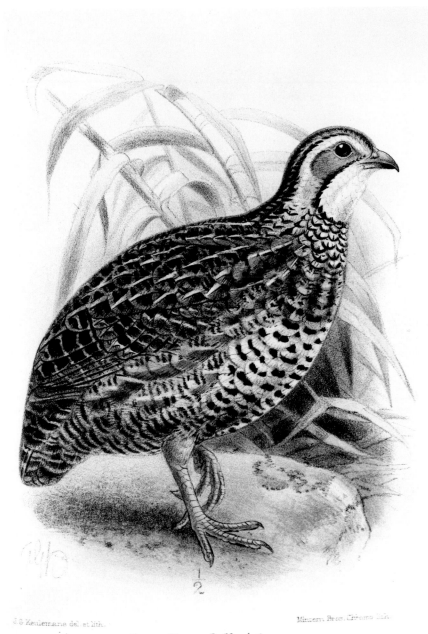

Francolinus shelleyi, ♂.

J.G. Keulemans del. et lith. Mintern Bros. Chromo lith.

25 ▪ SHELLEY'S FRANCOLIN *Francolinus shelleyi*

"Francolinus shelleyi." Chromolithograph, by John G. Keulemans. In *Game Birds*, vol. 22 of *Catalogue of the Birds in the British Museum*, ed. by R. Bowdler Sharpe and others (1874–98). ▪ John G. Keulemans, a Dutch painter, worked for most of his life in London illustrating, among other works, the massive twenty-seven-volume *Catalogue of the Birds in the British Museum*. He was an assiduous artist. Once when the lithographs he had made for a book were erased and a second edition was called for, he went back to the lithograph stones and industriously drew his birds all over again.

Of all the kinds of birds, none seems to delight artists more than the waders, the long-legged residents of marshes, streams, and shores. From the time in 1555 that Pierre Bélon showed his stork tangling with a snake, artists were attracted to the waders' handsome plumage and graceful attitudes. But there were problems fitting the whole bird into the page. Their legs and necks threatened to poke out of the margins and the artist had to devise ways of containing them. Thus Edward Lear (plate 33) mercilessly contorted one of his flamingos and John James Audubon pushed his heron's beak down into the water (plate 36). ▪ It may be surprising to find Edward Lear, most famous of all nonsense writers, in this company of serious artists, but it should not be. Although he is far better known for his sea-going owls and quadrille-dancing ravens, Lear was one of the finest of all painters of birds. In 1831, at the age of nineteen, self-taught in art and ornithology, Lear undertook to draw the species of parrots, working, as few artists then did, from live specimens. His vivid yet accurate portraits caught the attention of the Earl of Derby, who hired him to become, in effect, court painter to the hundreds of birds and beasts in the huge, hundred-acre private menagerie the earl kept on his estate. There, to amuse the earl's children, Lear began writing his nonsense verse and stories, gaining a zany immortality for such ornithological oddities as "the Visibly Vicious Vulture who wrote some Verses to a Veal-cutlet in a Volume bound in Vellum." ▪ Along the way Lear took up with John Gould, the most prodigious of all bird book publishers, who enlisted the best nature artists of

WADERS

his time to illustrate his books on birds of Europe, Great Britain, Asia, America, and Australia. Lear painted several dozen European birds for Gould before giving up the painting of birds altogether for those of landscapes. He found Gould "rough and violent" but liked him well enough to invite him for a visit, offering in a very Lear-like way, "good wine and a spare bed . . . if you like to put up with porcupine flesh and snails for dinner." ▪ "In his earliest phase of bird drawings," Lear said of Gould, "he owed everything to his excellent wife and myself." The excellent Elizabeth Gould served her husband as artist and wife for eighteen years before she died, worn out perhaps by the labor of producing six children and six hundred bird paintings. ▪ Gould, who before he turned to birds was a taxidermist (he stuffed the king's pet giraffe), was immensely industrious and self-centered. He often went out and shot specimens himself, did the necessary research, and made rough sketches for his artists to follow giving them minute instructions on appearance, attitudes, and backgrounds. He was also immensely successful, shrewdly publicizing himself and his business, counting among his subscribers 12 monarchs, 11 royal highnesses, 16 dukes and duchesses, 30 earls, and 61 baronets. His books, which made excellent use of the flexible virtues of lithography, were so large that, one subscriber complained, he "had to keep a boy nearby to carry them." Gould published an astonishing forty-one of them and, for scope and beauty, they have never been surpassed. But in his old age he bemoaned the fact that, in his busy thirty-three years, he was able to do only a quarter of the things he had set out to do.

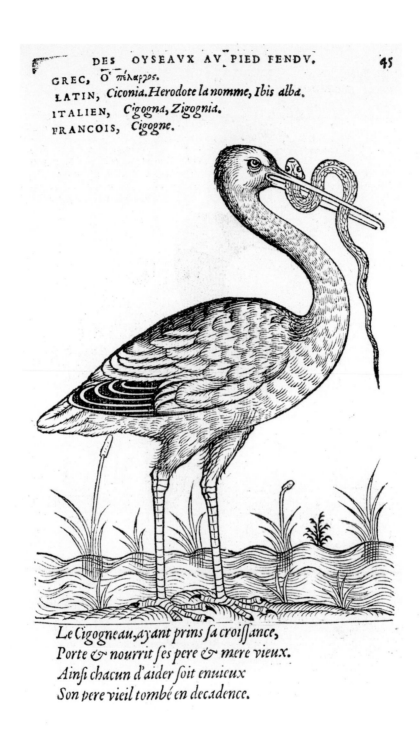

GREC, Ὁ πέλαργος.
LATIN, *Ciconia. Herodote la nomme, Ibis alba.*
ITALIEN, *Cigogna, Zigognia.*
FRANCOIS, *Cigogne.*

Le Cigogneau, ayant prins sa croissance,
Porte & nourrit ses pere & mere vieux.
Ainsi chacun d'aider soit enuieux
Son pere vieil tombé en decadence.

26 ▪ WHITE STORK *Ciconia ciconia*

"Ibis Alba." Woodcut, from drawing by Pierre Goudet. In *Pourtraicts d'oyseaux, animaux . . .* by Pierre Bélon (1557). ▪ The Frenchman Pierre Bélon, together with Aldrovandi and Gesner, laid the foundations in the sixteenth century for the serious study of ornithology. Bélon advanced the science of comparative anatomy in the first monograph about birds, his 1555 *L'Histoire de la nature des oyseaux. . . .* The text of *Pourtraicts . . .* , on the other hand, consists of charming, fanciful poems about each bird. The White Stork is praised as an exemplary child who concerns itself with the welfare of its parents and feeds and cares for them throughout their old age.

GEORGI MARCGRAVI

CAP. VI.
Iabiru. Iabiru guacu. Manucodiata.

IABIRV Braſilienſibus, Belgis vulgo *Negro.* Avis hæc magnitudine ſuperat Cignum. Corpus illius quatuordecim digitos longum: collum totidem, & brachii humani habens craſſitiem. Caput ſatis magnum, oculi nigri, roſtrum nigrum directè extenſum, & ſuperius verſus extremitatem paulum incurvatum; undecim digitos longum, duos & ſemis latum, ver-

ſus exteriora acuminatum; eſtque ſuperior roſtri pars paulo altior & major inferiori. Caret lingua & ſub gutture ingluviem habet mediocris magnitudinis. Crura longiſſima, duos ni-mirum pedes: ſuperiora enim unum pedem & digitum longa, & mediam partem pennis nuda; inferiora undecim digitos. Sunt autem crura recta, nigricantia, & quaſi ſquamata, digitum medium craſſa. In pedibus digiti quatuor, tres anterius, unus poſterius verſus; quorum me-dius quatuor digitos longus, cæteri paulo breviores. Tota avis veſtitur albis pennis inſtar cigni aut anſeris. Collum fere totum, nimirum octo digitorum, longitudine à capite nume-rando, caret pennis; ac hujus medietas cum capite tegitur nigra cute, reliqua alba cute. Sed puto in cute hæſiſſe pinnulas albas, & fuiſſe abreptas. Cauda lata deſinit cum extremitate alarum.

27 ▪ WOOD STORK *Mycteria americana*

"Iabiro Guaco." Woodcut. In *Historia naturalis Brasiliae auspicio et beneficio illustratis . . .* by William Piso and Georges Marcgrave (2d ed., 1658). ▪ Georges Marcgrave, a brilliant young naturalist, and William Piso, a physician, went to Brazil in 1640 to study the country. Marcgrave died before he could finish his *Natural History*. It took years to decipher the coded notes he had taken and for Piso to publish them. This somewhat schematic drawing of the Wood Stork accurately depicts the slight downward curve of the bill.

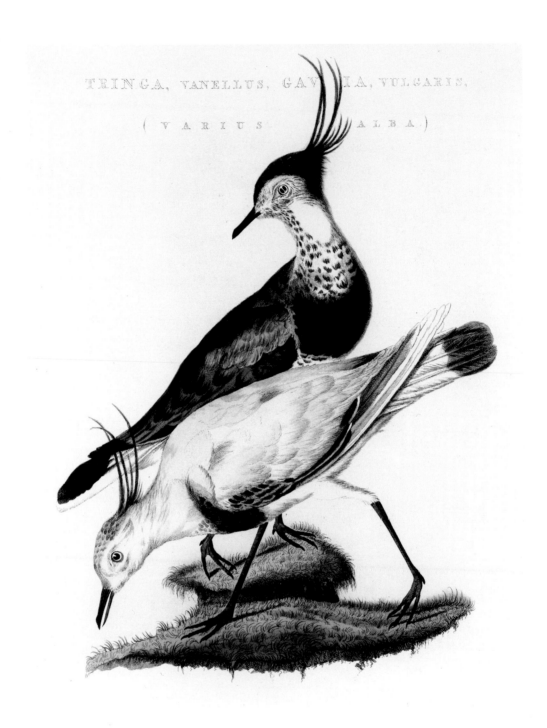

TRINGA, VANELLUS, GAVIA, VULGARIS,
(VARIUS ALBA)

28 ▪ LAPWING *Vanellus vanellus*

"Tringa." Hand-colored engraving, with etching, by a member of the Sepp family from drawing by C. Sepp or J. C. Sepp. In *Nederlandsche vogelen* . . . by Cornelius Nozeman and Martinus Houttuyn (1770–1829). ▪ Cornelius Nozeman was a Dutch apothecary and clergyman who compiled the first complete ornithology of his native Holland. After his death, the text was completed by Martinus Houttuyn and the Sepp family of Amsterdam took over the task of publishing it: Christian Sepp, his son, Jan Christian, and Jan Christian's son, Jan. Most of the engravings were done by Jan Christian. Lapwings are members of the plover family, distinguished by their long wispy crests.

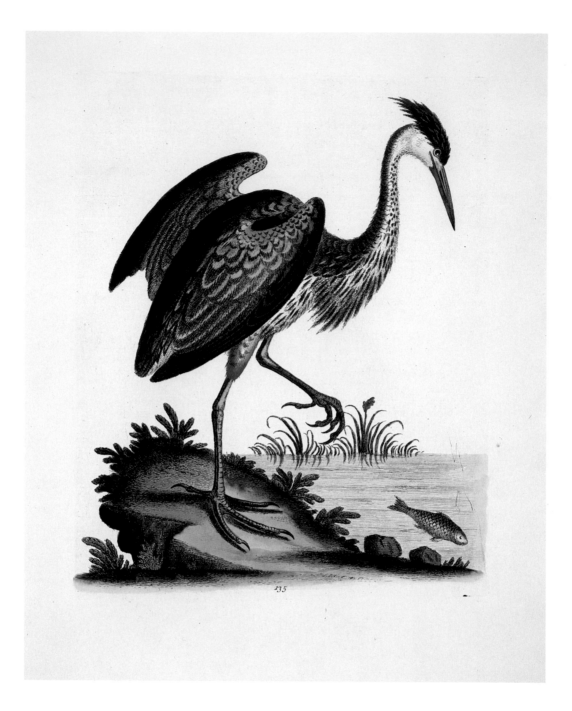

29 ▪ GREAT BLUE HERON *Ardea herodias*

"Ash Coloured Heron." Hand-colored etching, by George Edwards from his own drawing. In *A Natural History of Birds . . .* by George Edwards (1802–6). ▪ George Edwards's *Natural History* is, for its completeness and the accuracy and the excellence of its illustration, *the* great work of eighteenth-century English ornithology. Apprenticed to a merchant, Edwards was more interested in art and birds than trade. He wandered and watched in Europe for two years, came back to England, and, over a period of six years drew, etched, and wrote his four-volume *Birds*. The Great Blue Heron is one of the many American birds he included. This posthumous edition also includes *Gleanings of natural history.*

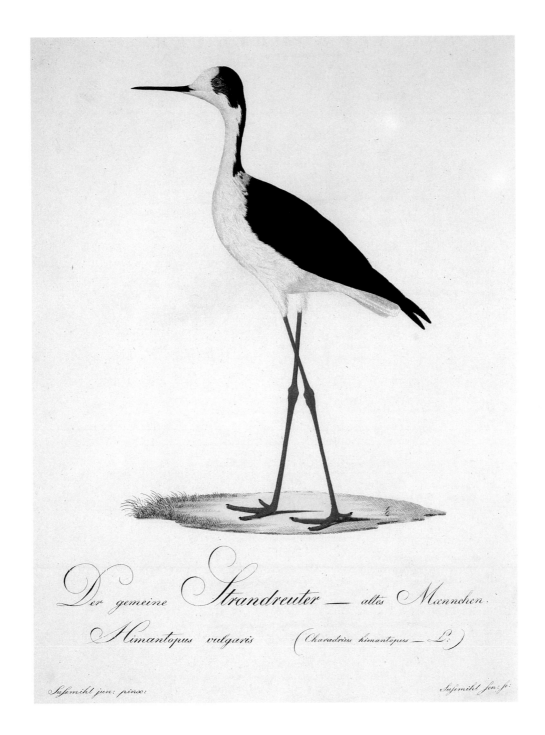

Der gemeine Strandreuter — altes Männchen.

Himantopus vulgaris (Charadrius himantopus — L.)

Susemihl jun: pinx: Susemihl sen: fc:

30 ▪ BLACK-WINGED STILT *Himantopus himantopus*

"Der Gemeine Strandreuter." Hand-colored etching, by member of Susemihl family from drawing by J. C. Susemihl. In *Teutsche Ornithologie . . .* by Moritz Borkhausen et al. (1800–11). ▪ It is not known which of the two Susemihl brothers or perhaps a son made this fine portrait of the needle-beaked wader with the improbable-looking legs, proportionately the longest in the bird world. In the shallow pools they frequent, stilts probe the mud for crustaceans and other small animal life. As they wade slowly through the water they lift each leg high in turn. In flight the legs trail straight behind.

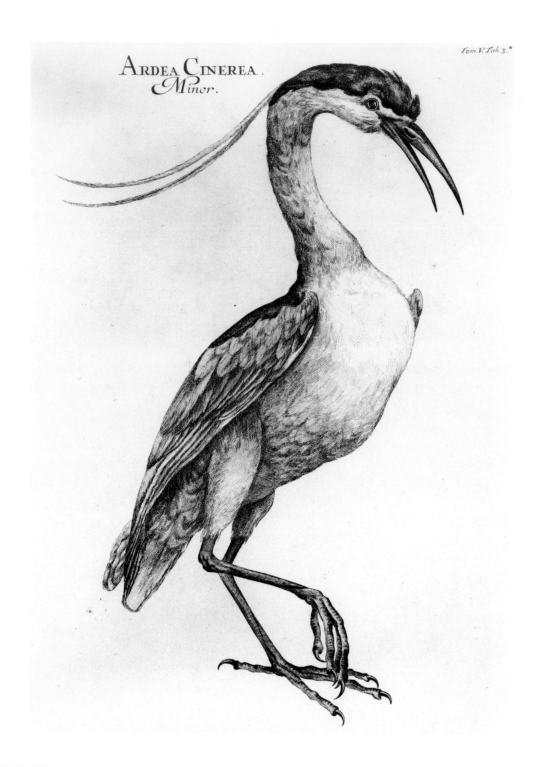

Tom.V.Tab.3.

ARDEA CINEREA.
Minor.

31 ▪ GRAY HERON *Ardea cinerea*

"Ardea Cinerea, Minor." Engraving, by J. Houbraken from drawing by Raimondo Manzini. In *Danubius Pannonico-Mysicus: Aves* by Luigi F. Marsigli (1726). ▪ Luigi Ferdinand Marsigli, a count of Bologna, was a military man who became embroiled in politics and was stripped of his general's rank. Returning to his youthful interests, he published a six-volume work on the natural history of the Danube. The illustrations were by Manzini who put great elegance into this heron but did not give it much life—as, for example, Audubon (plate 36) and Edwards (plate 29) did.

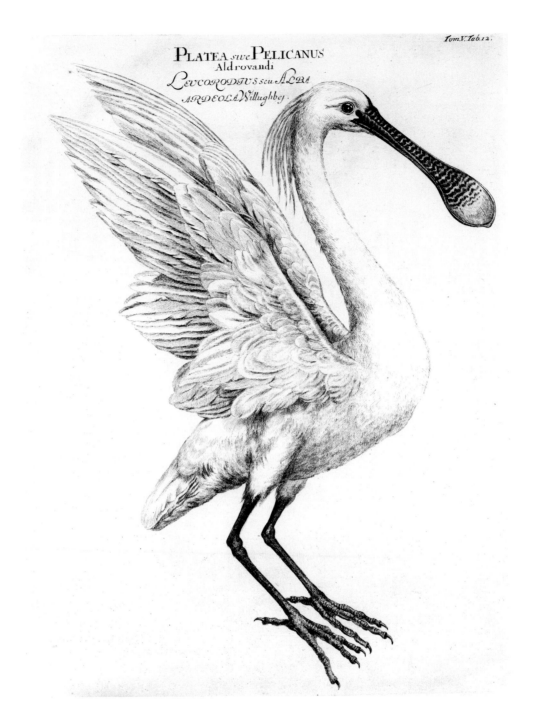

Tom.V.Tab.12.

PLATEA *sive* PELICANUS
Aldrovandi
Leucorodius seu Alba
Ardeola Willughbey.

32 ▪ WHITE SPOONBILL *Platalea leucorodia*

"Platea sive Pelicanus." Engraving, by J. Houbraken from drawing by Raimondo Manzini. In *Danubius Pannonico-Mysicus: Aves* by Luigi F. Marsigli (1726). ▪ The most noticeable feature of these large heron-like wading birds is their spatulate bill, an efficient tool in the capture of the aquatic insects, crustaceans, worms, and other animal life the spoonbill happens upon as it wades through shallow water moving its submerged bill from side to side. Until the eighteenth century this bird was called "Shoveler" or "Shovelard." Although both parents share in incubation and feeding, the males stray from the nests to force their attentions on nearby nesting females and unattached females.

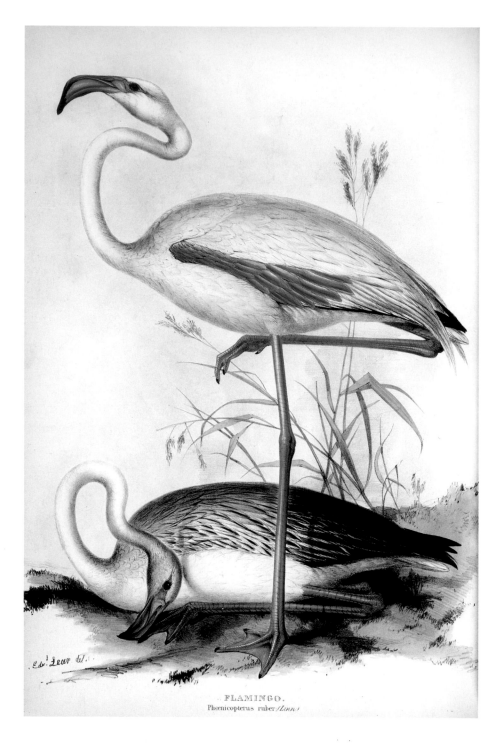

FLAMINGO.
Phoenicopterus ruber *(Linn.)*

33 ▪ GREATER FLAMINGO *Phoenicopterus ruber*

"Flamingo." Hand-colored lithograph, by Edward Lear. In *The Birds of Europe* by John Gould (1832–37). ▪ Although he was a serious bird artist Lear sometimes touched his subjects with the whimsy of his nonsense birds—even in this straightforward painting, the flamingo has a suggestion of the grotesque. Because the flamingos legs are so long and because they build mud nests on pedestals, it was once erroneously believed that they did not sit on their nests, as other birds do, but straddled them with their feet in water.

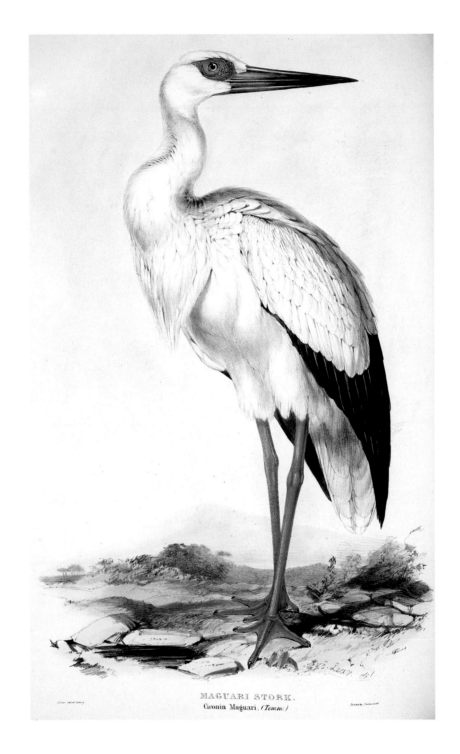

MAGUARI STORK.
Ciconia Maguari. (Temm.)

34 · MAGUARI STORK *Euxenura maguari*

"Maguari Stork." Hand-colored lithograph, by Edward Lear. In *The Birds of Europe* by John Gould (1832–37). ▪ Edward Lear's Maguari Stork does not really belong in *Birds of Europe* since it is a South American bird. However, Lear also drew some proper European storks for the book. Later on he drew many improper ones for his own nonsense books, including the seven quarrelsome storks of Lake Pipple-Popple who "pecked each other to little pieces so that at last nothing was left of any of them except their bills."

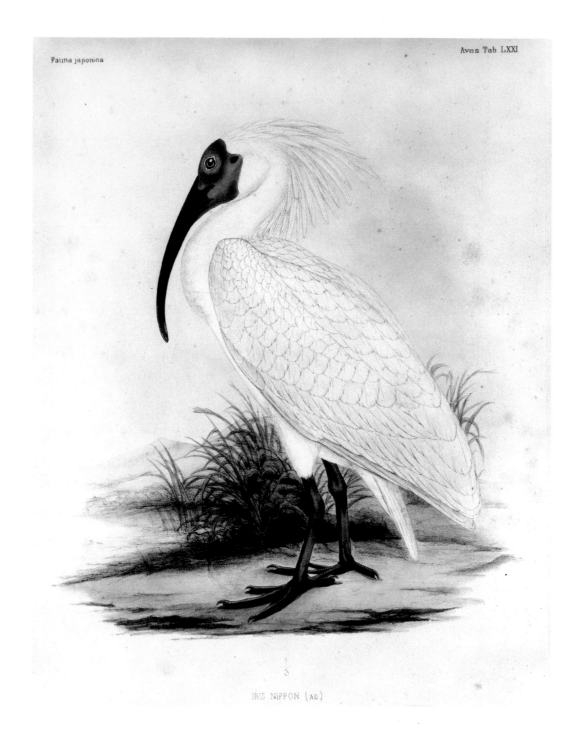

IBIS NIPPON (AD)

35 ▪ JAPANESE CRESTED IBIS *Nipponia nippon*

"Ibis Nippon." Hand-colored lithograph, by either Josef Wolf or Hermann Schlegel. In *Fauna Japonica . . .* by Philipp Franz von Siebold, Coenraad Jacob Temminck, and Hermann Schlegel (1833–50). ▪ The descriptions in this five-volume work, the first significant Western work on the fauna of Japan, are based on specimens collected by Philipp Franz von Siebold. As a young doctor, Siebold was personal physician to King William I of Holland. Restless, he joined the colonial army and wound up at a trading station on Nagasaki, where from 1823 to 1829 he studied the country's natural history.

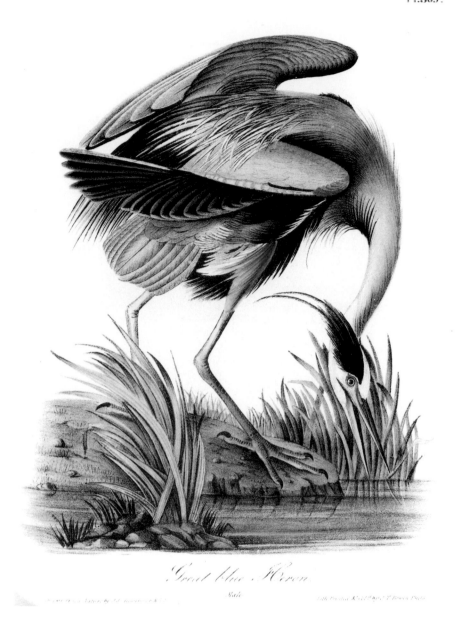

Great blue Heron
Male

36 ▪ GREAT BLUE HERON *Ardea herodias*

"Great Blue Heron." Hand-colored lithograph, by J. T. Bowen from engraving of drawing by John James Audubon. In *The Birds of America* by John James Audubon (1840–44). ▪ Audubon's epic *Birds of America* was printed in what was called a "double elephant folio," huge 39 × 26-inch sheets of hand-colored engravings with aquatint. It was expensive and only some 175 sets were sold. Audubon then published an inexpensive royal octavo lithographed edition, which sold thousands of copies and became a standard reference work. Large birds, such as this Great Blue Heron, were positioned to fit within one page. As Sacheverell Sitwell, an admirer of Audubon's, remarked, "Had an ostrich or an emu been among the birds of America, Audubon would, quite likely, have increased the dimensions of his folio to include it."

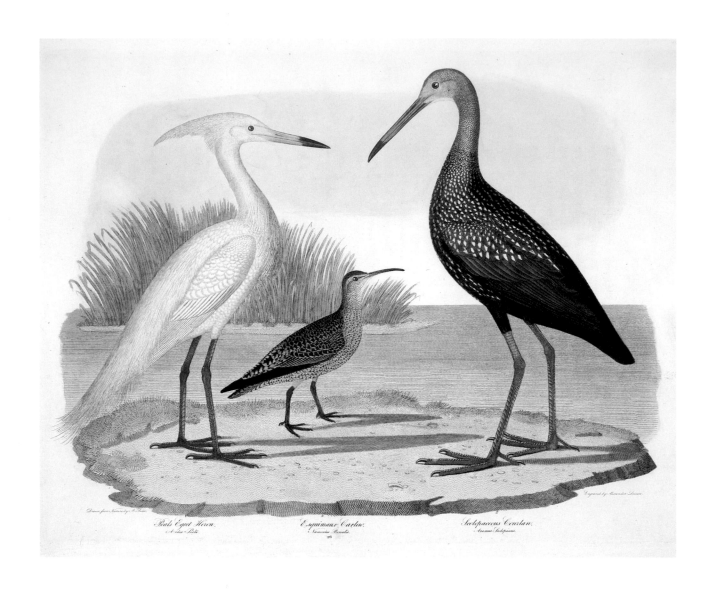

Drawn from Nature by C. Peale · Peal's Egret Heron. Ardea Peale. · Esquimaux Carlew. Numenius Borealis. 26 · Scolopaceous Courlan. Aramus Scolopaceus. · Engraved by Alexander Lawson.

37 ▪ REDDISH EGRET, WHITE PHASE *Egretta rufescens* ▪ LIMPKIN *Aramus guarauna* ▪
ESKIMO CURLEW *Numenius borealis*

"Peal's Egret Heron; Scolopaceous Courlan; Esquimaux Carlew." Hand-colored engraving, with etching, by Alexander Lawson from drawing by Alexander Rider. In *American Ornithology . . .* by Charles-Lucien Bonaparte (1825–33). ▪ Alexander Wilson died in 1813 before he could complete his *American Ornithology*. George Ord finished the last volumes and Wilson's great admirer, Charles-Lucien Bonaparte, put together a sequel describing and depicting American birds Wilson had not known. The artist, Alexander Rider, was faithful to Wilson's style of showing birds in profile in somewhat stiff attitudes.

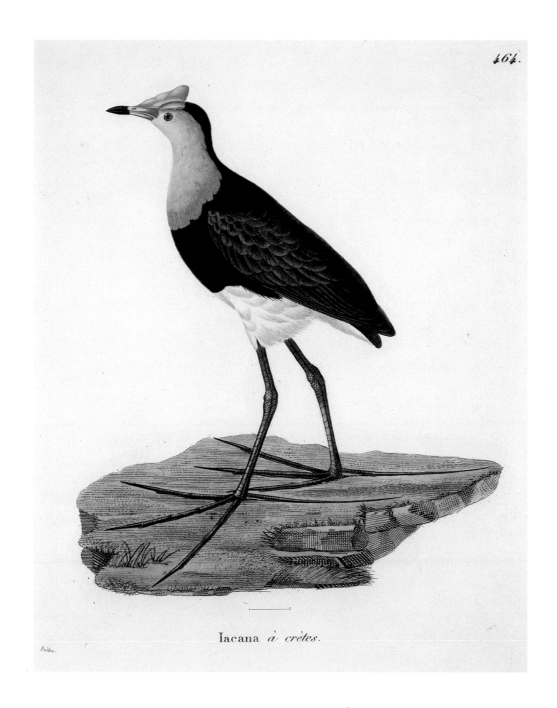

464.

Iacana *à crètes*.

Prêtre.

38 ▪ COMB-CRESTED JACANA *Irediparra gallinacea*

"Jacana à Crètes." Hand-colored engraving, with etching, from drawing by Jean-Gabriel Prêtre. In *Nouveau recuil de planches coloriées d'oiseaux . . .* by Coenraad Jacob Temminck and M. Laugier de Chartrouse (1820–39). ▪ The depiction of this elegant and detailed jacana on a water-lily leaf is highly appropriate since these small tropical and subtropical wading birds are often called "lily-trotters." Thanks to their exceptionally long toes and claws, all the members of this family appear to walk on water—their weight is distributed over such a wide area that floating leaves and other vegetation support them as they move about hunting food. The nest of grasses, leaves, and reeds rests on floating vegetation.

From the time Columbus brought back feathered trophies of his first voyage, Europeans were beguiled by the New World's birds. Some were recognizable as those that might inhabit their own fields, woodlands, and streams—swallows and ravens and kingfishers. Others were far-out variations on familiar birds—an outsize woodpecker with a huge white beak (plate 53). There were new delights—a bright red singer they called the Virginia nightingale (plate 46), and a thrush-like bird that mocked the song of every bird around (plate 45). America's birds soon had their likenesses in Europe's bird books and eventually had whole books to themselves. Three of these books, which have become landmarks, were by men who shared an all-absorbing passion for America's birds and a vaulting ambition to know and describe them. ▪

BIRDS OF FIELD AND WOODLAND

Mark Catesby was a diligent English naturalist who spent a dozen years in the southern colonies between 1712 and 1726, collecting and sketching birds. Back in England, because he·could not afford to employ an engraver, Catesby learned the art of engraving to make the plates himself. It took him some fifteen years to paint, write, and print his lovely *The Natural History of Carolina, Florida and the Bahama Islands*. The book went into three editions in English and one each in French, German, and Dutch. ▪ Alexander Wilson was a single-minded Scotsman, a silk weaver, and also a poet, who came to Pennsylvania in 1794. The day he landed he saw his first red-headed woodpecker and fell in love with the birds of his new home. He taught himself to identify them, then to illustrate and write about them, then to publish his works, and finally to travel all over the country, from Maine to Louisiana, by foot or on horseback, to peddle his *American Ornithology*. Merchants, farmers, doctors, and a couple of presidents—Thomas Jefferson and James Madison—bought Wilson's volumes as much out of patriotism as anything else, for this was the first all-American ornithology—painted, written, engraved, and printed in America, by an American citizen, and on American birds. ▪ John James Audubon was a romantic Frenchman, the illegitimate son of a sea captain, who came to America in 1803 to make his fortune as a businessman and, through his misfortune, to become the most famous of all bird painters. Settled on the Kentucky frontier as a merchant, Audubon went bankrupt, in part because he spent so much time watching and painting birds that he could not pay proper attention to business. Penniless but free to do for a living what he had done for pleasure, he set out to paint and publish all the birds of his adopted country. ▪ Unable to find anyone in the United States to publish his paintings, Audubon went to England where subscribers were taken by his cultivated frontier manners, his persuasive ways, and most of all by his *Birds of America* in which one admiring critic saw "the feathered races of the New World in the size of life, each in its particular attitude, its individuality and peculiarities . . . in motion or at rest, in their plays and their combats, in their anger fits and their caresses. . . . It is a real and palpable vision of the New World."

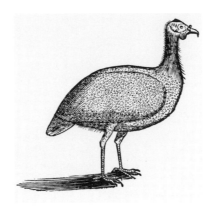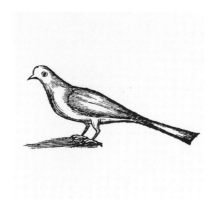

39 ▪ THREE BIRDS (detail of book plate)

Woodcuts. In *Historia naturalis Brasiliae auspicio et beneficio illustratis . . .* by William Piso and Georges Marcgrave (2d ed., 1658). ▪ In Marcgrave's work on the natural history of Brazil, many birds are described for the first time. Until the end of the seventeenth century, this was the only source of information on Brazilian zoology. Unfortunately, the drawings prepared by Marcgrave were so poorly executed by the engraver that the publisher substituted woodcuts previously made for an unrelated volume.

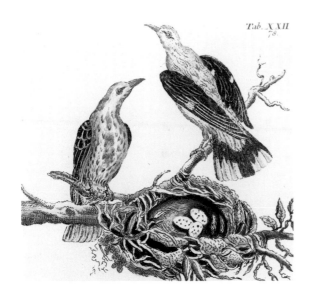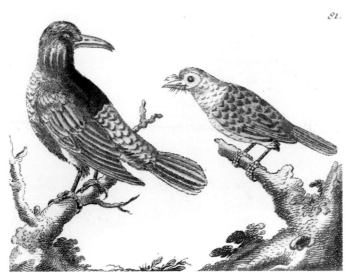

40 ▪ GOLDEN ORIOLE, MALE; FEMALE *Oriolus oriolus* ▪ YELLOW-RUMPED CACIQUE *Cacicus cela* ▪ ORIENTAL GREEN BARBET *Megalaima zeylanica*

"Der gemeiner Pirol; Jupujaba; Der Bartvogel." Hand-colored engraving, by Gottlieb Tobias Wilhelm from his own drawing. In *Unterhaltungen aus der Naturgeschichte . . . Vögel* by Gottlieb Tobias Wilhelm (1792–1802). ▪ The tiny illustrations in this small German natural history have a charm all their own. Here are represented colorful birds from three continents: the Golden Oriole, top, of Europe and Asia, the Yellow-rumped Cacique, left, a member of the blackbird family that lives in the New World tropics, and the Oriental Green Barbet found in Asia.

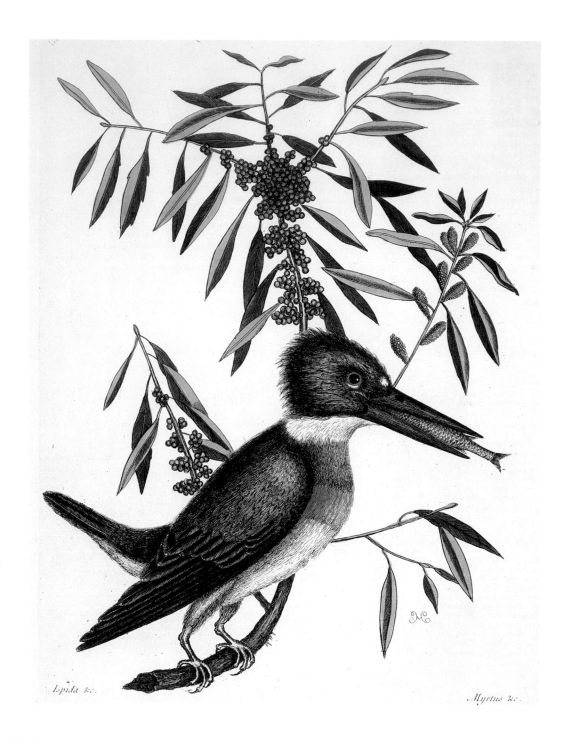

41 ▪ BELTED KINGFISHER *Ceryle alcyon*

"Kingfisher." Hand-colored etching, by Mark Catesby from his own drawing. In *The Natural History of Carolina, Florida and the Bahama Islands . . .* by Mark Catesby (2d ed., 1754). ▪ Mark Catesby's great achievement in creating the first extensive study of American ornithology is the more remarkable in that he not only collected and preserved the bird and botanical specimens, made the drawings, and wrote the text but also personally etched all the plates and hand-colored many of them. While not all the bird portraits are accurate, all are recognizable, and all have an air of engaging innocence.

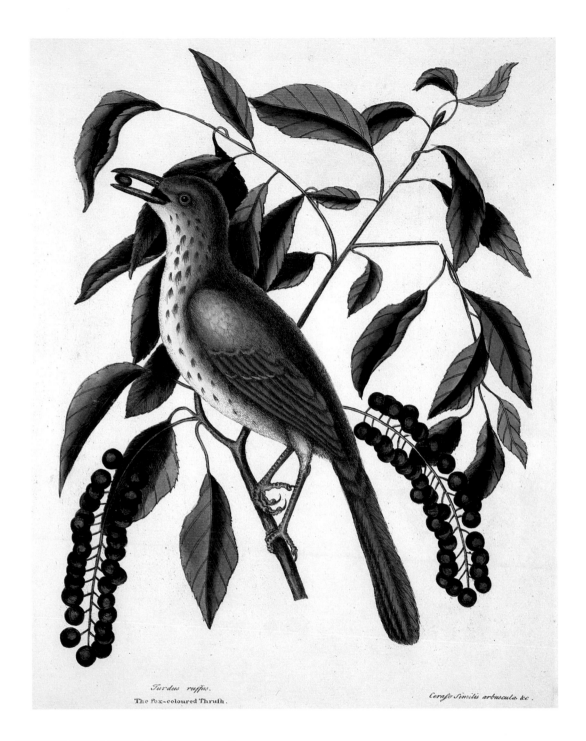

Turdus ruffus.
The Fox-coloured Thrush.

Cerasso Similis arbuscula &c.

42 ▪ BROWN THRASHER *Toxostoma rufum*

"Fox-coloured Thrush." Hand-colored etching, by Mark Catesby from his own drawing. In *The Natural History of Carolina, Florida and the Bahama Islands . . .* by Mark Catesby (2d ed., 1754). ▪ Mark Catesby's object was to describe and draw both the birds and plants of the southern colonies. Because etching was time-consuming, he decided to put plants and birds together in one plate. The result of his economy was a revolutionary approach that other painters soon followed—setting the bird in its natural habitat. He perched this Brown Thrasher in what he called "the clustered black cherry," the common wild cherry.

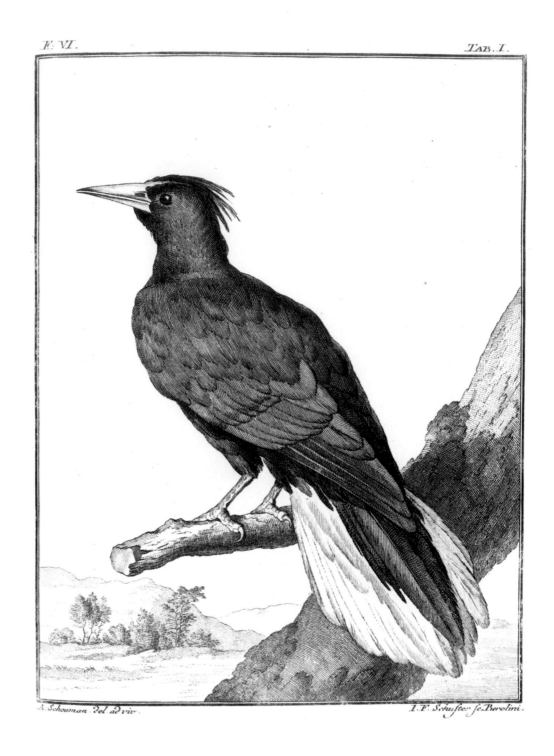

A. Schouman del ad viv. I. F. Schuster sc. Berolini.

43 ▪ CRESTED OROPENDOLA *Psarocolius decumanus*

"Xanthorni Decumanus." Engraving, by I. F. Schuster from drawing by Aert Schouman. In *Spicilegia Zoologica . . .* by Peter Simon Pallas (1767–72). ▪ The Dutch artist Aert Schouman was noted for his landscapes as well as for his zoological work. The background here, typically Dutch in style with its low horizon and expanse of sky, is amazingly detailed, focusing attention on the Crested Oropendola of the American tropics. Peter Simon Pallas, author of this book, is best known for his extensive explorations of Russia, commissioned by Catherine the Great.

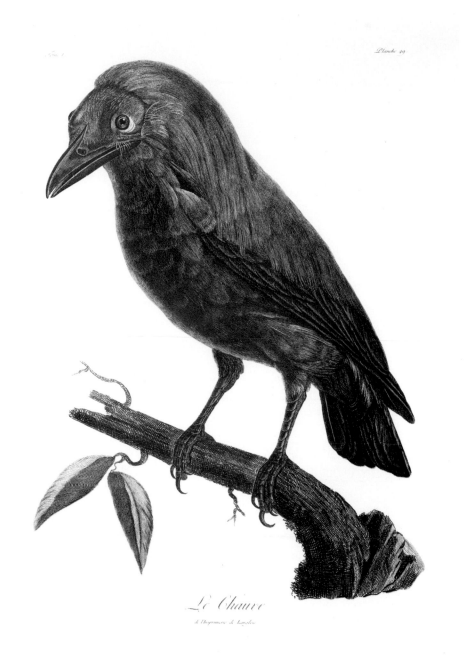

Le Chauve
à l'Imprimerie de Langlois

44 ▪ CAPUCHIN BIRD *Perissocephalus tricolor*

"Le Chauve." Engraving, with etching, by Langlois from drawing by Jacques Barraband. In *Histoire naturelle d'une partie d'oiseaux nouveaux . . .* by François Levaillant (1801–2). ▪ Jacques Barraband's illustration of the bird called "Le Chauve" has a surprising gleam in its eye; though certainly not present in the specimen Barraband worked from, it results in a lively picture. The Capuchin Bird is known by an impressive roster of popular names, all relating to its bald blackish skull: in addition to "Le Chauve" (bald one) there are "Col-Nu" (naked collar) and "Oiseau-mon-père," from its resemblance to a Capuchin monk.

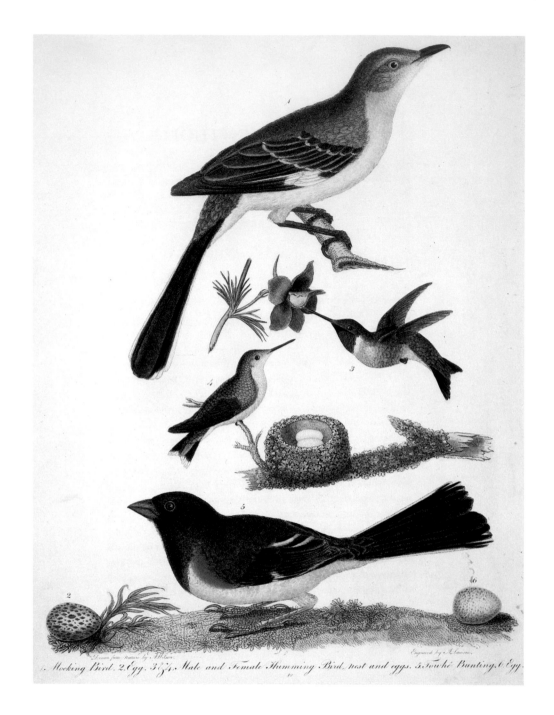

45 ▪ NORTHERN MOCKINGBIRD *Mimus polyglottus* ▪ RUBY-THROATED HUMMINGBIRD
Archilochus colubris ▪ RUFOUS-SIDED TOWHEE *Pipilo erythrophthalmus*

"1. Mocking Bird; 2. Egg; 3, 4. Male, Female Humming Birds, Nest and Eggs; 5. Towhé Bunting; 6. Egg." Hand-colored engraving, with etching, by A. Lawson from drawing by Alexander Wilson. In *American Ornithology . . .* by Alexander Wilson (1808–14). ▪ Alexander Wilson put birds together not to show relationship but to fit several into a plate in a satisfactory design. He was very partial to the mockingbird whose powers of mimicry astonished European bird fanciers. With its ability to imitate everything from "clear mellow tones of the wood thrush to the savage scream of the eagle," wrote Wilson, it stands "unrivaled by the feathered species of this or perhaps any other country."

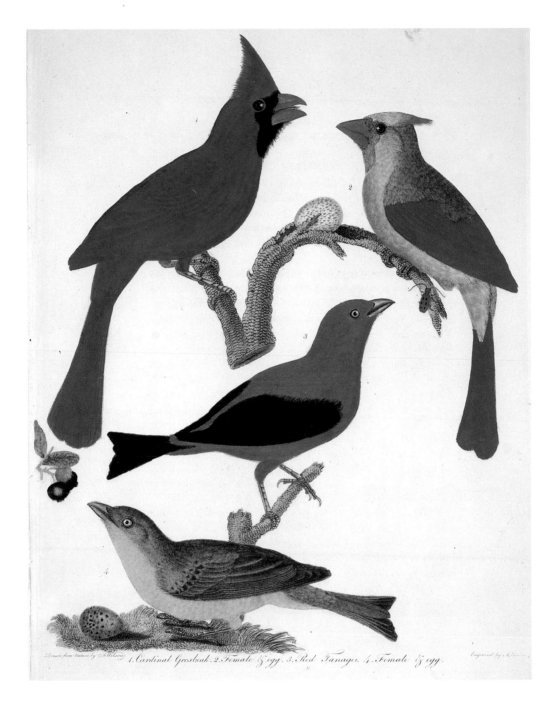

Drawn from Nature by A. Wilson. 1. Cardinal Grosbeak. 2. Female & egg. 3. Red Tanager. 4. Female & egg. Engraved by A. Lawson.

46 ▪ COMMON CARDINAL *Cardinalis cardinalis* ▪ SCARLET TANAGER *Piranga olivacea*

"1. Cardinal Grosbeak; 2. Female & egg; 3. Red Tanager; 4. Female & egg." Hand-colored engraving, with etching, from drawing by Alexander Wilson. In *American Ornithology . . .* by Alexander Wilson (1808–14). ▪ Cardinals, wrote Alexander Wilson, "are usually called Virginia nightingales," and are entitled to the name "from the clearness and variety of their notes. Many of them resemble the high note of a fife and are nearly as loud." Sometimes they repeat "a favorite passage, twenty or thirty times successively for a whole morning, which, like a good story too often repeated, becomes at length tiresome." Wilson calls the tanager a "gaudy foreigner . . . drest in the richest scarlet, set off with the most jetty black."

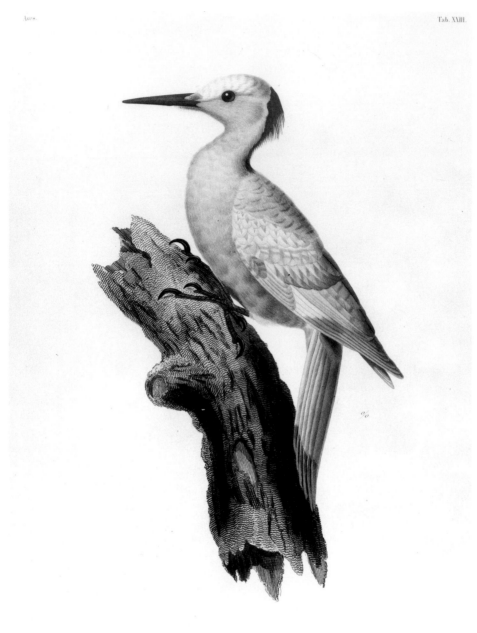

COLAPTES superciliaris. (Cq?) (Var alb.)
(Col?) CARPINTERO comun

47 ▪ WEST INDIAN RED-BELLIED WOODPECKER (WHITE VAR.) *Melanerpes superciliaris*

"Carpintero, Commun." Hand-colored engraving, with etching, by Massard from drawing by Edouard Traviès. In *Histoire physique, politique et naturelle de l'Île de Cuba . . .* by Ramon de la Sagra (1839–61). ▪ This handsome woodpecker is a white variant of the West Indian Red-bellied Woodpecker. The Spanish name means "carpenter," and is applied to all woodpeckers, referring to, of course, their capable beaks. The French naturalist Alcide d'Orbigny wrote the volume on ornithology in Sagra's multivolume series about Cuba.

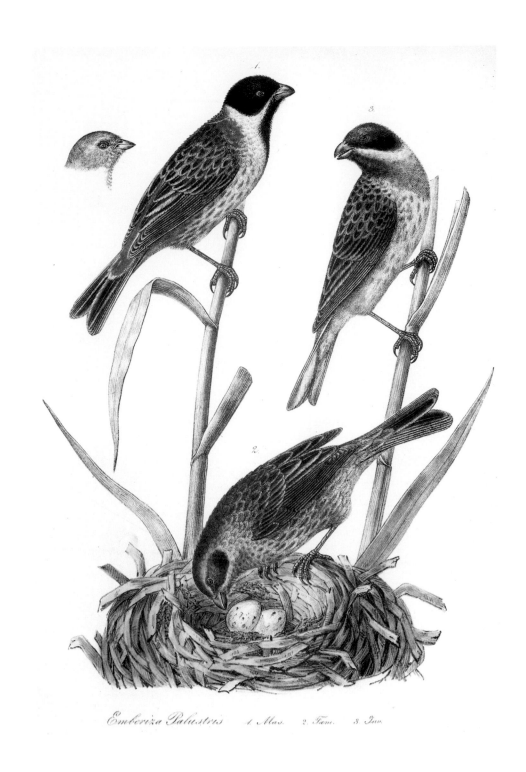

Emberiza Palustris *1. Mas.* *2. Fœm.* *3. Juv.*

48 ▪ REED BUNTING *Emberiza schoeniclus*

"Emberiza Palustris." Hand-colored lithograph, by Battistelli from drawing by Carlos Ruspi. In *Iconografia della fauna Italica . . .* by Charles-Lucien Bonaparte (1832–41). ▪ The Reed Buntings here are intended to represent the various plumages of the species rather than a family group. This sprightly bird with its constantly flicking tail breeds in reed beds and marshy places.

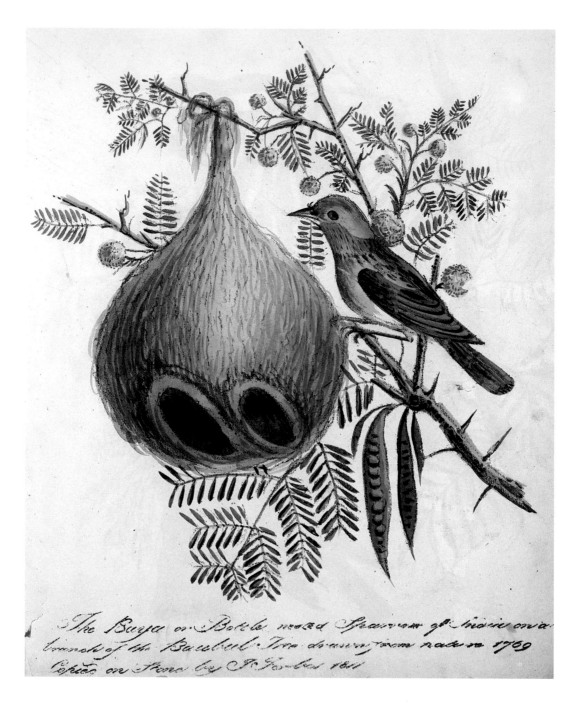

The Baya or Bottle nested Sparrow of India on a branch of the Baubul Tree drawn from nature 1769 Copied on Stone by J. Forbes 1811

49 ▪ BAYA WEAVER *Ploceus philippinus*

"Baya or Bottle Nested Sparrow." Hand-colored lithograph, by James Forbes. In *Oriental Memoirs . . .* by James Forbes (1813). ▪ As an agent of the East India Company, James Forbes traveled through the Orient, filling in his time by observing the environment and drawing the local birds. The male Baya Weaver constructs an elaborate pear-shaped nest of narrow strips of grass and leaves. Entry to the completed nest is through a long, woven tunnel that hangs vertically from the side of the nest. Fanciful local lore credits the female weaver with sticking fireflies on the damp mud to light her abode, an impossibility since the nest is quite dry by the time she takes up residence. This portrait of the Baya is believed to be one of the first lithographs made of a bird.

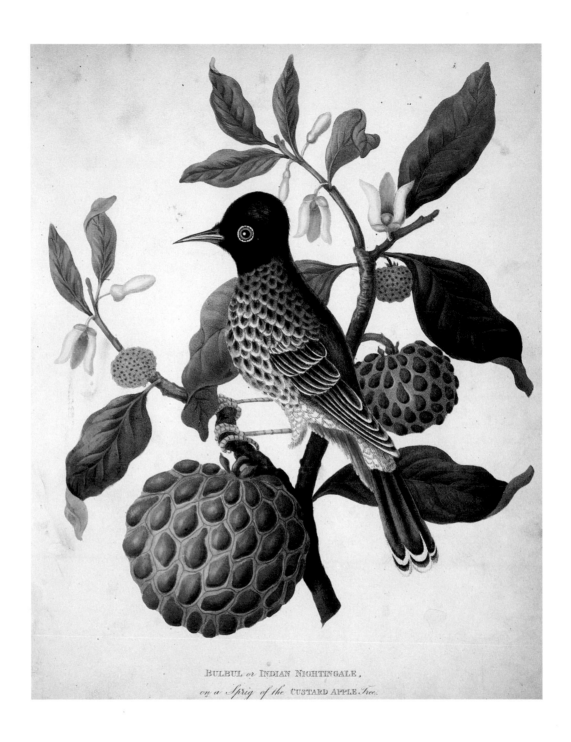

BULBUL or INDIAN NIGHTINGALE,
on a Sprig of the CUSTARD APPLE Tree.

50 ▪ RED-VENTED BULBUL *Pycnonotus cafer*

"Bulbul or Indian Nightingale." Aquatint, from drawing by W. Hooker. In *Oriental Memoirs . . .* by James Forbes (1813). ▪ The bulbul has long suffered through misidentification. Its cheerful calls bear little resemblance to the melodious song of the Nightingale, with which it is confused, as the two birds are not at all related. And here Forbes's use of the name "Indian Nightingale" further adds to the problem of mislabeling. More true is that the bulbul is appreciated for its friendliness and is tolerated despite its decided preference for tender fruits and flowers in the garden. This bulbul is sitting in a custard apple tree.

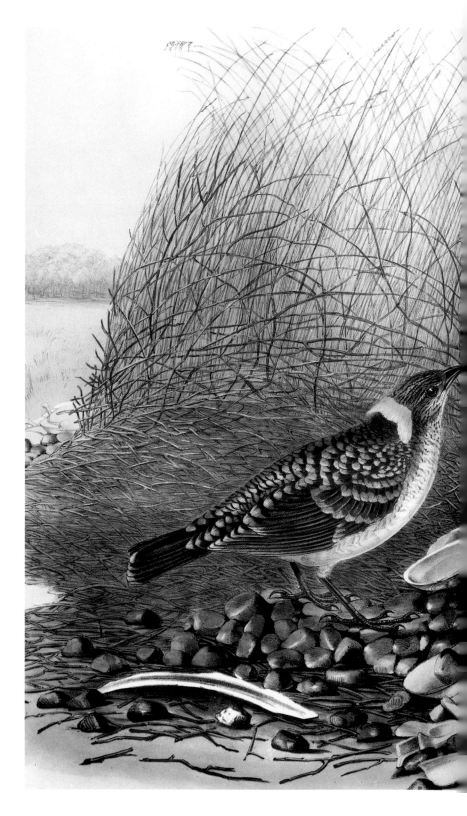

51 ▪ SPOTTED BOWERBIRD

Chlamydera maculata

"Spotted Bower-bird." Hand-colored lithograph, by John and Elizabeth Gould. In *The Birds of Australia* by John Gould (1840–48). ▪ Bowerbirds are among the great architects of the bird world: to attract mates the males construct, repair, and decorate elaborate structures called bowers. These are used only for courtship and mating

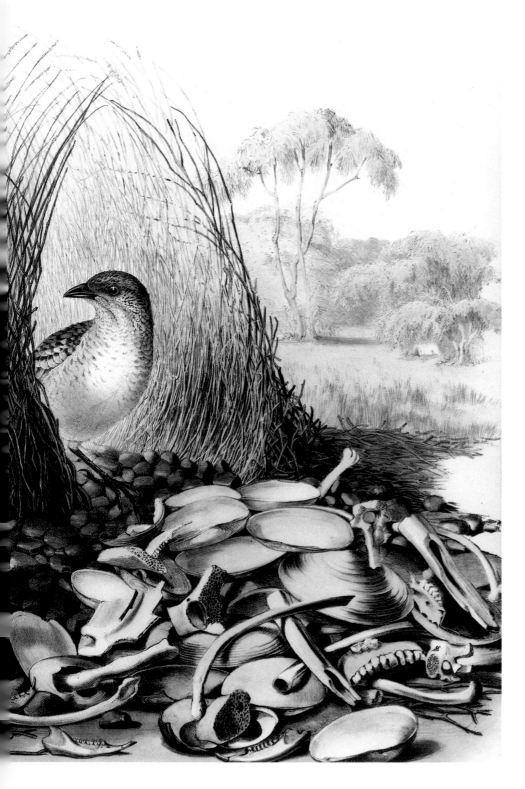

encounters; the female later builds her own nest where she hatches and raises her young. The Spotted Bowerbird is one of the group known as "avenue builders," the reason being apparent from the illustration. Ever the showman, Gould made dramatic use of double spreads of art in his book, as seen above.

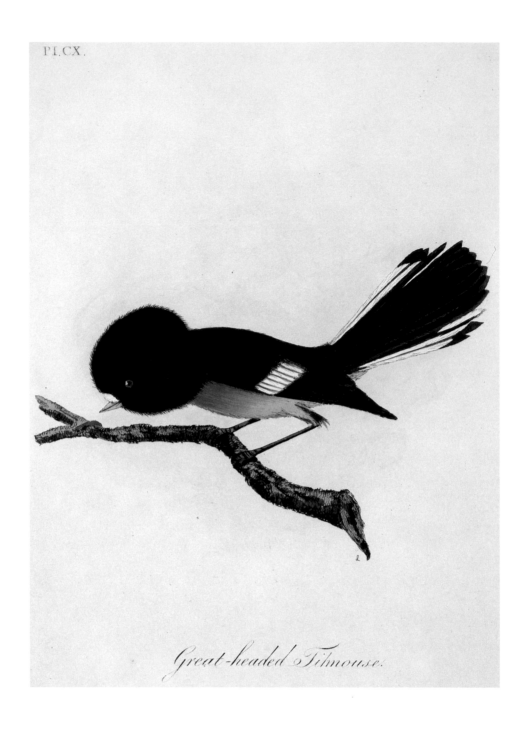

Great-headed Titmouse.

52 ▪ NEW ZEALAND TIT *Petroica macrocephala*

"Great-Headed Titmouse." Hand-colored etching, by John Latham from his own drawing. In *A General History of Birds* by John Latham (1821–28). ▪ John Latham was a successful small-town doctor who industriously made himself one of England's leading ornithologists by describing and depicting—not always accurately—three thousand bird species, several hundred for the first time. His research was published beginning in 1781 in his original work, *A General Synopsis of Birds*, which he reissued over the years. When past eighty, having lost a fair-sized fortune, he tried to regain some of it by republishing *Synopsis* with some additions as *A General History of Birds*.

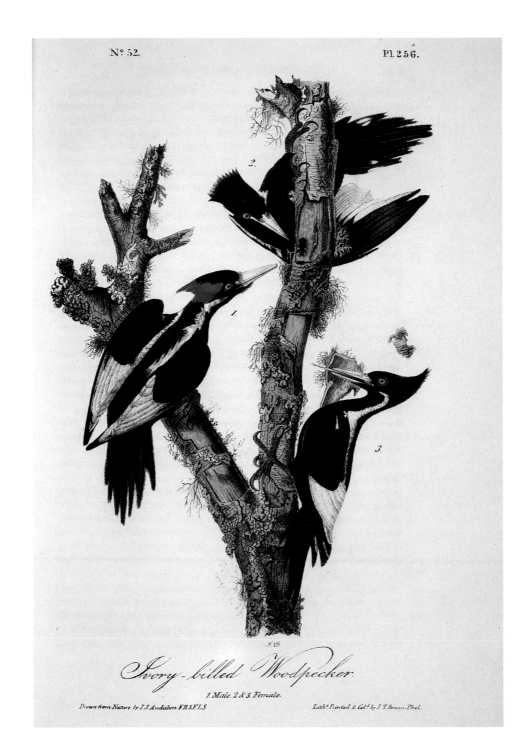

Pl. 256.

Ivory-billed Woodpecker.

1 Male. 2 & 3. Female.

Drawn from Nature by J.J. Audubon F.R.S.F.L.S.

Lith.ᵈ Printed & Col.ᵈ by J.T. Bowen. Phil.

53 ▪ IVORY-BILLED WOODPECKER *Campephilus principalis*

"Ivory-billed Woodpecker." Hand-colored lithograph, by J. T. Bowen from engraving of drawing by John James Audubon. In *The Birds of America* by John James Audubon (1840–44). ▪ Audubon was not only an artist but a fine observant naturalist. Of the Ivory-billed Woodpecker, now probably extinct in the United States, he wrote, "Its notes are clear loud and yet rather plaintive . . . and resemble the false, high note of a clarinet. The strength of this woodpecker is such that I have seen it detach pieces of bark seven or eight inches long with a single blow of its powerful bill."

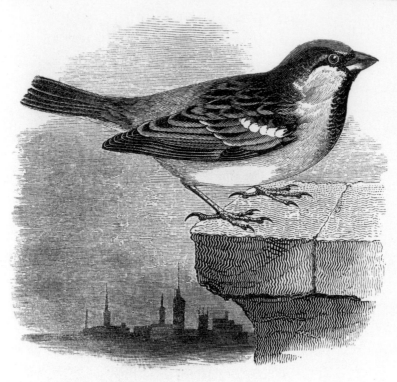

PASSER DOMESTICUS (Linnæus*).

THE HOUSE-SPARROW.

Passer domesticus.

54 ▪ HOUSE SPARROW *Passer domesticus*

"House Sparrow." Wood-engraved text illustration. In *A History of British Birds* by William Yarrell (4th ed., 1871–85). ▪ William Yarrell's *A History of British Birds*, published first in 1837–43, has had a remarkably long life, going through many edited, revised, and supplemented versions, the latest one issued in 1927. It was a useful guide to England's birds. One of the most familiar of them was the House Sparrow, a bird that now lives on every continent except Antarctica, having been widely introduced by man.

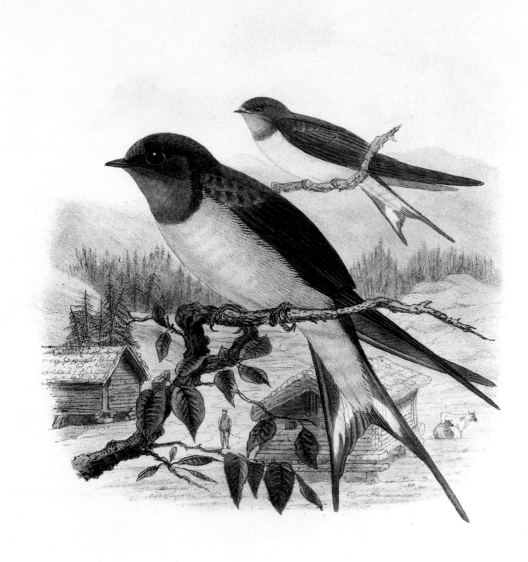

C.W.W. del.

Mintern. Bros. imp

HIRUNDO ERYTHROGASTRA

55 ▪ BARN SWALLOW *Hirundo rustica*

"Hirundo Erythrogastra/American Chimney Swallow." Hand-colored lithograph, by Claude W. Wyatt. In *A Monograph of the Hirundinidae, or Family of Swallows*, by Richard Bowdler Sharpe and Claude Wilmott Wyatt (1885–94). ▪ Claude W. Wyatt published his own work on British birds in addition to furnishing the 103 illustrations of swallows for Sharpe's monograph. The Barn Swallow usually nests in rural areas in proximity to people, returning to its nesting site each spring. All swallows devour prodigious numbers of flying insects, caught on the wing during their unmistakable aerial acrobatics.

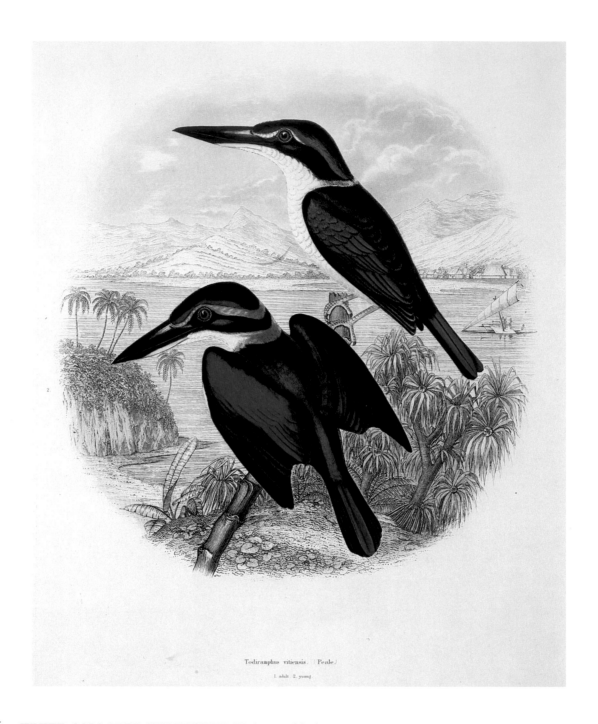

Todiramphus vitiensis. (Peale.)

1 adult 2 young

56 ▪ WHITE-COLLARED KINGFISHER *Halcyon chloris*

"Todiramphus Vitiensis." Hand-colored engraving, by Dongal from drawing by Titian Ramsey Peale. In *United States Exploring Expedition . . . 1838 . . . Mammalogy and Ornithology* by John Cassin (1858). ▪ Titian Peale, of the noted family of American artists, was a fine ornithologist as well as a first-rate painter. He went along as artist-naturalist on the U.S. Exploring Expedition, which explored the Pacific from Antarctica north. He set these White-collared Kingfishers against an idyllic South Seas landscape. The bird's scientific name, *halcyon*, is a Greek word that derives from *hals* (sea) + *kyon* (conceiving), referring to the legend that kingfishers bred on the open sea, and so calmed the waters. This later gave rise to the expression "halcyon days."

Ptilonopus Perousei. Peale.

Th. Peale. del.

Hinshelwood. sc.

57 ▪ MANY-COLORED FRUIT DOVE *Ptilinopus perousii*

"Ptilounopus Perousei." Hand-colored engraving, by Hinshelwood from drawing by Titian Ramsey Peale. In *United States Exploring Expedition . . . 1838 . . . Mammalogy and Ornithology* by John Cassin (1858). ▪ Titian Peale came by his interest in natural history from his father, Charles Willson Peale, who was not only an eminent portraitist but also founded and ran the country's first natural history museum in Philadelphia. Titian drew the Many-colored Fruit Doves from specimens he collected on the U.S. Exploring Expedition.

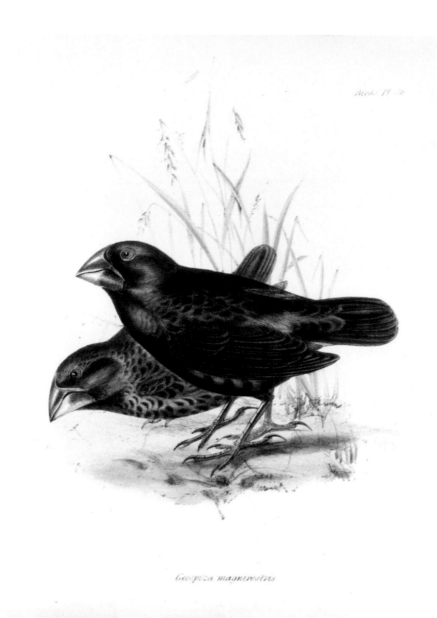

Geospiza magnirostris

58 ▪ LARGE GROUND FINCH *Geospiza magnirostris*

"Geospiza Magnirostris." Hand-colored lithograph, by John and Elizabeth Gould. In *The Zoology of the Voyage of H.M.S. Beagle . . .* by Charles Darwin (1841). ▪ John and Elizabeth Gould illustrated a report on Charles Darwin's historic voyage on the *Beagle*. This Large Ground Finch is one of the fourteen species of the famous "Darwin finches" he cited in the Galapagos. Back in England, Darwin reflected on the fact that while the birds differed among the islands, they were obviously related: "one might really fancy that from an original paucity of birds in this archipelago, one species had been taken and modified for different ends." This notion of adaptation and survival helped shape his theory of evolution.

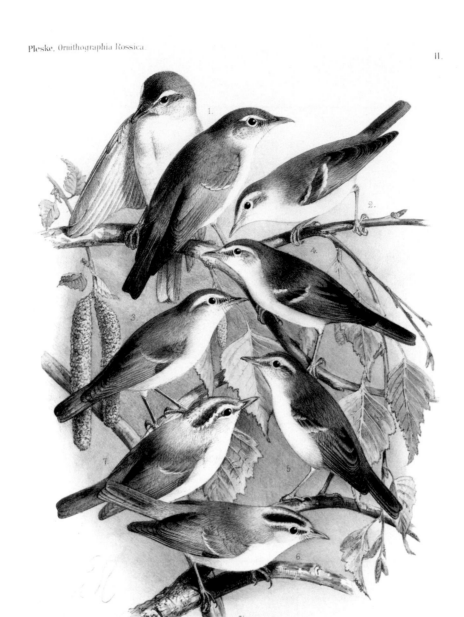

59 ▪ ARCTIC WARBLER *Phylloscopus borealis* ▪ GREEN WILLOW WARBLER *P. nitidus* ▪ GREENISH WARBLER *P. trochiloides* ▪ PALE-LEGGED WILLOW WARBLER *P. tenellipes* ▪ LARGE-CROWNED WILLOW WARBLER *P. occipitalis*

["Old World Warblers"]. Hand-colored lithograph, by Gustave Mützel. In *Ornithographia Rossica* by Theodor D. Pleske (1889–92). ▪ This volume, the only one published in an ambitious proposed work on all the birds of Russia, is devoted entirely to the Sylviidae, or Old World Warblers. Its extensive scholarly text and illustrations are based on the collections of the zoological museum in St. Petersburg, of which Pleske was director. The species of warblers include many that look alike. There are, for example, over forty species in the genus *Phylloscopus*, many of them so similar that even skilled birdwatchers have difficulty telling them apart.

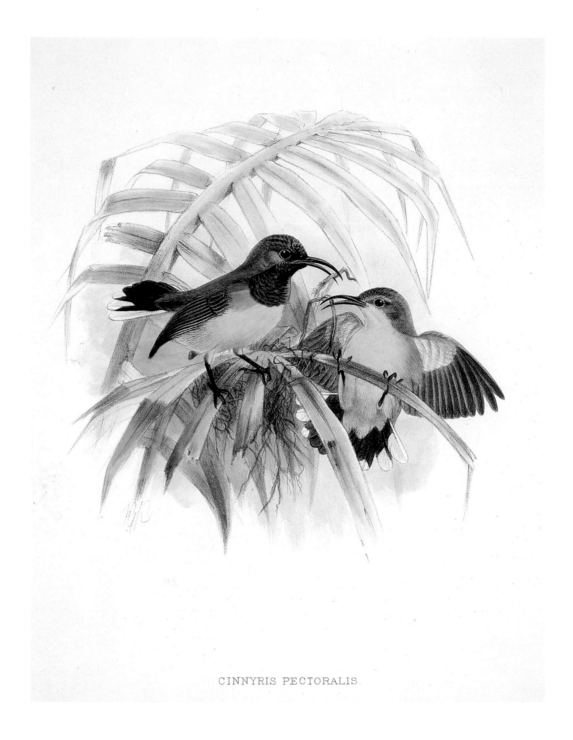

CINNYRIS PECTORALIS.

60 • YELLOW-BELLIED SUNBIRD *Nectarinia jugularis*

"Cinnyris Pectoralis." Hand-colored lithograph, by John Gerrard Keulemans. In *A Monograph of the Nectariniidae* . . . by George Ernest Shelley (1876–80). ▪ John Gerrard Keulemans brought a special expertise to his lithographs of sunbirds. As a young man, he bought a plantation in West Africa, where he planned to spend his life. But the plantation failed and he went back to Europe to a highly successful career as an illustrator. His observations of sunbirds, remembered from Africa, combined with his general knowledge of sunbirds, enabled him to depict the species from all over for Shelley's scholarly monograph. The Yellow-bellied Sunbird is from New Guinea.

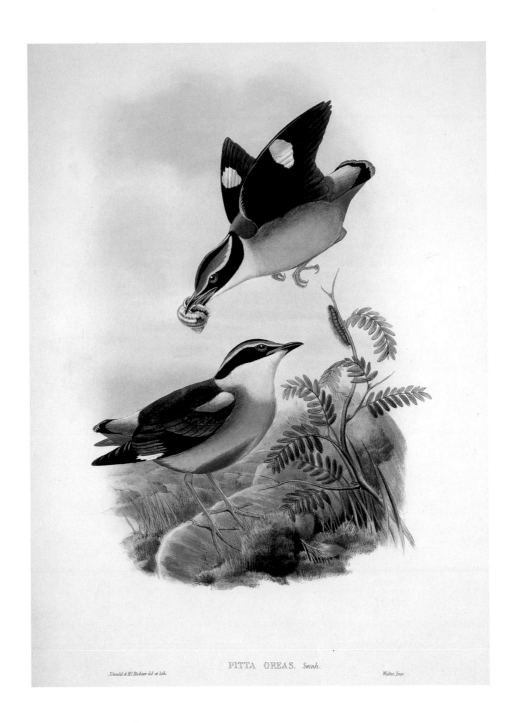

PITTA OREAS, *Swinh.*

J.Gould & H.C.Richter del et lith. Walter, Imp.

61 ▪ FAIRY PITTA *Pitta nympha*

"Pitta Oreas." Hand-colored lithograph, by John Gould and William Hart. In *The Birds of Asia* by John Gould and Richard Bowdler Sharpe (1850–83). ▪ Pittas are a little-known family of small, brightly colored perching birds inhabiting Southeast Asia and nearby areas. They are distinguished by their almost nonexistent tails and an astonishing range of colors. A stickler for relevant detail, Gould had his artist indicate the Fairy Pitta's diet with the snail in its beak and the caterpillar on a nearby plant. Pittas are seldom-observed creatures of the forest floor, where their bright colors are surprisingly difficult to see. Their loud whistles, however, are heard frequently. They are not at all uncommon in the parts of Australasia where they occur.

It took a while before artists began putting their birds into realistic backgrounds. In early works, birds would sit stiffly on bare branches or settle in some unconvincing patch of grass. The bird, after all, was the point of the picture, not the background. But by the nineteenth century birds could enjoy more natural settings, as is apparent with the swimming birds, the birds of open waters. An American gull could survey its ocean domain from an Oregon rock (plate 72) and Daniell's penguins could feel at home in their chilly Patagonian landscape (plate 64). ▪ Though artists could, and often did, go out into nature to make sketches, most of them were not field naturalists but spent their time in their studios, working from birdskins and other people's notes. Particularly in the early days, when information was scant, they had to guess at facts or, worse, make them up. One misguided artist sat his Arctic owl in a blooming magnolia tree. ▪ Getting specimens of native birds to work from was not hard. Cornelius Nozeman, a Dutch apothecary who gathered all of Holland's birds into one book, had little trouble obtaining the swimming birds of his waterbound country (plates 68, 69, 70). Alien birds were at a premium. Traders off to distant places found it profitable to bring back, along with the usual silks, spices, and gems, whatever birdskins they could get from local hunters. Sailors made a little money on the side by collecting birds on their homeward journeys. Though they tried to bring them back alive, they usually found it easier, as one contemporary wrote, "to flay those of the most beautiful colors" and just bring back the skins. ▪ It was often possible to

SWIMMERS

find rare specimens close to home. Aldrovandi had access to the aviary owned by the grand duke of Tuscany whose collection included a cassowary and Paradise Widowbirds. Even larger aviaries, fenced with brass wire, were kept in Prague by Rudolph II, king of Hungary and Bohemia, who had the first Dodo Europe had ever seen, and by a Dutch merchant named Ameshoff who kept an alliterative flock of choucous, carrosus, and cranes from three continents. ▪ On a smaller scale, wealthy merchants and interested aristocrats had their "cabinets of curiosities," modest collections of stuffed birds and animals. An artist could often prevail on the owner to let him study the birds or even borrow one. (John Gould was notorious for borrowing but not giving back.) George Edwards, the most prolific of eighteenth-century English artists and publishers, would, he wrote, work "at the private house of some curious gentlemen who set apart days for the assembling of known and inquisitive searchers after nature." But when he was drawing a Great Horned Owl Edwards went to a more plebeian source, the Mourning Beech Tavern at Aldersgate, which kept the bird as a kind of pub mascot. ▪ Sometimes good fortune filled in gaps. During a war with France, Captain Washington Shirley, who had a curiosity about nature, captured a French vessel that was carrying a collection of birds and birdskins to Mme Pompadour, Louis XV's mistress. He turned them over to Edwards who had no compunctions at all about accepting the loot. "It is an ill wind," he remarked smugly, "that blows nobody good." But later, in a fit of fairness, he called one of the birds the Pompadour Cotinga.

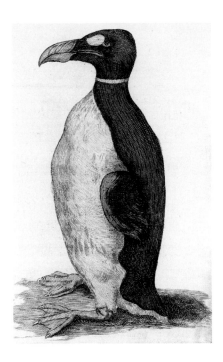

62 ▪ GREAT AUK *Pinguinus impennis*

Engraving, with etching. In *Museum Wormianum . . .* by Ole Worm (1655). ▪ The Great Auk is one of the most tragic figures in nature. It once lived in enormous numbers in the North Atlantic but, unable to fly, it was helpless against hunters who slaughtered it for its soft feathers. In 1844, it became extinct. This one was a pet of Danish scientist Ole Worm; the ring around its neck was its collar. Later artists, copying this print, mistook the collar for the bird's plumage.

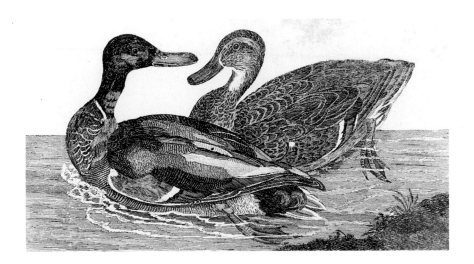

63 ▪ MALLARD *Anas platyrhynchos*

"Wild Duck." Etching, probably by Peter Mazell from uncredited drawing. In *The British Zoology* by Thomas Pennant (4th ed., 1776–77). ▪ The Mallard is, perhaps, the world's most widespread duck. It is the commonest wild duck in the Northern Hemisphere and is ancestor to most domestic ducks. The family togetherness shown here is temporary. After mating, the drake leaves his mate to tend the nest while he goes off to join other males.

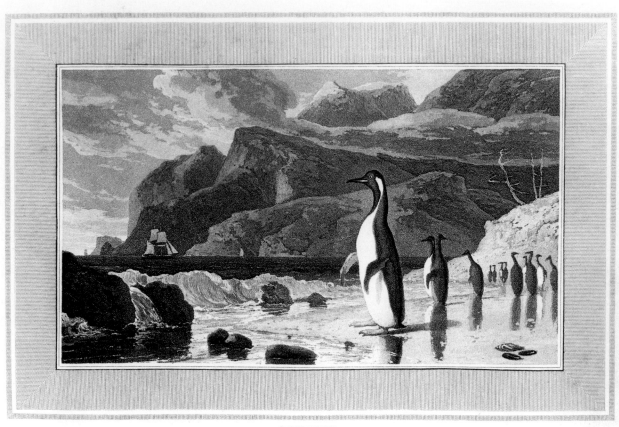

PENGUIN.

Designed & Engraved by Will^m Daniell & Published by M^rs Cadell & Davies London March 1 1807.

64 ▪ KING PENGUIN *Aptenodytes patagonicus*

"Penguins." Monochrome aquatint, by William Daniell from his own drawing. In *Interesting Selections from Animated Nature with Illustrative Scenery* by William Daniell (1809). ▪ The British artist and engraver William Daniell wrote and illustrated many books documenting his extensive travels in Great Britain, India, and other eastern lands. *Interesting Selections . . .* consists of scenic views of exotic locales, each featuring a native animal or bird, with brief descriptions, including this disturbing picture of one early explorer's behavior: "They [penguins] are said to be very tenacious of life. Forster knocked down many of them, which he left as lifeless while he went in pursuit of others; but they all afterwards got up and walked off with great gravity." This peaceful group has evidently not met Forster.

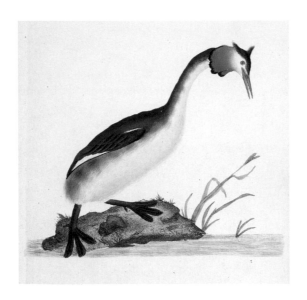

65 ▪ GREAT CRESTED GREBE *Podiceps cristatus*

"Grebe." Hand-colored engraving, with etching, by Edward Donovan from his own drawing. In *The Natural History of British Birds . . .* by Edward Donovan (1794–1819).

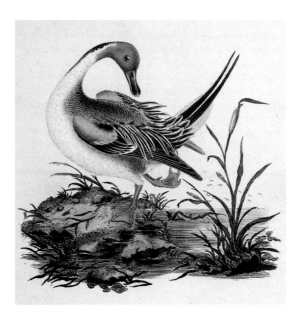

66 ▪ NORTHERN PINTAIL *Anas acuta*

"Pin-tail Duck." Hand-colored engraving with etching, by Edward Donovan from his own drawing. In *The Natural History of British Birds . . .* by Edward Donovan (1794–1819).

Edward Donovan was one of several wealthy Englishmen who became distinguished naturalists. He used the specimens in his private London Museum and Institute of Natural History as the basis for his *Natural History of British Birds*. Like many bird artists, Donovan portrayed only the colorful males—even though it did diminish the ornithological value of the book. The Pintail Duck shows off Donovan's skills as a colorist and his knack for making birds lifelike—with its head twisting around and leg stretched out in back, the duck seems ready to dance off the page.

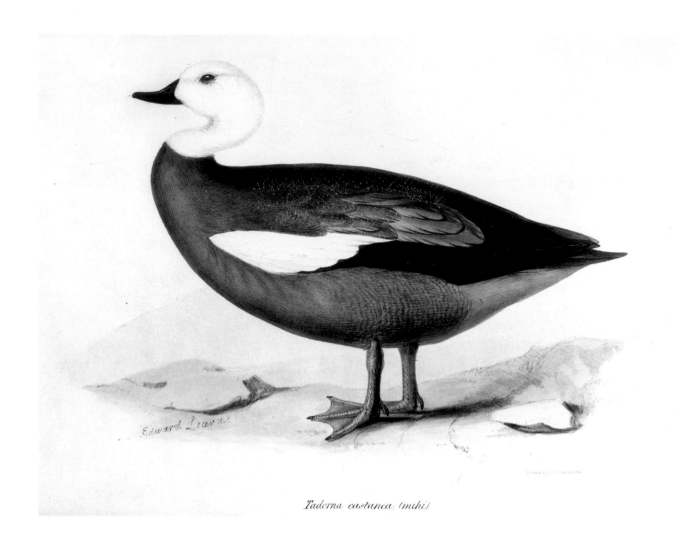

Tadorna castanea (mihi)

67 ▪ PARADISE SHELDUCK, FEMALE *Tadorna variegata*

"Tadorna Castanea." Hand-colored lithograph, by G. Scharf from drawing by Edward Lear. In *A Monograph on the Anatidae . . .* by Thomas Eyton (1838). ▪ Edward Lear did paintings for a good many ornithologies—his work was highly regarded and his fees were modest. For Thomas Eyton, a naturalist rich enough to publish his own lavish books, he drew half a dozen ducks. Among them was the New Zealand Paradise Shelduck, an offbeat duck that nests in depressions or burrows that it finds on the ground, in trees, or even in buildings.

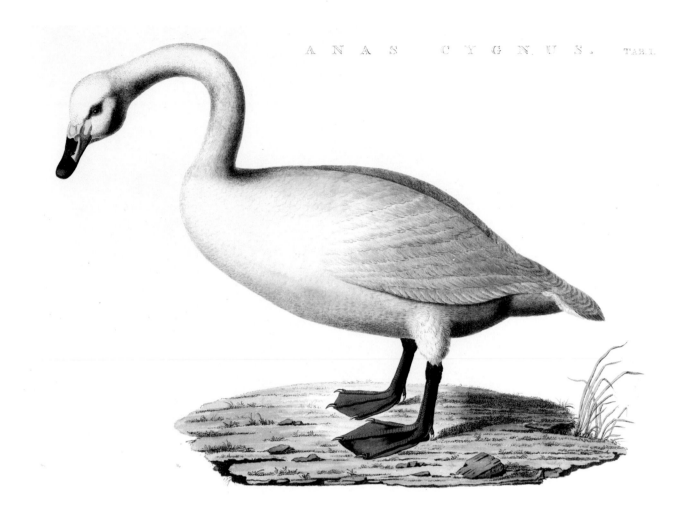

68 ▪ WHOOPER SWAN *Cygnus cygnus*

"Anas Cygnus." Hand-colored engraving, with etching, by C. Sepp or J. C. Sepp from his own drawing. In *Nederlandsche vogelen . . .* by Cornelius Nozeman and Martinus Houttuyn (1770–1829). ▪ In beginning his work on Dutch birds, Cornelius Nozeman was carrying on a native tradition of productive interest in ornithology. Marcgrave and Piso and Coenraad Jacob Temminck were notable compatriots. Another was Georg Eberhard Rumpf, a trader in the Dutch East Indies who went blind and dictated from memory, in Latin, the text of four books on the region. The graceful, gentle-seeming Whooper Swan is a fierce protector of its nest, and will attack any human or animal that approaches.

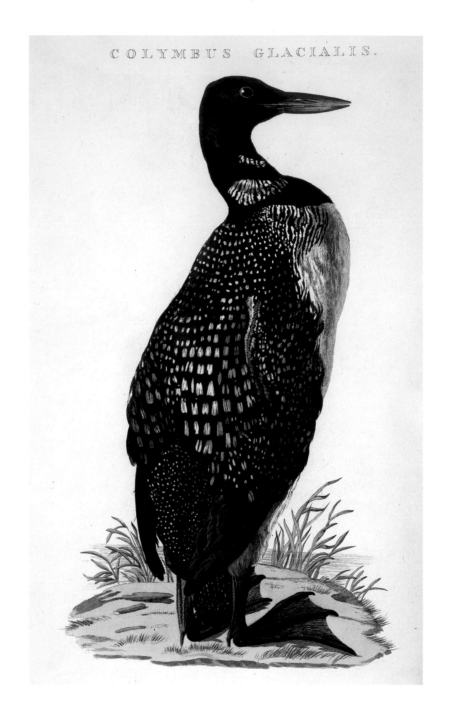

COLYMBUS GLACIALIS.

69 ▪ GREAT NORTHERN DIVER *Gavia immer*

"Colymbus Glacialis." Hand-colored engraving, with etching, by C. Sepp or J. C. Sepp from his own drawing. In *Nederlandsche vogelen . . .* by Cornelius Nozeman and Martinus Houttuyn (1770–1829). ▪ Divers, known in the United States as loons, are large, fish-eating swimmers, distinguished by their diving abilities. Because their legs are encased within the body to the ankle joint, these birds are clumsy on land but are powerful swimmers and fliers. While Nozeman included them in his survey of birds in the Netherlands, the Great Northern Divers do not actually breed there. Loon calls, especially the Great Northern Diver's, are wonderfully eerie and compelling, especially during mating season.

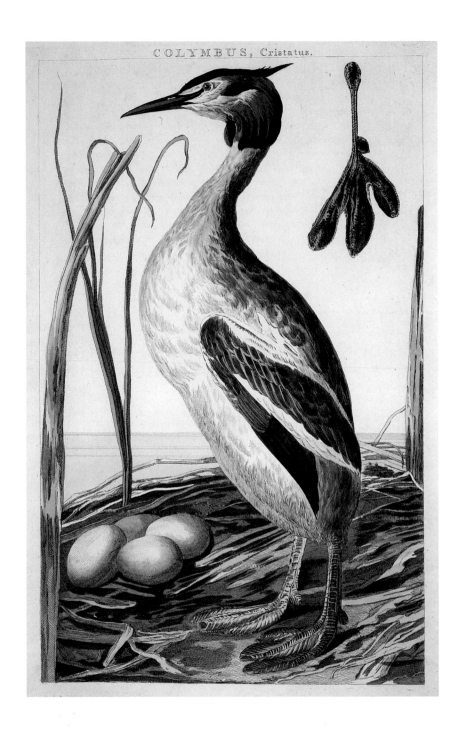

COLYMBUS, Cristatus.

70 ▪ GREAT CRESTED GREBE *Podiceps cristatus*

"Colymbus Cristatus." Hand-colored engraving, with etching, by C. Sepp or J. C. Sepp from his own drawing. In *Nederlandsche vogelen . . .* by Cornelius Nozeman and Martinus Houttuyn (1770–1829). ▪ Jan Christian Sepp, who probably did this engraving of a Great Crested Grebe, is best known for his meticulous drawings of insects. His passion for beautiful detail is evident in his treatment of the grebe's reedy nesting site framed by upright grasses, the clutch of eggs, and the careful depiction, upper right, of the grebe's unusual foot, which is not webbed, as it is in other water birds, but lobed.

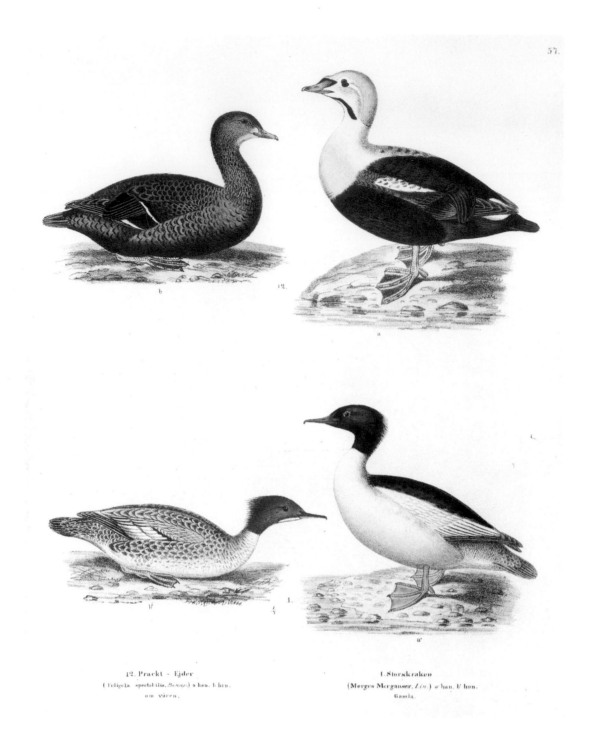

12. Prackt - Ejder
(Foligvla spectabilis, *Bonap.*) a hau. b hon.
om våren.

1. Storskraken
(Mergus Merganser, *Lin.*) a hau. b hon.
Gamla.

71 ▪ KING EIDER *Somateria spectabilis* ▪ GOOSANDER *Mergus merganser*

"Storskraken; Prackt-Ejder." Hand-colored lithograph, by Magnus Peter Körner. In *Skandinaviska föglar . . .* by Magnus Peter Körner (1839–46). ▪ Lithographs generally permit the artist to make sweeping lines and achieve large effects. Magnus Peter Körner had a delicate touch and his lithographs rival the finest engravings in their linear details. He would gather several birds into one drawing and still give the small identifying marks—the serrated bill of the merganser, for example—that good ornithological illustration requires.

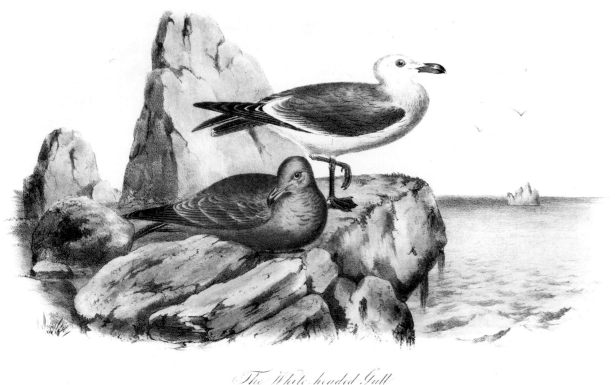

The White-headed Gull

Larus Heermanni (*Cassin*)

72 ▪ HEERMANN'S GULL *Larus heermanni*

"White Headed Gull." Hand-colored lithograph, by J. T. Bowen from drawing by George White. In *The Natural History of the Washington Territory* . . . by James Graham Cooper and George Suckley (1860). ▪ The U.S. Army expeditions that went west before the Civil War to map routes for transcontinental railroads had on their rosters medical corps officers who served as naturalists. They found many birds new to American ornithology. Drs. Cooper and Suckley, who studied the botany and zoology of the northern route, reported the "White Headed Gull." Found along the Pacific coast, it was named for A. L. Heermann, an ornithologist on the expedition.

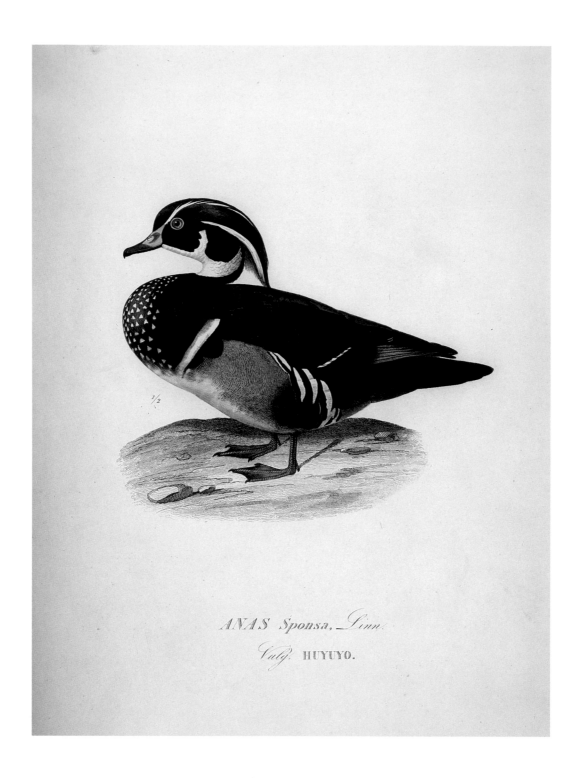

ANAS *Sponsa, Linn.*
Vulg. HUYUYO.

73 ▪ WOOD DUCK *Aix sponsa*

"Anas Sponsa." Hand-colored engraving, with etching, by Perdinel from drawing by Edouard Traviès. In *Histoire physique, politique et naturelle de l'Île de Cuba . . .* by Ramon de la Sagra (1839–61). ▪ The dapper male Wood Duck leaves the task of incubating the eggs and raising the young to his more modest mate. The nest is situated high in a tree cavity, from which the newly hatched young jump to the ground without injury and follow their mother to the water.

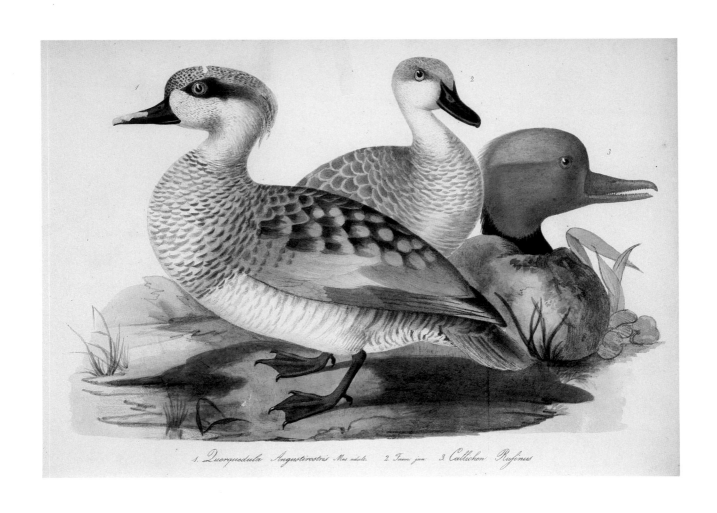

1. *Querquedula Angustirostris Mas adulte.* 2. *Fœm. jun* 3. *Callichen Rufinus.*

74 ▪ MARBLED TEAL, MALE; FEMALE *Anas angustirostris* ▪ RED-CRESTED POCHARD *Netta rufina*

"Querquedula Augustirostris; Callichen Rufinus." Hand-colored lithograph, by Battistelli from drawing by Carlos Ruspi. In *Iconografia della fauna Italica . . .* by Charles-Lucien Bonaparte (1832–41). ▪ This group portrait includes the Red-crested Pochard whose large head has been greatly exaggerated here. By contrast, the two Marbled Teal, small dabbling ducks with subdued plumage, are drawn to scale.

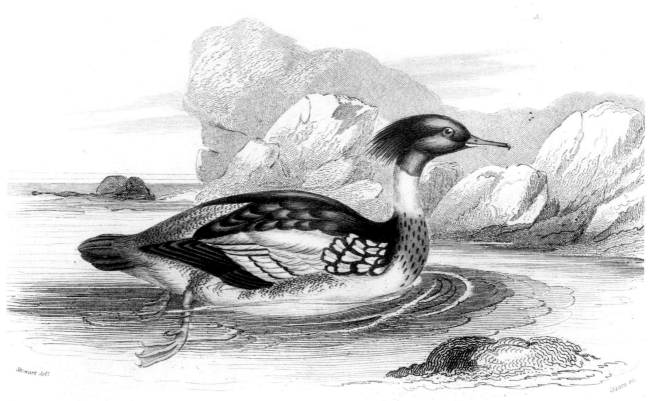

THE RED-BREASTED MERGANSER

75 ▪ RED-BREASTED MERGANSER *Mergus serrator*

"Red-breasted Merganser." Hand-colored etching, by William Lizars from drawing by James Stewart. In *Birds of Great Britain and Ireland*, Part 4: *Natatores* by William Jardine (Naturalist's Library) (1860). ▪ William Jardine edited a forty-volume series called the *Naturalist's Library* and wrote the one on swimming birds himself. A rich and dedicated man, he had a collection of six thousand birdskins in his home, Jardine Hall. The Red-breasted Merganser is an abundant bird and a lucky one. As with other fish-eating ducks, its dietary habits are its salvation—hunters find the fish-flavored flesh distasteful and so leave the duck pretty much alone.

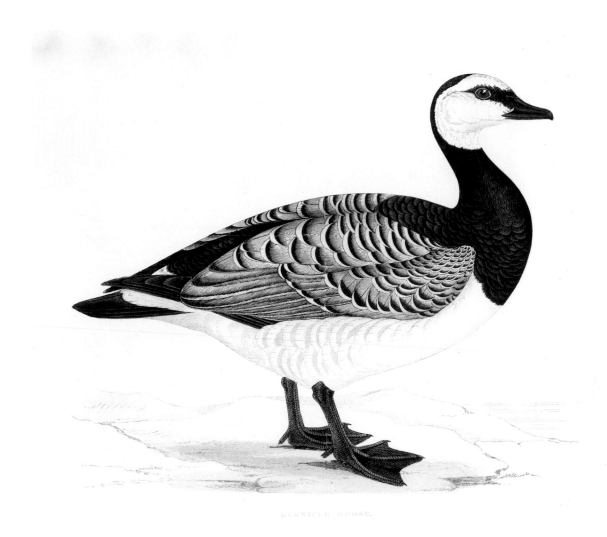

BERNICLE GOOSE.

76 ▪ BARNACLE GOOSE *Branta leucopsis*

"Bernicle Goose." Hand-colored wood engraving, by Benjamin Fawcett from his own drawing. In *British Game Birds and Wildfowl* by Beverly Robinson Morris (1891). ▪ Because this goose bred in the unpeopled Arctic, nothing was known about its breeding habits until recently. This allowed the spread of the belief that the birds hatched from barnacles; many artists and writers promulgated this nonsense, including the great Aldrovandi. The early Catholic Church declared Barnacle Geese fish, rather than fowl, and permitted them to be eaten on Fridays. Jewish rabbinical authorities from the twelfth to the nineteenth centuries debated whether these birds were poultry, subject to laws of ritual slaughter; fish, which might be permitted; fruit, totally acceptable; or crawling things, proscribed.

Pioneer ornithologists had trouble visualizing creatures like griffins and phoenixes and harpies for the good reason that they did not exist. But they included these myths in their books anyway because their public believed in them. Later artists had to contend with strange birds that did exist but had to be seen to be believed—birds with bizarre beaks and implausible plumage, with tails that trailed three feet behind or curved up into the shape of a lyre. They knew them as exotic birds that flooded into Europe from Africa, the Americas, and the Orient—cockatoos and toucans, hornbills and iridescent hummingbirds with, wrote one overwhelmed observer, "the hue of roses steeped in liquid fire." There were also a few last remnants of the disappearing Dodo—"that extraordinary production of nature"—and creatures

EXOTIC BIRDS

so ravishingly beautiful that they were called birds of paradise. As fast as they came in, bookmakers would rush to include them in their latest publications. ▪ After a while, instead of having the birds sent back to the ornithologists, the ornithologists were sent out to the birds. Pierre Sonnerat spent several years in Indonesia where several helpful rajahs would deliver their rarest specimens to him. Philipp Franz von Siebold became so absorbed in studying the birds of Japan that officials, suspecting him of spying, made him a virtual prisoner for seven years and then banished him. ▪ For so gentle a profession as ornithology, it was distressingly perilous work. Three of John Gould's Australian collectors died getting birds for him, one from a fever, one from an exploding gun, and a third from the spears of aborigines. Every one of the six naturalists sent along on one Dutch East Indies expedition was killed either by disease or rebellious tribesmen. ▪ Natural history in the eighteenth and nineteenth centuries was a matter that governments took very much to heart. The British sent out three Pacific expeditions headed by Captain James Cook whose naturalists collected scores of birds for the British Museum before he was killed in Hawaii. The French mounted a South Pacific expedition headed by Count Laperouse who sent back new species until he and his fleet were lost on a reef in the Santa Cruz islands. ▪ In the United States, it helped to have natural historians in high places. On the instructions of President Jefferson, an accomplished naturalist himself, the Lewis and Clark Expedition brought back hundreds of animals and plants, among them birds that Alexander Wilson included in his *American Ornithology*. When Jefferson Davis, a student of natural history, was Secretary of War, he deployed army expeditions to survey possible western railroad routes and sent naturalists along. ▪ It was often a lonely life for the naturalist out in the foreign field. Sonnerat solaced himself by taking a Japanese wife, but others had only the work itself to offset the feeling of isolation. James Forbes, who spent years in Asia, Africa, and America, filled his long hours collecting birds and compiling his *Oriental Memoirs*. In them, he paid a touching tribute to his work that, he wrote, "beguiled the monotony of four voyages, cheered a solitary residence and softened the long period of absence from my native country."

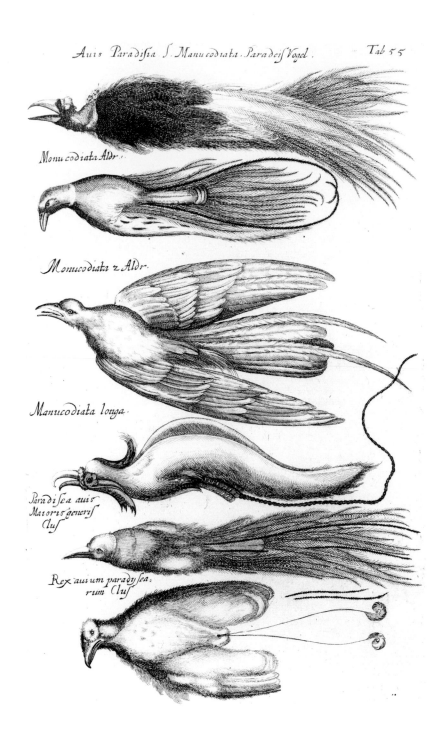

Avis Paradisia S. Manucodiata. Paradeis Vogel. Tab 55

Monucodiata Aldr.

Monucodiata 2 Aldr.

Manucodiata longa.

Paradisea auis
Maioris generis
Cluf

Rex auium paradysea=
rum Cluf

77 ▪ BIRDS OF PARADISE *Paradisaeidae*

"Avis Paradisia/S. Manucodiata/Paradeis Vogel." Engraving, by Matthäus Merian. In *Historia naturalis de avibus* . . . by John Jonston (1650–62). ▪ There is something odd about the birds in this engraving: they have no legs. Birds of paradise skins, which had moved along trade routes from New Guinea to China and Nepal, were prepared by New Guineans in the traditional manner by removing the feet and sometimes the wings. Magellan's surviving crew and other early explorers returned to Europe with these skins, bringing with them fantastic explanations for the footless birds. It wasn't until skins with the feet still attached arrived in Europe that these quaint beliefs were put to rest.

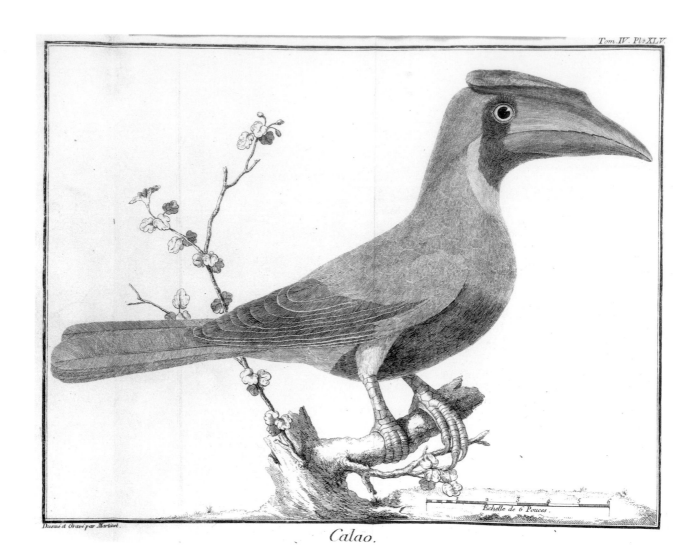

Dessiné et Gravé par Martinet.

Echelle de 6 Pouces.

Calao.

78 ▪ RED-BILLED HORNBILL *Tockus erythrorhynchus*

"Calao." Engraving, with etching, by François Martinet from his own drawing. In *Ornithologia . . .* by Mathieu Jacques Brisson (1760). ▪ The Red-billed Hornbill is a gaudy bird with black-and-white plumage, red beak, and patches of yellow bare skin. This individual was drawn by Martinet for Mathieu Jacques Brisson's 1760 *Ornithologia*, which anticipated modern approaches to classification and included more species of birds—fifteen hundred—than any work up to that time.

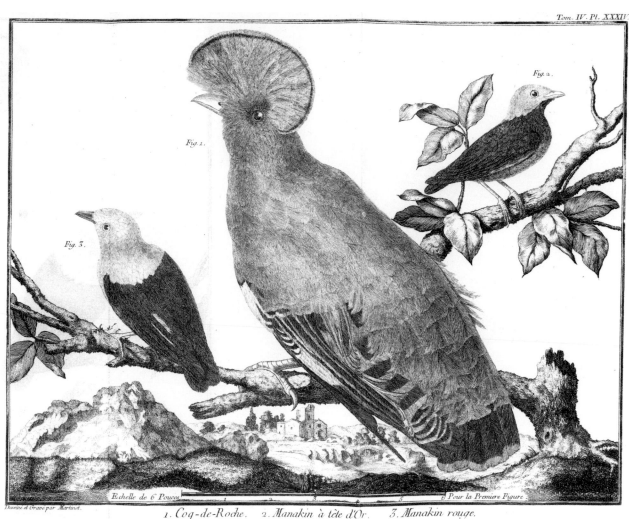

Fig. 1.

Fig. 2.

Fig. 3.

Echelle de 6 Pouces. Pour la Première Figure.

Dessiné et Gravé par Martinet.

1. *Coq-de-Roche.* 2. *Manakin à tête d'Or.* 3. *Manakin rouge.*

79 ▪ GUIANAN COCK-OF-THE-ROCK *Rupicola rupicola* ▪ CRIMSON-HOODED MANAKIN *Pipra aureola* ▪ GOLDEN-HEADED MANAKIN *P. erythrocephala*

"Coq de Roche; Manakin à tête d'Or; Manakin rouge." Engraving, with etching, by François Martinet from his own drawing. In *Ornithologia . . .* by Mathieu Jacques Brisson (1760). ▪ The Cock-of-the-Rock and the manakin live in the American tropics, where the males perform spectacular communal courtship dances on traditional courts or "arenas" in the forest. The females come to the arenas to mate, but then nest and raise their young alone.

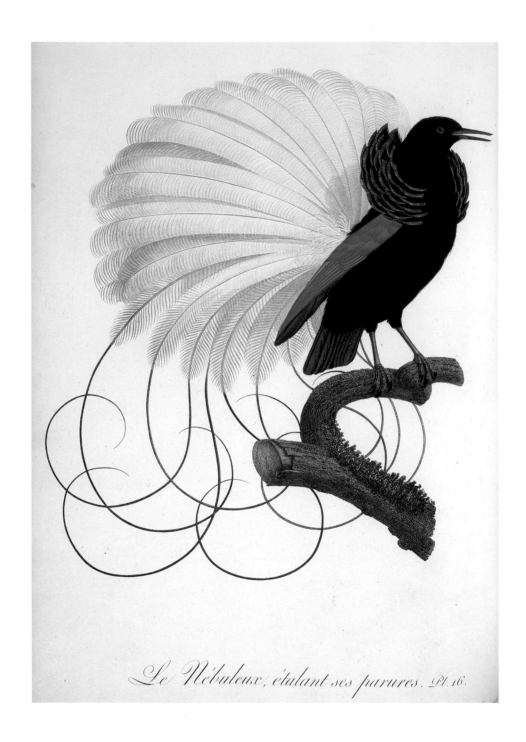

Le Nébuleux, étalant ses parures. Pl. 16.

80 ▪ TWELVE-WIRED BIRD OF PARADISE *Seleucidis melanoleuca*

"Le Nébuleux." Color-printed and hand-finished engraving, with etching, by Pérée from drawing by Jacques Barraband. In *Histoire naturelle des oiseaux de paradis . . .* by François Levaillant (1801–6). ▪ In the early nineteenth century, birds of paradise were known almost entirely from birdskins brought to Europe. Jacques Barraband, the finest French bird painter of his day, imagined that the flank plumes could be raised in display, and in so doing created the fantasy bird shown here. Actually, the birds plumage is not this versatile and its colors are much brighter.

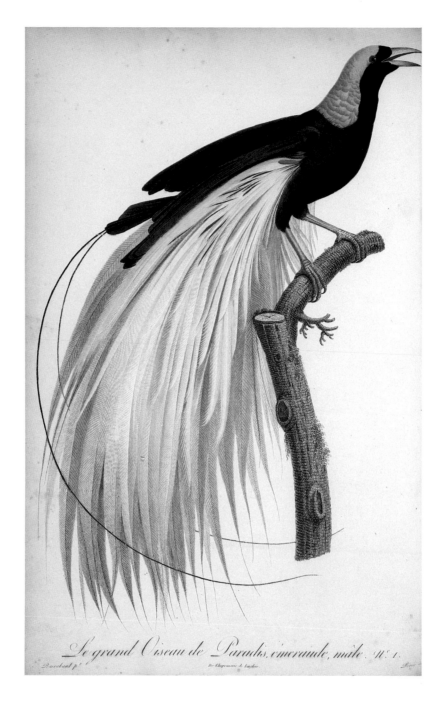

Le grand Oiseau de Paradis, émeraude, mâle. N.º 1.

81 ▪ GREATER BIRD OF PARADISE *Paradisaea apoda*

"Grand Oiseau de Paradis Emeraude." Color-printed and hand-finished engraving, with etching, by Pérée from drawing by Jacques Barraband. In *Histoire naturelle des oiseaux de paradis . . .* by François Levaillant (1801–6). ▪ The published works of François Levaillant, a dedicated traveler and skilled ornithologist, include several that are considered among the most beautiful in the history of ornithological illustration. Much credit for the sumptuousness of all Levaillant's books must go to his printer, Langlois, who perfected the art of printing in colors, embellished with hand-retouching. What appear to be part of this bird's tail are actually spectacular yellow flank plumes trailing behind and erected during courtship in a golden cascade over the bird's back.

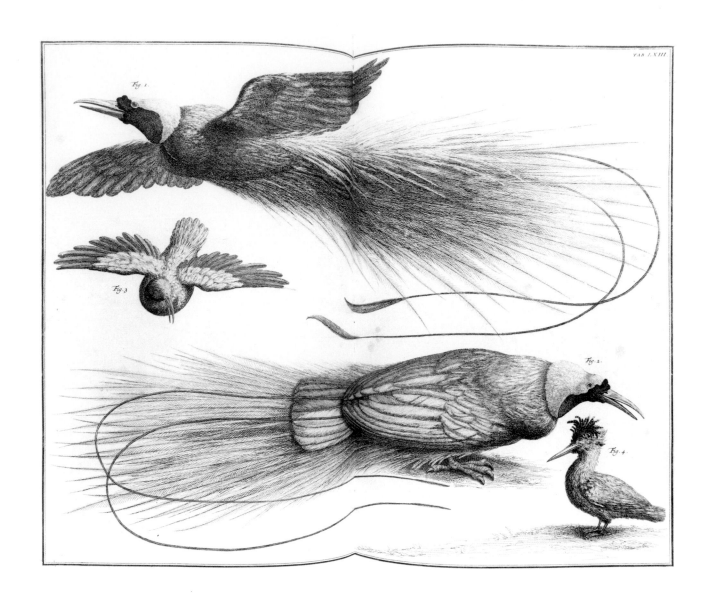

82 • GREATER BIRD OF PARADISE (2) *Paradisaea apoda* • FLOWERPECKER? *Dicaeidae?* •
COMMON KINGFISHER? *Alcedo atthis?*

"Oiseau de Paradis d'Aroles (2); Oiseau Tsioei; Alcyon, d'Amboine." Etching. In *Locupletissimi rerum naturalium thesauri . . .* by Albert Seba (1734–65). • The birds in this plate were all specimens kept by Albert Seba in his "cabinet of curiosities." *Locupletissimi* is a four-volume catalogue of its contents. Note that the birds of paradise have feet, unlike those shown in plate 77. Seba, an apothecary of Amsterdam, built a huge bird collection, which he sold to Peter the Great for fifteen thousand florins. Then he went back and built an even bigger one for himself.

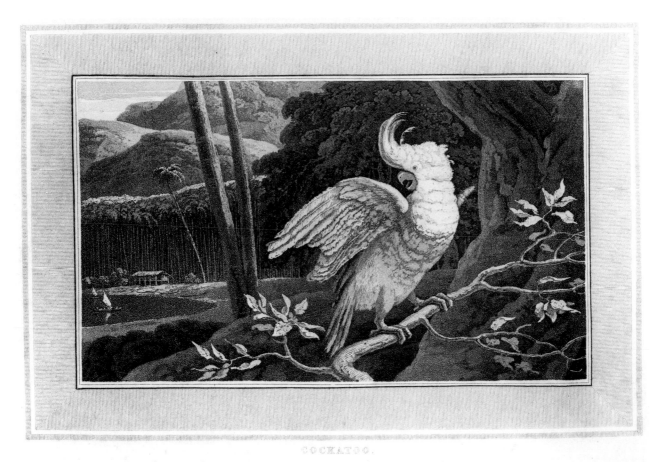

COCKATOO.

Designed & Engraved by Will^m Daniell, & Published by Mess^{rs} Cadell & Davies London March 1 1807.

83 ▪ WHITE COCKATOO *Cacatua alba*

"Cockatoo." Monochrome aquatint, by William Daniell from his own drawing. In *Interesting Selections from Animated Nature with Illustrative Scenery* by William Daniell (1809). ▪ William Daniell observed that "the sagacity and aptness of imitation, which is so conspicuous in other parrots, seems to be in great measure denied to the cockatoo." But, he added, "To compensate for this deficiency, he has an elegant crest." Daniell underestimated the abilities of the cockatoos, for many species can become very good "talkers." The White Cockatoo illustrated here is rare and not well known.

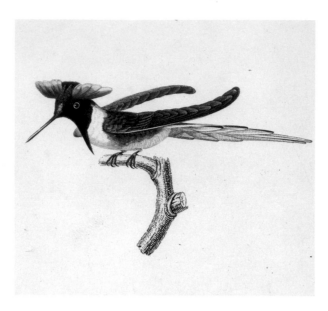

84 ▪ HORNED SUNGEM *Heliactin cornuta*

"Oiseau-Mouche aux Huppes d'Or." Color-printed and hand-finished engraving, with etching, by J. L. D. Coutant from drawing by Jean-Gabriel Prêtre. In *Histoire naturelle des oiseaux-mouches . . .* by René Primevère Lesson (1829–30).

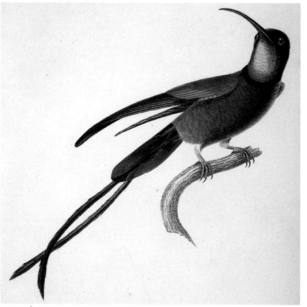

85 ▪ CRIMSON TOPAZ *Topaza pella*

"Colibri Topaze." Color-printed and hand-finished engraving, with etching, by J. L. D. Coutant from drawing by Jean-Gabriel Prêtre. In *Histoire naturelle des colibris . . .* by René Primevère Lesson (1831).

Lesson first saw his exotic hummingbirds—sometimes called "flying jewels"—while serving as naturalist-apothecary on a French naval vessel in the South Pacific, possibly on a stopover in South America. Back home, working on ornithology, he displayed them in among the most beautiful of all bird books. "They sparkle with the brilliance of gold and red copper," he wrote of his oiseaux-mouches, ". . . glints of rubies and emeralds, the red of fire. . . ."

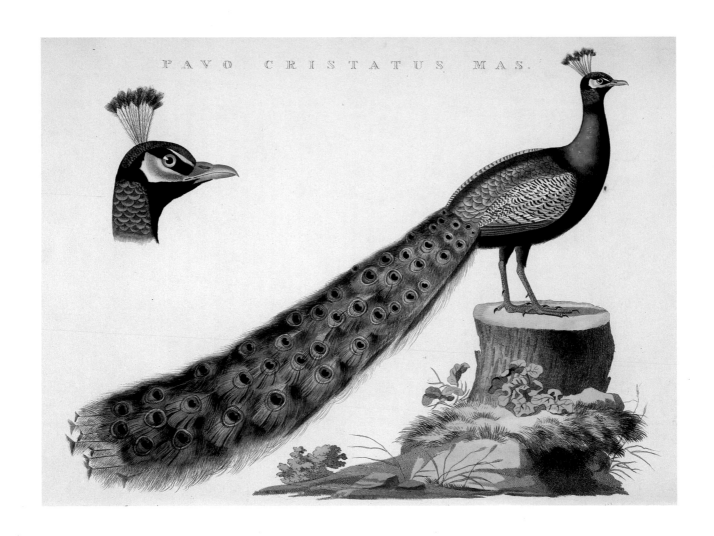

PAVO CRISTATUS MAS.

86 ▪ COMMON PEAFOWL *Pavo cristatus*

"Pavo Cristatus—Pavo—Paauw." Hand-colored engraving, with etching, by C. Sepp or J. C. Sepp from his own drawing. In *Nederlandsche vogelen . . .* by Cornelius Nozeman and Martinus Houttuyn (1770–1829). ▪ Although peafowl were not native birds, Europeans included them in their national ornithologies—as Nozeman did—partly because they had been domesticated but mostly because they were so handsome. The authors wrote glowingly about the male's beauty but had harsh things to say about its raucous call. "The appearance of an angel," complained one ornithologist, "and the voice of the devil inharmonious."

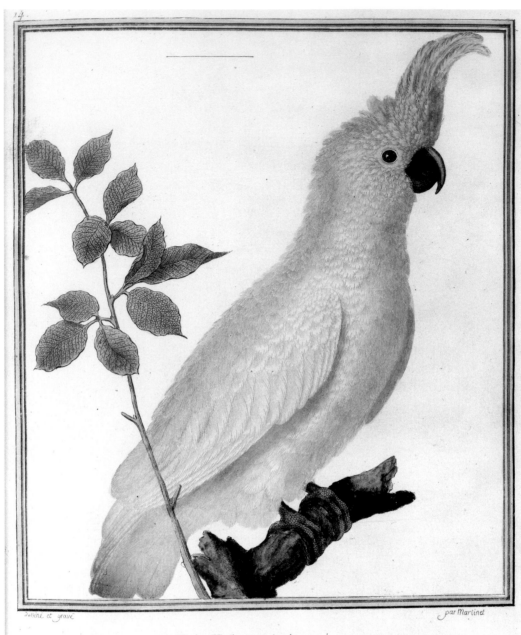

Petit Kakatoes à hupe jaune.

87 ▪ SULPHUR-CRESTED COCKATOO *Cacatua galerita*

"Petit Kakatoes à hupe jaune." Hand-colored engraving, with etching, by François Martinet from his own drawing. In *Planches enluminées d'histoire naturelle par Martinet* . . . by Le Comte de Buffon (1765–83) ▪ Buffon dominated French science for decades partly by his work, partly by his personality. His *Histoire naturelle* had more facts about the natural sciences than any other encyclopedia, his *Planches enluminées* showed more birds than any other ornithology. "M. de Buffon," said one witty aristocrat, "has never spoken to me of the marvels of the earth without inspiring in me the thought that he himself was one of them."

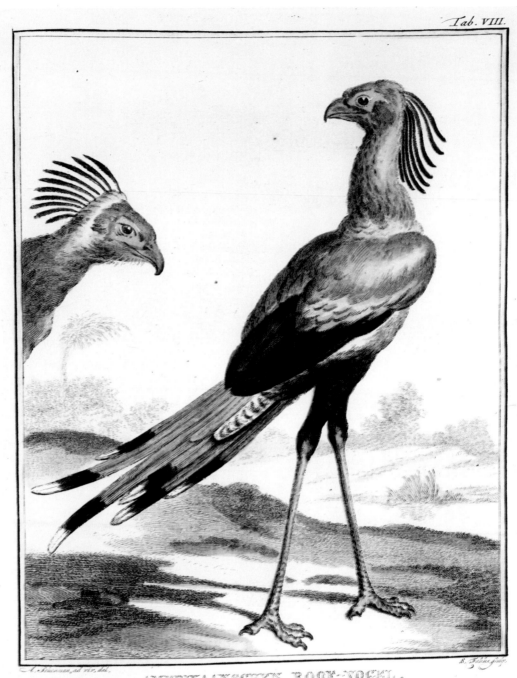

Tab. VIII.

AMERIKAANSCHEN ROOF-VOGEL.

88 ▪ SECRETARY BIRD *Sagittarius serpentarius*

"Amerikaanschen roof-vogel." [sic] Hand-colored engraving, by S. Fokke from drawing by A. Schouman. In *Natuurkunde beschryving . . .* by Arnout Vosmaer (1804). ▪ This illustration is lent a weird surrealist air by the disembodied head of a second Secretary Bird peering into the picture, the rest of it cut off at the plate mark. The bird, an atypical African bird of prey, catches snakes by running them down rather than diving at them. It gets its name from its head feathers, which look like the quill pens secretaries used to tuck behind their ears.

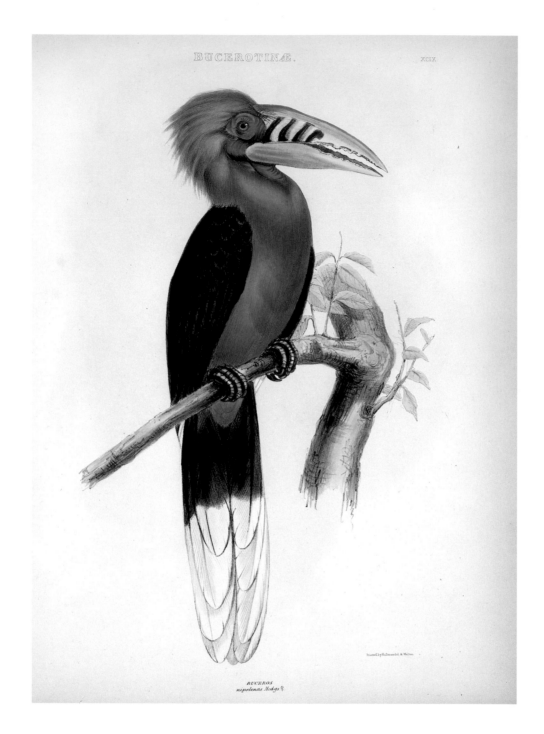

89 ▪ RUFOUS-NECKED HORNBILL *Aceros nipalensis*

"Buceros." Hand-colored lithograph. In *The Genera of Birds* . . . by George Robert Gray (1849). ▪ Despite their ponderous appearance, these bills are very lightweight, hollow, or honeycombed structures. Hornbills, who mate for life, demonstrate unique nesting behavior. The male helps the female to seal herself within a cavity, usually in a tree, and she remains there until her young are partly grown. Then she escapes, the hole is resealed, and she helps her mate pass food to her brood. Many artists illustrated this work by George Robert Gray who was at the British Museum for forty years, latterly in charge of their bird collection.

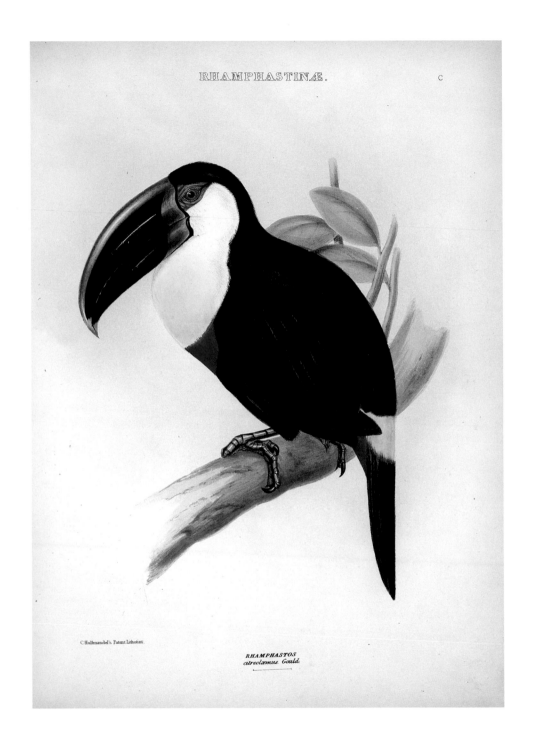

C.Hullmandel's Patent Lithotint.

RHAMPHASTOS
citreolæmus. Gould.

90 ▪ CITRON-THROATED TOUCAN *Ramphastos citreolaemus*

"Ramphastos." Hand-colored lithograph. In *The Genera of Birds . . .* by George Robert Gray (1849). ▪ Identification of a toucan is simple—the disproportionate, cumbersome-looking bill is unmistakable—but distinguishing among the thirty-seven species is an expert's job: these birds vary in their garish assortment of beak and plumage colors and range from one to two feet in length. Their lightweight bills are used not only for obvious tasks—food gathering and eating, defense, noise-making—but also for recognizing their own species and perhaps in courtship.

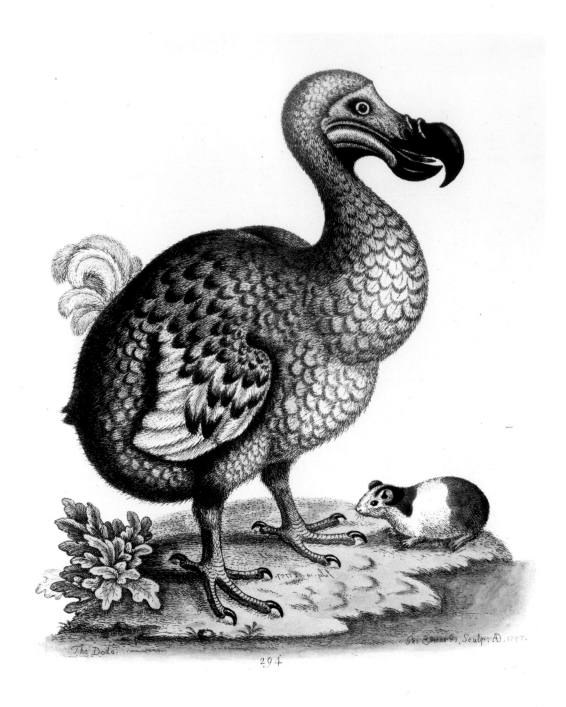

The Dodo.

294

Pet Edwards Sculp: AD. 1757.

91 ▪ DODO *Raphus cucullatus*

"Dodo." Hand-colored etching, by George Edwards from his own drawing. In *A Natural History of Birds . . .* by George Edwards (1802–6). ▪ Unlike his contemporary, Donovan, who chose to depict birds native to Britain, George Edwards concentrated on foreign birds, working whenever possible from captive live models and otherwise from mounted specimens. His drawing was based on an oil painting made in the late-seventeenth century from a live Dodo brought to England from the island of Mauritius. If Edwards's drawing resembles John Tenniel's illustration for the Dodo in *Alice's Adventures in Wonderland*, it is probably because they worked from the same painting.

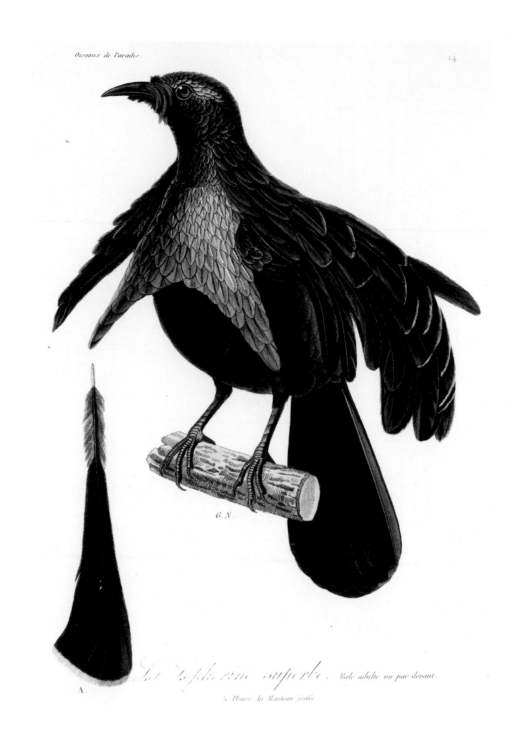

La Lophorine superbe. Mâle adulte vu par devant

A. Plume du Manteau isolée

92 ▪ SUPERB BIRD OF PARADISE *Lophorina superba*

"La Lophorine Superbe." Color-printed and hand-finished engraving, with etching, by Massard from drawing by Paul-Louis Oudart. In *Histoire naturelle des oiseaux de paradis . . .* by René Primevère Lesson (1834–35). ▪ Many of the plates in this small book fold out to accommodate the extravagant and long plumages of the birds. The Superb Bird of Paradise is fairly compact, however, and easily fits on a single page. Following a happy, successful life in France writing popular books on exotic birds, Lesson lost his pension and returned to his role as an apothecary, and eventually, chemistry professor.

MACROCERCUS ARARAUNA.
Blue & Yellow Macaw

93 ▪ BLUE AND YELLOW MACAW *Ara ararauna*

"Blue and Yellow Macaw." Hand-colored lithograph, by Edward Lear. In *Illustrations of the Family of Psittacidae, or Parrots . . .* by Edward Lear (1830–32). ▪ Much as they admire Edward Lear's birds, ornithologists complain that he made particular portraits of individual birds, rather than generalized depictions of a species, the purpose of zoological illustration. Possibly the fact that he drew from live parrots at the London zoo and got to know them as personalities led Lear into ornithological error. Certainly, though, it added to the liveliness of this parrot portrait.

RUPICOLA SANGUINOLENTA.

94 ▪ ANDEAN COCK-OF-THE-ROCK *Rupicola peruviana*

"Cock-of-the-Rock." Hand-colored lithograph, by Joseph Smit. In *Exotic Ornithology . . .* by Philip Lutley Sclater and Osbert Salvin (1866–69). ▪ British ornithologists Sclater and Salvin set out to chronicle new and rare birds from all over the world. What they found in the American tropics, however, was remarkable for its beauty and scope, and it was to the avifauna here that they directed their research.

Podarge *cornu.*

Prêtre.

95 ▪ JAVAN FROGMOUTH *Batrachostomus javensis*

"Podarge Cornu." Hand-colored engraving, with etching, from drawing by Jean-Gabriel Prêtre. In *Nouveau recuil de planches coloriées d'oiseaux . . .* by Coenraad Jacob Temminck and M. Laugier de Chartrouse (1820–39). ▪ Javan frogmouths are solitary nocturnal birds that use their broad beaks to catch insects to eat. The stiff hair-like feathers surrounding the bill are thought to aid the bird in detecting prey.

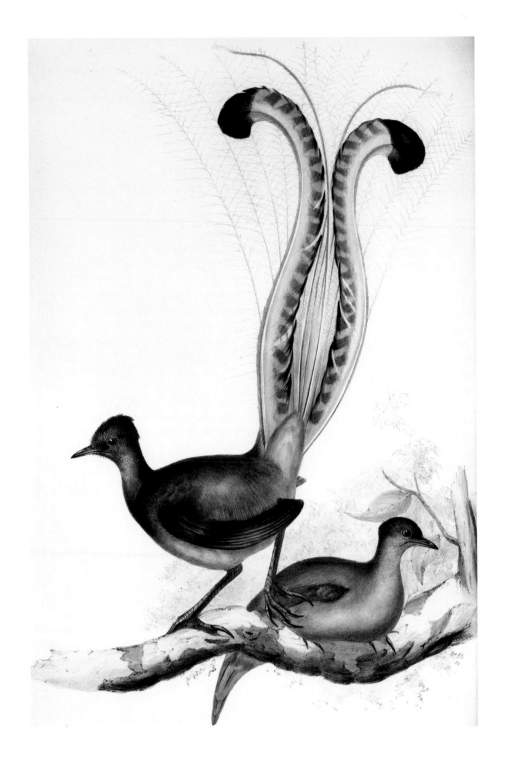

96 ▪ SUPERB LYREBIRD *Menura superba*

"Lyre-Bird." Hand-colored lithograph, by John and Elizabeth Gould. In *The Birds of Australia* by John Gould (1840–48). ▪ In instructing his wife, Elizabeth, on this portrait of the Superb Lyrebird, Gould made sure the pose would plainly show the reason for the name. Mrs. Gould went along with her husband on his two-year stay in Australia. She trekked out into the wilds to look at birds, made field sketches, and also gave birth to their sixth child. When she died, at age thirty-seven, Gould mourned her deeply and named a finch, *Amadina gouldiae*, after her.

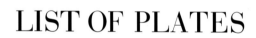

LIST OF PLATES

1 ▪ SHORT-EARED OWL *Asio flammeus*

2 ▪ PEREGRINE FALCON *Falco peregrinus*

3 ▪ "HAWKING OR FALCONRY"

4 ▪ GYRFALCON *Falco rusticolus*

5 ▪ EAGLE OWL *Bubo bubo* ▪ TAWNY OWL *Strix aluco* ▪
EUROPEAN NIGHTJAR *Caprimulgus europaeus*

6 ▪ CROWNED EAGLE *Stephanoaetus coronatus* ▪ PEREGRINE FALCON *Falco peregrinus* ▪
SECRETARY BIRD *Sagittarius serpentarius*

7 ▪ LAPPET-FACED VULTURE *Torgos tracheliotus*

8 ▪ COLLARED SCOPS OWL *Otus bakkamoena*

9 ▪ GYRFALCON *Falco rusticolus*

10 ▪ BARN OWL *Tyto alba*

11 ▪ AMERICAN BALD EAGLE *Haliaeetus leucocephalus*

12 ▪ GREAT HORNED OWL *Bubo virginianus*

13 ▪ GREAT HORNED OWL *Bubo virginianus* ▪ BARN OWL *Tyto alba* ▪
FLYCATCHER *?species* ▪ HAWK OWL *Surnia ulula*

14 ▪ MERLIN *Falco columbarius*

15 ▪ GYRFALCON *Falco rusticolus*

16 ▪ DOMESTIC FOWL *Gallus domesticus*

17 ▪ RUFF *Philomachus pugnax*

18 ▪ DOMESTIC FOWL *Gallus domesticus*

19 ▪ ROCK PARTRIDGE *Alectoris graeca*

20 ▪ CRESTED BOBWHITE *Colinus cristatus*

21 ▪ OCELLATED QUAIL *Cyrtonyx ocellatus*

22 ▪ ELLIOT'S PHEASANT *Syrmaticus ellioti*

23 ▪ GOLDEN PHEASANT × LADY AMHERST PHEASANT *Chrysolophus pictus × C. amherstiae*

24 ▪ LADY AMHERST PHEASANT *Chrysolophus amherstiae*

25 ▪ SHELLEY'S FRANCOLIN *Francolinus shelleyi*

26 ▪ WHITE STORK *Ciconia ciconia*

27 ▪ WOOD STORK *Mycteria americana*

28 ▪ LAPWING *Vanellus vanellus*

29 ▪ GREAT BLUE HERON *Ardea herodias*

30 ▪ BLACK-WINGED STILT *Himantopus himantopus*

31 ▪ GRAY HERON *Ardea cinerea*

32 ▪ WHITE SPOONBILL *Platalea leucorodia*

33 ▪ GREATER FLAMINGO *Phoenicopterus ruber*

34 ▪ MAGUARI STORK *Euxenura maguari*

35 ▪ JAPANESE CRESTED IBIS *Nipponia nippon*

36 ▪ GREAT BLUE HERON *Ardea herodias*

37 ▪ REDDISH EGRET *Egretta rufescens* ▪ LIMPKIN *Aramus guarauna* ▪
ESKIMO CURLEW *Numenius borealis*

38 ▪ COMB-CRESTED JACANA *Irediparra gallinacea*

39 ▪ THREE BIRDS

40 ▪ GOLDEN ORIOLE *Oriolus oriolus* ▪ YELLOW-RUMPED CACIQUE *Cacicus cela* ▪
ORIENTAL GREEN BARBET *Megalaima zeylanica*

41 ▪ BELTED KINGFISHER *Ceryle alcyon*

42 ▪ BROWN THRASHER *Toxostoma rufum*

43 ▪ CRESTED OROPENDOLA *Psarocolius decumanus*

44 ▪ CAPUCHIN BIRD *Perissocephalus tricolor*

45 ▪ NORTHERN MOCKINGBIRD *Mimus polyglottus* ▪ RUBY-THROATED HUMMINGBIRD
Archilochus colubris ▪ RUFOUS-SIDED TOWHEE *Pipilo erythrophthalmus*

46 ▪ COMMON CARDINAL *Cardinalis cardinalis* ▪ SCARLET TANAGER *Piranga olivacea*

47 ▪ WEST INDIAN RED-BELLIED WOODPECKER *Melanerpes superciliaris*

48 ▪ REED BUNTING *Emberiza schoeniclus*

49 ▪ BAYA WEAVER *Ploceus philippinus*

50 ▪ RED-VENTED BULBUL *Pycnonotus cafer*

51 ▪ SPOTTED BOWERBIRD *Chlamydera maculata*

52 ▪ NEW ZEALAND TIT *Petroica macrocephala*

53 ▪ IVORY-BILLED WOODPECKER *Campephilus principalis*

54 ▪ HOUSE SPARROW *Passer domesticus*

55 ▪ BARN SWALLOW *Hirundo rustica*

56 ▪ WHITE-COLLARED KINGFISHER *Halcyon chloris*

57 ▪ MANY-COLORED FRUIT DOVE *Ptilinopus perousii*

58 ▪ LARGE GROUND FINCH *Geospiza magnirostris*

59 ▪ ARCTIC WARBLER *Phylloscopus borealis* ▪ GREEN WILLOW WARBLER *P. nitidus* ▪
GREENISH WARBLER *P. trochiloides* ▪ PALE-LEGGED WILLOW WARBLER *P. tenellipes* ▪
LARGE-CROWNED WILLOW WARBLER *P. occipitalis*

60 ▪ YELLOW-BELLIED SUNBIRD *Nectarinia jugularis*

61 ▪ FAIRY PITTA *Pitta nympha*

62 ▪ GREAT AUK *Pinguinus impennis*

63 ▪ MALLARD *Anas platyrhynchos*

64 • KING PENGUIN *Aptenodytes patagonicus*

65 • GREAT CRESTED GREBE *Podiceps cristatus*

66 • NORTHERN PINTAIL *Anas acuta*

67 • PARADISE SHELDUCK *Tadorna variegata*

68 • WHOOPER SWAN *Cygnus cygnus*

69 • GREAT NORTHERN DIVER *Gavia immer*

70 • GREAT CRESTED GREBE *Podiceps cristatus*

71 • KING EIDER *Somateria spectabilis* • GOOSANDER *Mergus merganser*

72 • HEERMANN'S GULL *Larus heermanni*

73 • WOOD DUCK *Aix sponsa*

74 • MARBLED TEAL *Anas angustirostris* • RED-CRESTED POCHARD *Netta rufina*

75 • RED-BREASTED MERGANSER *Mergus serrator*

76 • BARNACLE GOOSE *Branta leucopsis*

77 • BIRDS OF PARADISE *Paradisaeidae*

78 • RED-BILLED HORNBILL *Tockus erythrorhynchus*

79 • GUIANAN COCK-OF-THE-ROCK *Rupicola rupicola* • CRIMSON-HOODED MANAKIN *Pipra aureola* •
GOLDEN-HEADED MANAKIN *Pipra erythrocephala*

80 • TWELVE-WIRED BIRD OF PARADISE *Seleucidis melanoleuca*

81 • GREATER BIRD OF PARADISE *Paradisaea apoda*

82 • GREATER BIRD OF PARADISE *Paradisaca apoda* • FLOWERPECKER? *Dicaeidae?* •
COMMON KINGFISHER? *Alcedo atthis?*

83 • WHITE COCKATOO *Cacatua alba*

84 • HORNED SUNGEM *Heliactin cornuta*

85 • CRIMSON TOPAZ *Topaza pella*

86 • COMMON PEAFOWL *Pavo cristatus*

87 • SULPHUR-CRESTED COCKATOO *Cacatua galerita*

88 • SECRETARY BIRD *Sagittarius serpentarius*

89 • RUFOUS-NECKED HORNBILL *Aceros nipalensis*

90 • CITRON-THROATED TOUCAN *Ramphastos citreolaemus*

91 • DODO *Raphus cucullatus*

92 • SUPERB BIRD OF PARADISE *Lophorina superba*

93 • BLUE AND YELLOW MACAW *Ara ararauna*

94 • ANDEAN COCK-OF-THE-ROCK *Rupicola peruviana*

95 • JAVAN FROGMOUTH *Batrachostomus javensis*

96 • SUPERB LYREBIRD *Menura superba*

Tab. XXXII.

Hubler pinx.

Goutelet sc.

1	Charadrius vociferus.	7 Columba zenaida.	13 Icterus (?) vulg. Solivio.	19 ?........ vulg. Bueyero.
2	Colymbus dominicensis.	8 Quiscalus atroviolaceus.	14 Polyborus vulgaris.	20 Sturnella Ludoviciana.
3	Falco (?)	9 Tyrannus (?)	15 Columba passerina.	21 Saurothera Merlini.
4	Anas sponsa.	10 Passerina olivacea.	16 Picus (?) vulg. Carpintero jabado.	22 Crotophaga ani.
5	Quiscalus baritus.	11 Muscicapa virens.	17 Picus (?) vulg. Carpintero verde.	23 Corvus Jamaicensis.
6	Turdus rubripes.	12 Quiscalus (?) vulg. Toti mayito.	18 Columba carolinensis.	24 Noctua Siju.

Imp. de Bougeard.

A BIBLIOGRAPHIC CHECKLIST
OF THE EXHIBITION

The following list contains those titles represented in "Splendid Plumage," an exhibition held at The New York Public Library, February-April 1988, and in *The Bird Illustrated 1550–1900*. They are among the most important works culled from several hundred titles in the area of ornithology, and from all areas of the Library: The Arents Collection of Books in Parts, General Research Division, Oriental Division, Rare Books and Manuscripts Division, The Miriam and Ira D. Wallach Division of Arts, Prints and Photographs, Science and Technology Research Center, and the Spencer Collection. ▪ Of the books that much research was based upon, the following were particularly helpful: Oliver L. Austin's *Birds of the World* (1961); Grzimek's *Animal Life Encyclopedia* (1972); Christine Jackson's *Bird Illustrators* (1975) and *Bird Etchings* (1985); David Knight's *Zoological Illustrations* (1977); A. M. Lysaght's *The Book of Birds* (1975); *The Encyclopedia of Birds*, edited by Christopher M. Perrins (1985); and Peyton Skipwith's *The Great Bird Illustrators and Their Art* (1979). ▪ Artists and craftspersons have been identified whenever reasonably possible. In the interest of clarity, technical printmaking terminology has been avoided. Historical, artistic, and bibliographic information has been drawn from the four sources at the top of page 116. The interested reader is urged to seek these listings for further material.

ANKER, JEAN. *Bird Books and Bird Art*. Copenhagen: Copenhagen University, 1938.

BALIS, JAN. *Merveilleux plumages. Dix siècles de livres d'oiseaux* (exhibition catalogue 1968–69). Translated by Lambert Maka. Brussels: Bibliothèque Royale, 1968.

NISSEN, CLAUS. *Schöne Vögelbucher. Ein Überblick der Ornithologischen Illustration nebst Bibliographie*. Vienna: Reichner, 1936.

ZIMMER, J. T. *Catalogue of the Edward E. Ayer Ornithological Library*. 2 vols. Chicago: The Field Museum of Natural History, 1926.

(Citations for Anker, Balis, and Nissen refer to entry numbers; those for Zimmer indicate the volume and page.)

Plate entries marked by an asterisk (*) indicate illustrations also in this book.

ALDROVANDI, ULISSE. *Opera omnia*. 13 vols. Vols. 1–3, *Ornithologiae hoc est de avibus historiae libri XII* (1599–1603). Bologna, 1599–1668. 14 × 9″. ▪ Woodcuts by Cristoforo and G. B. Coriolanus from drawings by Lorenzo Bennini, Jacopo Ligozzi, and Cornelius Swint. Vol. 1, pl. opp. p. 464: Peregrine Falcon (*Falco peregrinus*).* ▪ Aldrovandi's encyclopedic and detailed descriptions of birds constituted one of the three great sixteenth-century books upon which later ornithologists based their works. ▪ *Ref: Balis, 11; Nissen, 18.*

AUDEBERT, JEAN-BAPTISTE, and LOUIS JEAN-PIERRE VIEILLOT. *Histoire naturelle des oiseaux dorés où à reflets métalliques. . . .* 2 vols. Paris: Desray, 1800–2. 13½ × 10″. ▪ 190 color-printed and hand-retouched copperplate etchings by Audebert from his own drawings, assisted by other artists, printed by Langlois. Vol. 1, pl. 3: Reunion Starling (*Fregilupus varius*). ▪ Audebert claimed to have developed his own special methods of color printing to depict the brilliant metallic plumages of his subjects: gold was used in the hand finishing, and in two special deluxe editions gold was used for printing text. Two hundred copies were issued with printed gold captions, and twelve with the entire text in gold. The standard edition with inked text, which includes this copy, was issued in an edition of either one hundred or three hundred. ▪ *Ref: Anker, 14; Balis, 52; Nissen, 16; Zimmer 1:17.*

AUDUBON, JOHN JAMES. *The Birds of America*. 4 vols. London, 1827–38. 39 × 26″ (approx.). ▪ 435 hand-colored etchings, with engraving and aquatint, principally by Robert Havell, Jr. (some by R. Havell, Sr., and William Lizars) from watercolor studies by Audubon and assistants. Vol. 1, pl. 66: Ivory-billed Woodpecker (*Campephilus principalis*). ▪ This book of Audubon's superb "double elephant" folio prints is the greatest achievement of all his works. ▪ *Ref: Anker, 17–19; Balis, 124; Nissen, 17; Zimmer 1:18–19.*

———. *The Birds of America*. 7 vols. Philadelphia: Chevalier, 1840–44. 10¼ × 6½″. ▪ 500 hand-colored lithographs by J. T. Bowen from the drawings by J. J. Audubon. Vol. 4, pl. 256: Ivory-billed Woodpecker (*Campephilus principalis*).* Vol. 6, pl. 369: Great Blue Heron (*Ardea herodias*).* ▪ Wanting to make some money and have his *Birds of America* be widely accessible, Audubon issued an inexpensive small-format edition in 1840, with his *Ornithological Biography* as text. ▪ *Ref: Anker, 19; Nissen, 18; Zimmer 1:22.*

BEECHEY, FREDERICK WILLIAM, ed. *The Zoology of Captain Beechey's Voyage . . . During a Voyage to the Pacific and Behring's Straits . . . in the Years 1825, 1826, 1827, and 1828*. London: Bohn, 1839. 11 × 8¾″. ▪ 4 plans, 44 hand-colored engravings by Zeitter from drawings by Edward Lear, G. B. Sowerby, and J. D. C. Sowerby. Pl. 11: Elegant Quail (*Lophortyx douglasii*). Lear, artist. ▪ The ornithology section, with twelve plates, was written by Nicholas Vigors, who had previously worked with John Gould and William Jardine and had also contributed articles to London's *Zoological Journal*. ▪ *Ref: Anker, 517; Nissen, 285; Zimmer 1:51.*

BÉLON, PIERRE. *Pourtraicts d'oyseaux, animaux, serpens, herbes, arbres, hommes et femmes d'Arabie et d'Egypte*. Paris, 1557. 9½ × 6¼″. ▪ Woodcuts. p. 44: probably Hadada (*Bostrychia hagedash*). p. 45: White Stork (*Ciconia ciconia*).* ▪ Published two years after the author's landmark *L'Histoire de la nature des oyseaux . . .* (the first monograph on birds), this collection of bird and animal portraits is accompanied by poetry. ▪ *Ref: Nissen, 43.*

BEWICK, THOMAS. *A History of British Birds*. 2 vols. Vol. 1, *Land Birds*. Newcastle: Hodgson, 1797; vol. 2, *Water Birds*. Newcastle: Walker, 1804. 8¹/₁₆ × 4¾″. ▪ 448 wood engravings by Bewick from his own drawings. Vol. 1, pp. 36, 37: Common Kestrel (*Falco tinnunculus*). Vol. 2, p. 95: Ruff (*Philomachus pugnax*).* ▪ The title was reissued many times, in part due to the lively and accurate text illustrations. William Yarrell, who was to write his *History of British Birds* (1871), assisted Bewick in text revisions for his 1847 edition. ▪ *Ref: Balis, 42; Nissen, 46; Zimmer 1:57.*

————. *A History of British Birds.* Chicago: Cherryburn, 1944. 7⅞ × 6″. ▪ 3 unbound wood engravings restruck from original blocks, 1797–1804. Domestic Fowl (*Gallus domesticus*).* Eurasian Bittern (*Botaurus stellaris*). Black Woodpecker (*Picus martius*).

BLOME, RICHARD. *The Gentleman's Recreation, in Two Parts. The First being an Encyclopedia of the Arts and Sciences. . . . The Second Part Treats of . . . Hawking . . . Cock-fighting. . . .* London: S. Rotcroft, 1686. 16½ × 10¾″. ▪ Copperplate etchings by Arthur Soly, Simon Grigelin, and others from drawings by Francis Barlow and others. Frontis., Pt. 2: Hawking scenes depicting 9 birds of prey.* ▪ A seventeenth-century instructional book, intended for the well-bred gentleman of means.

BOLTON, JAMES. *Harmonia Ruralis, or an Essay towards a Natural History of British Song Birds.* Rev. ed. 2 vols. in 1. London: Henry Bohn, 1845. 12 × 9¾″. ▪ 80 hand-colored copperplate etchings by Bolton from his own drawings. Pl. 27: Linnet (*Acanthis cannabina*). ▪ Bolton often included an insect and/or plant in the illustrations to indicate a bird's environment and diet. ▪ *Ref: Nissen, 55; Zimmer 1:64.*

BONAPARTE, CHARLES-LUCIEN-JULES-LAURENT. *American ornithology; or, The natural history of birds inhabiting the United States, not given by Wilson.* 4 vols., port. (with plates from vols. 2 & 4). Philadelphia: S. A. Mitchell (vol. 1); Carey, Lee & Carey (vols. 2,3); Carey & Lee (vol. 4), 1825–33. 15 × 11½″; 14¾ × 11½″ (matted plates). ▪ 27 hand-colored engravings, with etching, by Alexander Lawson from drawings by Titian Ramsey Peale, A. Rider, and J. J. Audubon. Pl. 26: 1. Reddish Egret (*Egretta rufescens*); 2. Limpkin (*Aramus guarauna*); 3. Eskimo Curlew (*Numenius borealis*). * Rider, artist. ▪ *Ref: Anker, 47; Balis, 125; Nissen, 56; Zimmer 1:64, 65.*

————. *Iconografia della Fauna Italica. . . .* 3 vols. Rome: Bonifazi, 1832–41. Vol. 1, *Mammiferi e ucceli.* 15¾ × 11″. ▪ 48 hand-colored lithographs by Battistelli from drawings by Carlos Ruspi, Petrus Quattrocchi, and others. Pl. 34: Reed Bunting (*Emberiza schoeniclus*).* Pl. 39: Rock Partridge (*Alectoris graeca*).* Pl. 47: 1 & 2. Marbled Teal, male, female (*Anas angustirostris*); 3. Red-crested Pochard (*Netta rufina*).* ▪ *Ref: Anker, 48; Balis, 126; Nissen, 58; Zimmer 1:65, 67.*

————. *Iconographie des pigeons non figurés par Mme Knip. . . .* Paris: Bertrand, 1857–58. 21 × 14½″. ▪ 55 hand-colored lithographs by Lemercier from drawings by Paul Oudart. Pl. 38: Pacific Pigeon (*Ducula pacifica*). ▪ *Ref: Nissen, 57; Zimmer 1:78.*

BORKHAUSEN [also borckhausen], MORITZ B. et al. *Teutsche Ornithologie. . . .* Darmstadt, 1800–11. 18½ × 12½″. ▪ 125 hand-colored copperplate etchings by J. C. Susemihl and

family from their own drawings. Pl.: Barn Owl (*Tyto alba*).* Pl.: Black-winged Stilt (*Himantopus himantopus*).* ▪ It was issued in twenty-one parts, but many copies lack the final portion. This copy is complete. ▪ *Ref: Anker, 52; Nissen, 486; Zimmer 1:81.*

BRENCHLEY, JULIUS. *Jottings during the Cruise of H.M.S. Curacoa among the South Sea Islands in 1865.* London: Longmans, 1873. 10¼ × 6¾″. ▪ 52 hand-colored lithographs (21 of birds) by Joseph Smit, printed by Mintern Bros. Pl. 14: Eastern Black-capped Lory (*Lorius hypoinochrous*). ▪ George Robert Gray wrote the ornithological descriptions for *Jottings . . .* as well as those for other voyages, including that of the *Beagle.* There he assisted John Gould in the preparation of his notes, which Charles Darwin included in his text. ▪ *Ref: Zimmer 1:92.*

BRISSON, MATHIEU JACQUES. *Ornithologia, sive synopsis methodica sistens avium divisionem in ordines . . . Ornithologie ou méthode. . . .* 6 vols. & suppl. Paris: Bauche, 1760. 10 × 7½″. ▪ Copperplate etchings by François Nicholas Martinet from his own drawings. Vol. 4, pl. 34: Guianan Cock-of-the-Rock (*Rupicola rupicola*); Crimson-hooded Manakin (*Pipra aureola*); Golden-headed Manakin (*P. erythrocephala*).* Vol. 4, pl. 45: Red-billed Hornbill (*Tockus erythrorhynchus*).* Vol. 5, pl. 2: Little Bustard (*Otis tetrax*). ▪ One of the earliest systematic treatises on birds, it is considered among the best, if not the best, done in eighteenth-century France. ▪ *Ref: Anker, 69; Balis, 39; Nissen, 70; Zimmer 1:94.*

BRITISH MUSEUM DEPT. OF ZOOLOGY, NATURAL HISTORY. *Catalogue of the birds in the British Museum.* Edited by Richard Bowdler Sharpe. 27 vols. London, 1874–98. Diff. sizes, most approx. 9 × 5½″. ▪ 387 hand-colored lithographs and chromolithographs by Joseph Smit, John Gerrard Keulemans, Mintern Bros., and others from drawings by Smit, Keulemans, and others. Vol. 8, pl. 8: Great Gray Shrike (*Lanius excubitor*). Smit, artist. Vol. 22, pl. 6: Shelley's Francolin (*Francolinus shelleyi*). Keulemans, artist.* ▪ *Ref: Zimmer 1:95–98.*

BUFFON, GEORGES-LOUIS LE CLERCQ, COMTE DE. *Histoire naturelle, générale et particulière. . . .* 44 vols. Vols. 16–24, *Oiseaux,* numbered 1–9 (1770–86). Paris, 1749–1804. 8⅜ × 7½″. ▪ Copperplate etchings by Dufour from drawings by DeSève. Vol. 21 (6), pl. 3: Sulphur-crested Cockatoo (*Cacatua galerita*). ▪ A first edition of Buffon's work. Although originally containing DeSève's illustrations, the bird sections were later specially reissued and joined with Martinet's *Planches enluminées. . . .* ▪ *Ref: Anker, 74; Nissen, 78; Zimmer 1:104–6.*

————. *Planches enluminées d'histoire naturelle par Martinet, executées par Daubenton. . . .* 3 vols. Paris: Imprimérie royale, 1765–83(?). 12¾ × 9½″. ▪ 1,008 hand-colored cop-

perplate etchings by François Nicholas Martinet from his own drawings. Vol. 1, pl. 1: Domestic Fowl (*Gallus domesticus*).* Vol. 1, pl. 14: Sulphur-crested Cockatoo (*Cacatua galerita*).* ▪ The illustrations for *Planches enluminées . . .* were originally intended to be used in a special ten-volume issue of the *Oiseaux* volume of Buffon's first edition of his *Histoire naturelle, générale. . . .* Curiously, even though Buffon was listed as author of the above title, it was actually issued by Edmé-Louis Daubenton. ▪ *Ref: Anker, 76; Balis, 40; Nissen, 78; Zimmer 1:104–6.*

————. *Histoire naturelle . . . redigé par Sonnini.* 127 vols. Vols. 37–64, *Oiseaux,* numbered 1–28 (1800–1801). Paris: Dufart, 1799–1808. Various sizes, largest 8 × 5". ▪ Copperplate etchings from drawings by DeSève and Jacques Barraband. Vol. 63 (27), pl. 246: 1. Gray Parrot (*Psittacus erithacus*); 2. Sulphur-crested Cockatoo (*Cacatua galerita*). DeSève, artist.

————. *Oeuvres complètes. . . .* Rev. ed. by Lapécède. 12 vols. Vols. 9–12, *Oiseaux* (1818). Paris: Rapet, 1817–18. 8¼ × 5½". ▪ Copperplate etchings by Plée from drawings by Jean-Gabriel Prêtre. Vol. 9, p. 189: Short-eared Owl (*Asio flammeus*); Barn Owl (*Tyto alba*); Tawny Owl (*Strix aluco*). ▪ *Ref: Zimmer 1:109.*

————. *Oeuvres complètes . . . de Buffon. . . .* 12 vols. Vols. 5–8, *Oiseaux* (1853). Paris: Garnier, 1853–55. 10¾ × 7½". ▪ Hand-colored etchings. Vol. 5, p. 171: 1. Eagle Owl (*Bubo bubo*); 2. Scops Owl (*Otus scops*); 3. Long-eared Owl (*Asio otus*). ▪ Buffon's influence through the nineteenth century was pervasive; his books went through numerous editions, translations, and adaptations.

CASSIN, JOHN. *Mammalogy and ornithology.* Vol. 8 (with atlas vol.) of United States Navy Dept. (*United States Exploring Expedition . . . 1838.* By Authority of Congress. Philadelphia: C. Sherman & Sons, 1858. 22½ × 14½". ▪ 42 hand-colored steel-engravings of birds by T. House, Dongal, Hinshelwood, and others, from drawings by Titian Ramsey Peale and others. Pl. 16: White-collared Kingfisher (*Halcyon chloris*). Peale, artist.* Pl. 33: Many-colored Fruit Dove (*Ptilinopus perousii*). Peale, artist.* ▪ The birds brought back from the U.S. government-sponsored round-the-world naval voyages led by Charles Wilkes were part of the expedition's total of 4,000 zoological specimens, 50,000 plants, and 2,500 artifacts that were to form the basis of the Smithsonian Institution's collections. ▪ *Ref: Nissen, 90; Zimmer 2:675–76.*

————. *Illustrations of the birds of California, Texas, Oregon, British and Russian America. . . .* Reissue of 1853–56 ed. Philadelphia: Lippincott, 1862. 10½ × 7". ▪ 50 hand-colored lithographs by William Hitchcock from drawings by George White, printed and colored by J. T. Bowen. Pl. 28:

Pinyon Jay (*Gymnorhinus cyanocephala*). ▪ American ornithologist John Cassin intended this study of the birds of the western regions of America as a supplement to Audubon's 1840 octavo edition of *Birds of America.* ▪ *Ref: Anker, 92; Nissen, 89; Zimmer 1:124–25.*

CATESBY, MARK. *The Natural History of Carolina, Florida and the Bahama Islands: containing the figures of Birds, Beasts, Fishes, Serpents, Insects, and Plants . . . Together with their descriptions in English and French. . . .* 2d ed. 2 vols. London: Marsh, 1754. 21¾ × 14½". ▪ 220 hand-colored copperplate etchings by Catesby from his own drawings, 3 by George Ehret. Vol. 1, pl. 28: Brown Thrasher (*Toxostoma rufum*).* Vol. 1, pl. 69: Belted Kingfisher (*Ceryle alcyon*).* ▪ This first important work of American ornithology was originally issued in 1731–43. The 1754 edition was edited by George Edwards who had just published his own great work, *A Natural History of Birds . . . ,* in 1743–51. ▪ *Ref: Anker, 94; Balis, 24; Nissen, 94.*

[CHAPBOOKS, A COLLECTION OF]. *Youth's Natural History of Birds.* Concord, N.H., 1832. 4 × 2½". ▪ Wood engravings. p. 14: Owl. p. 15: Wild Goose. *A History of Birds.* Concord, N.H., 1843. 4½ × 2¾". Wood engravings. pp. 6, 7: Wigeons. *The History of Birds.* Portland, Maine, 186–? 3¾ × 2½". Wood engravings. pp. 14, 15: Falcons. ▪ Chapbooks were tiny-format informational children's texts. The common birds depicted can only be identified generically.

CHERNEL, ISTVAN. *Magyararorszag Madari* (Hungarian ornithology). Budapest, 1899. 11¾ × 8". ▪ Text illus., 40 chromolithographs by Czettel es Deutsche from drawings by Necsy and Julius de Hary. Pl. 23: Chaffinch (*Fringilla coelebs*); Linnet (*Acanthis cannabina*). ▪ Chernel later became editor of *Aquila,* the journal of the Royal Hungarian Institute of Ornithology. ▪ *Ref: Nissen, 101.*

COOPER, JAMES GRAHAM, and GEORGE SUCKLEY. "Zoological report . . . upon the birds collected on the survey." In *The natural history of the Washington Territory . . . Minnesota, Nebraska, Kansas, Oregon, and California. . . .* New York: Ballière Bros., 1860. 12 × 10". ▪ 12 lithographs, some hand-colored, by Bowen & Co. [Col.] pl. 5: Heermann's Gull (*Larus heermanni*).* Pl. 21: Raven (*Corvus corax*). ▪ Several different editions of this report on the 1853–57 survey of the northern Pacific railroad route were issued, and the plates depicting birds were published several times, including in *Birds of North America* (1860). ▪ *Ref: Anker, 106.*

CORY, CHARLES BARNEY. *The birds of Haiti and San Domingo.* Boston: Estes & Lauriat, 1884–85. 11⅞ × 9". ▪ Map, uncolored text figures, 22 hand-colored lithographs from drawings by Cory. Pl. opp. p. 158: Northern Jacana (*Jacana spinosa*). ▪ Only three hundred copies were printed. ▪ *Ref: Nissen, 108; Zimmer 1:138.*

CUVIER, GEORGES. *Le règne animal distribué d'après son organization.* . . . 11 vols. in 22. Vol. 2, *Oiseaux: Atlas* (1836). Paris: Masson, 1836–49(?). 10½ × 6¾″. ▪ 100 hand-colored copperplate engravings by Anhedouche and Guyard from drawings by Edouard Traviès, printed by Rémond. Pl. 12: Eagle Owl (*Bubo bubo*); Tawny Owl (*Strix aluco*). Pl. 31: Common Swift (*Apus apus*); European Nightjar (*Caprimulgus europaeus*). Pl. 54: Ivory-billed Aracari (*Pteroglossus flavirostris*); Keel-billed Toucan (*Ramphastos sulfuratus*). ▪ Baron Cuvier's work, like that of Buffon, was enormously influential and was reissued many times, in many different editions. ▪ *Ref: Anker, 111.*

DANIELL, WILLIAM. *Interesting selections from animated nature with illustrative scenery.* 2 vols. London: Cadell & Davies, 1809. 11 × 15¾″. ▪ 120 monochrome aquatints by Daniell from his own drawings. Vol. 1, pl.: White Cockatoo (*Cacatua alba*).* Vol. 1, pl.: King Penguin (*Aptenodytes patagonicus*).* ▪ Daniell's illustrations for this book had appeared in *Wood's Zoography*, published the previous year.

DARWIN, CHARLES. *The zoology of the voyage of H.M.S. Beagle, under the command of Captain Fitzroy . . . 1832–1836.* Part 3, *Birds* by John Gould. London: Smith, Elder, 1841. 12½ × 9¾″. ▪ 49 hand-colored lithographs by Elizabeth Gould from sketches by J. Gould. Pl. 36: Large Ground Finch (*Geospiza magnirostris*).* ▪ Darwin's theory of evolution was based in part on observations and writings produced during the famous voyage of the *Beagle*, and recorded in this modest but important book. ▪ *Ref: Anker, 173; Balis, 51; Nissen, 207; Zimmer 1:157–58.*

DAVID, ARMAND, and EMILE OUSTALET. *Les oiseaux de la Chine.* 2 vols. Paris: Masson, 1877. 9½ × 6″ (text); 9½ × 6½″ (atlas). ▪ 124 hand-colored lithographs by M. Arnoul, printed by Bequet. Pl. 6: Collared Scops Owl (*Otus bakkamoena*).* Pl. 103: Lady Amherst Pheasant (*Chrysolophus amherstiae*).* ▪ Considered the first important monograph written on this subject, the work describes 807 species of birds, 249 of which are unique to China. ▪ *Ref: Anker, 113; Balis, 70; Nissen, 116; Zimmer 1:159.*

DESCOURTILZ, JEAN T. *Ornithologie Brésilienne ou Histoire des oiseaux du Brésil.* . . . Rio de Janeiro: Thomas Reeves, 1854–56 (c. 1852). 24 × 18½″. ▪ 12 chromolithographs by Waterlow & Sons, London, from drawings by Descourtilz. Pl. 10: 1. Blue-throated Conure (*Pyrrhura cruentata*); 2. Canary-winged Parakeet (*Brotogeris versicolorus*); 3. Golden Conure (*Aratinga guarouba*); 4. Golden-capped Conure (*A. auricapilla*). ▪ There are only twelve plates in this copy, although citations list forty-eight. ▪ *Ref: Nissen, 122; Zimmer 1:166.*

DESMAREST, ANSELM-GAETAN. *Histoire naturelle des tangaras, des manakins et des todiers.* Paris: Garnery & Del-achausée, 1805–7. 21½ × 14¼″. ▪ 72 etchings, partly hand-colored, partly color-printed by Gremilliet from drawings by Mme Knip (Pauline de Courcelles). Pl. 35: Scarlet Tanager (*Piranga olivacea*). ▪ Mme Knip, a pupil of Jacques Barraband's, went on to illustrate other important works such as a monograph on the pigeons. ▪ *Ref: Anker, 116; Nissen, 123.*

DONOVAN, EDWARD. *The Natural History of British Birds.* . . . 10 vols. in 5. London, 1794–1819. 10 × 5½″. ▪ 224 hand-colored engravings, with etching, by Donovan from his own drawings. Vol. 3/4, pl. 68: Great Crested Grebe (*Podiceps cristatus*).* Vol. 5/6, pl. 129: Northern Pintail (*Anas acuta*).* ▪ An important early English ornithology whose plates are distinguished for their coloring, rather than their scientific value. ▪ *Ref: Nissen, 133; Zimmer 1:175.*

EDWARDS, GEORGE. *A natural history of birds . . . (with) Gleanings of natural history.* . . . 7 vols. in 6. London, 1802–6. 18 × 11½″. ▪ 362 hand-colored copperplate etchings by Edwards from his own drawings, originally publ. in 1743–64 and 1758–64 eds. Vol. 3, pl. 135: Great Blue Heron (*Ardea herodias*).* Vol. 7, pl. 294: Dodo (*Raphus cucullatus*).* ▪ Outstanding both for its detailed and accurate text and for the high quality of the illustrations. Many birds, including American species, were shown for the first time. ▪ *Ref: Anker, 124, 126; Zimmer 1:201–3.*

ELLIOT, DANIEL GIRAUD. *A monograph of the Phasianidae or family of the pheasants.* 6 parts. New York, 1870–72. 24¾ × 19½″. ▪ 2 uncolored and 79 hand-colored lithographs by Josef Wolf and J. Smit, and J. Wolf and J. G. Keulemans, printed by M. & N. Hanhart, and P. W. M. Trap. Pl. 13 bis: Elliot's Pheasant (*Syrmaticus ellioti*). Wolf and Smit, artists.* Pl. 17: Hybrid pheasant (*Chrysolophus pictus × C. amherstiae*). Wolf and Smit, artists.* ▪ *Ref: Anker, 130; Nissen, 156; Zimmer 1:206.*

———. *A monograph of the Paradisaeidae or birds of paradise.* London, 1873. 23⅞ × 18½″. ▪ 1 uncolored and 36 hand-colored lithographs by J. Smit from drawings by Josef Wolf, printed by M. & N. Hanhart. Pl. 19: Black Sickle-bill Bird of Paradise (*Epimachus fastuosus*). ▪ Josef Wolf created some of his best bird portraits for this sumptuous album, whose publication was made possible by the wealthy and generous D. G. Elliot. Elliot also produced other extravagantly illustrated studies on the hornbills, the pittas, and the grouses. ▪ *Ref: Anker, 131; Nissen, 157; Zimmer 1:207.*

Encyclopédie methodique. . . . 196(?) vols. Vols. 123–31, *Oiseaux* by J. P. E. Mauduyt de la Varenne (1823). Paris, 1774–1832(?). 11¾ × 8¾″. ▪ 240 copperplate etchings by Barrois, Pierron, Cornu, and others from drawings by Bénard and Jean-Gabriel DeSève. Vol. 131, pl. 240: Rhinoceros Hornbill (*Buceros rhinoceros*); Great Hornbill (*B. bicornis*);

Crowned Hornbill (*Tockus alboterminatus*); Rufous Motmot (*Baryphthengus ruficapillus*). ▪ Bird volumes from one of the gargantuan eighteenth-century encyclopedias. Anker lists the first edition as 196 volumes, published 1782–1812. ▪ *Ref: Anker, 134; Nissen, 162.*

Encyclopédie, ou dictionnaire raisonné . . . par Diderot. . . . 28 vols. *Recueil de planches,* vol. 6, *Histoire naturelle* (1768). Paris: Briasson, 1751–77. 17 × 11″. ▪ 22 copperplate etchings by François Martinet from his own drawings, printed by Bénard. Pl. 31: 1. Helmeted Guineafowl (*Numida meleagris*); 2. Blue Crowned Pigeon (*Goura cristata*); 3. Hocco ?; 4. Purple Swamphen (*Porphyrio porphyrio*). ▪ The best known of the great eighteenth-century encyclopedias. Martinet arranged his illustrations according to the classification system devised by Brisson for his *Ornithologia.* . . . ▪ *Ref: Anker, 132–33.*

EYTON, THOMAS C. *A monograph on the Anatidae, or duck tribe.* London: Longman, 1838. 11¾ × 9″. ▪ Wood-engraved text illus., 30 lithographs (6 hand-colored) by G. Scharf from drawings by E. Lear, Eyton, and Scharf, printed by Hullmandel. Pl. 19: Paradise Shelduck (*Tadorna variegata*). Lear, artist.* ▪ *Ref: Anker, 139; Nissen, 163; Zimmer 1:214.*

FORBES, JAMES. *Oriental memoirs . . . written during seventeen years residence in India.* . . . 2 vols. London: White, Cochrane, 1813. 11½ × 9½″. ▪ Aquatints, engravings, and hand-colored lithographs by J. Forbes, W. Hooker, and others. 9 plates depict birds. Vol. 1, following p. 53: Baya Weaver (*Ploceus philippinus*).* Vol. 1, following p. 53: Red-vented Bulbul (*Pycnonotus cafer*).* ▪ Forbes's memoir includes two lithographs, which are probably the first illustrations of birds in this medium. ▪ *Ref: Anker, 148.*

FRANCE. COMMISSION DES MONUMENTS D'EGYPTE. *Description de L'Egypte, ou recueil des observations . . . publié par les Ordres de sa Majesté L'Empereur Napoléon.* . . . 21 vols. in 19. Vol. 1 of 2 vols., *Histoire naturelle: Atlas.* (1809). Paris: Imprimerie Impériale, 1809–28. 27 × 20″. ▪ 14 copperplate engravings of birds by Bouquet from drawings by Jacques Barraband, Henri-Joseph Redouté, and Jean-Gabriel Prêtre. Pl. 12: Imperial Eagle (*Aquila heliaca*). Barraband, artist (unsigned). ▪ Savigny's monograph on the ibis (1805) was written as part of the ornithological text for *Description.* . . . ▪ *Ref: Anker, 438; Nissen, 431; Zimmer 2:549–50.*

GESNER, CONRAD. *Historiae animalium.* 5 vols. in 3. *Liber III qui est de avium* (1555). Zurich, 1551–87. 14¾ × 9¾″. ▪ Woodcuts from drawings principally by Lukas Schan. p. 742: Short-eared Owl (*Asio flammeus*).* P. 743: Hoopoe (*Upupa epops*). ▪ One of the three great ornithological works of the sixteenth century. ▪ *Ref: Balis, 10; Nissen, 178.*

GOSSE, PHILIP HENRY. *Popular British ornithology.* . . . 2d ed. London, 1853. 6½ × 5″. ▪ 20 hand-colored lithographs by Gosse. Pl. 1: Chaffinch (*Fringilla coelebs*); Yellowhammer (*Emberiza citrinella*); Snow Bunting (*Plectrophenax nivalis*); Skylark (*Alauda arvensis*). ▪ Charmingly illustrated popular work, arranged by the months of the year. ▪ *Ref: Nissen, 190.*

GOULD, JOHN. *A century of birds from the Himalaya Mountains.* London, 1831–32. 20½ × 14¼″. ▪ 90 hand-colored lithographs by Elizabeth Gould, printed by Hullmandel. Pl. 39: Black-throated Jay (*Garrulus lanceolatus*). ▪ As an artist, Elizabeth Gould was one of John Gould's first collaborators; she worked from his sketches. *Century.* . . . was the first in a series of beautifully illustrated large-plate bird books that Gould published. ▪ *Ref: Anker, 168; Nissen, 191; Zimmer 1:251.*

———. *The birds of Europe.* 5 vols. London, 1832–37. 21¼ × 14¼″. ▪ 448 hand-colored lithographs by Elizabeth Gould from sketches by John Gould, and Edward Lear, printed by C. Hullmandel. Vol. 4, pl. 285: Maguari Stork (*Euxenura maguari*). Lear, artist.* Vol. 4, pl. 287: Greater Flamingo (*Phoenicopterus ruber*). Lear, artist.* ▪ Like virtually all of Gould's publications, this work was issued in parts over a number of years. ▪ *Ref: Anker, 169; Nissen, 192; Zimmer 1:251–52.*

———. *A monograph of the Trogonidae, or family of trogons.* London, 1836–38. 21½ × 14½″. ▪ 36 hand-colored lithographs by John and Elizabeth Gould, and Edward Lear, printed by Hullmandel. Pl. 2: Mountain Trogon (*Trogon mexicanus*). J. and E. Gould, artists. ▪ Twelve of the thirty-four species described and illustrated were previously unknown. A revised and enlarged edition was issued in 1858–75. ▪ *Ref: Anker, 171; Nissen, 196.*

———. *The birds of Australia.* 7 vols. London, 1840–48. 22¾ × 15″. ▪ 600 hand-colored lithographs by John Gould and H. C. Richter, and J. and E. Gould, from drawings by Gould and Richter, and John and Elizabeth Gould, printed by C. Hullmandel, and Hullmandel & Walton. Vol. 3, pl. 14: Superb Lyrebird (*Menura superba*). J. and E. Gould, artists.* Vol. 4, pl. 8: Spotted Bowerbird (*Chlamydera maculata*). J. and E. Gould, artists.* ▪ This was the last work that John Gould's wife, Elizabeth, helped illustrate.

———. *A monograph of the Odontophorinae, or partridges of America.* London, 1844–50. 22¼ × 14¾″. ▪ 32 hand-colored lithographs by John Gould and H. C. Richter, printed by Hullmandel and Walton, and C. Hullmandel. Pl. 12: Crested Bobwhite (*Colinus cristatus*).* Pl. 8: Ocellated Quail (*Cyrtonyx ocellatus*).* ▪ One of five monographs issued by Gould devoted to a single bird group or family. The others describe

and depict the trogons, toucans, pittas, and hummingbirds. ▪ *Ref: Anker, 176; Nissen, 201; Zimmer 1:257.*

———. *The birds of Great Britain.* 5 vols. London, 1862–73. 21¾ × 14¼″. ▪ 367 hand-colored lithographs by William Hart, H. C. Richter, and Josef Wolf from drawings by Hart, Richter, J. Gould, and Wolf, printed by Walter. Vol. 1, pl. 13: Gyrfalcon (*Falco rusticolus*). Wolf, Hart, artists.* Vol. 1, pl. 19: Merlin (*Falco columbarius*). Wolf, Richter, artists.* ▪ *Ref: Nissen, 203; Zimmer 1:261.*

———, and RICHARD BOWDLER SHARPE. *The birds of Asia.* 7 vols. London, 1850–83. 22¼ × 15½″. ▪ 530 hand-colored lithographs by John Gould and William Hart, Gould and H. C. Richter, Richter and Josef Wolf, and W. Hart, printed by Hullmandel and Walton, T. Walter, and Walter and Cohn. Vol. 5, pl. 65: Fairy Pitta (*Pitta nympha*). Gould and Hart, artists.* ▪ Gould did not live to see the completion of this enormous work, nor that of the later *Birds of New Guinea . . . ,* which he had also begun. Both were completed by R. Bowdler Sharpe. ▪ *Ref: Anker, 178; Nissen, 202; Zimmer 1:256–58.*

———. *The birds of New Guinea and the adjacent Papuan Islands. . . .* 6 vols. London, 1875–88. 22 × 15″. ▪ 320 hand-colored lithographs by William Hart, and J. Gould and William Hart, printed by Walter, and Mintern Bros. Vol. 5, pl.: Goldie's Bird of Paradise (*Paradisaea decora*). Hart, artist. Vol. 6, pl. 39: Striped Gardener Bowerbird (*Amblyornis subularis*). Hart, artist. ▪ Among them, John Gould and his artists left a combined legacy of 2,999 hand-colored lithographed plates in his many published works. ▪ *Ref: Anker, 181; Nissen, 204; Zimmer 1:262.*

GRAY, GEORGE ROBERT. *The genera of birds. . . .* 3 vols. London: Longmans, 1849. 15⅞ × 11¾″. ▪ Uncolored lithographs, lithotint, and hand-colored lithographs by David William Mitchell, Josef Wolf, and Edward Lear, printed by Hullmandel. Vol. 2, pl. 99: Rufous-necked Hornbill (*Aceros nipalensis*).* Vol. 2, pl. 100: Citron-throated Toucan (*Ramphastos citreolaemus*).* ▪ *Ref: Nissen, 211; Zimmer 1:268.*

GREENE, WILLIAM THOMAS. *Parrots in captivity.* Vols. 1 and 2 of 3. London: G. Bell, 1884–87. 10 × 7″. ▪ 81 chromolithographs, retouched by hand, by Benjamin Fawcett from drawings by Alexander F. Lydon. Vol. 1, pl. opp. p. 125: Red-faced Lovebird (*Agapornis pullaria*). Vol. 2, pl. opp. p. 8: Yellow Roselle (*Platycercus flaviolus*). ▪ A rare monograph on parrots. Fawcett and his pupil Lydon were better known for their work in wood engraving. ▪ *Ref: Nissen, 215; Zimmer 1:274.*

HAHN, KARL WILHELM, and HEINRICH C. KÜSTER. *Die Vögel aus Asien, Africa, America und Neu-Holland in Abbildungen nach der Natur. . . .* Nuremburg, 1818–23. 10½ × 8¼″. ▪ 85 hand-colored lithographs by K. W. Hahn and H. C. Küster. Fasc. 4, pl. 1: Red-throated Caracara (*Daptrius americanus*).

▪ The early sections were Hahn's work, while Küster prepared the final two. Although Nissen describes the art in this and other Hahn works as copperplate engravings, this book actually consists of hand-colored lithography. ▪ *Ref: Nissen, 218; Zimmer 1:281.*

HORSFIELD, THOMAS. *Zoological researches in Java and the neighboring islands.* London: Kingsbury, 1821–24. 11½ × 9″. ▪ 74 plates, including copperplate engravings by William Taylor and hand-colored lithographs by August Pelletier from drawings by John Curtis. Pl.: Bronze-winged Jacana (*Metopidius indicus*). ▪ The first book about birds by an American to contain lithographs. Horsfield wrote an impressive number of natural history studies based on discoveries made during his frequent travels. ▪ *Ref: Anker, 212.*

JARDINE, WILLIAM. *The Natural history of humming-birds.* 2 vols. The Naturalist's Library. Edinburgh: Lizars, 1833–34. 6¾ × 4″. ▪ 64 hand-colored steel-plate etchings by William Lizars from drawings by Jardine, with 2 engraved ports. and text illus. Vol. 1, pl. 21: Horned Sungem (*Heliactin cornuta*). Vol. 2, pl. 12: Dot-eared Coquette (*Lophornis gouldii*). ▪ A small format, low price, and fine illustrations were important factors in the immense popularity of the series, which was reissued several times. ▪ *Ref: Anker, 223–24; Nissen, 252; Zimmer 1:324–27, 329–32.*

———. *The Natural history of game-birds.* 2 vols. The Naturalist's Library. Edinburgh: Lizars, 1834. 6¾ × 4″. ▪ 30 hand-colored steel-plate etchings by William Lizars from drawings by Prideaux J. Selby and James Stewart, with engraved port. and text illus. Pl. 21: Black Grouse (*Lyrurus tetrix*). Selby, artist. Reprint, 1845. (Naturalist's Library.) 1 additional colored illus. Pl. 19: Rock Ptarmigan (*Lagopus mutus*). Selby, artist. ▪ *Ref: Anker, 224–26; Nissen, 252; Zimmer 1:324–28, 330–31.*

———. *Birds of Great Britain and Ireland.* 4 vols. Vol. 4, *Rasores and Grallatores.* The Naturalist's Library. Edinburgh: Lizars, 1842. 6¾ × 4½″. ▪ 34 hand-colored steel-plate etchings by William Lizars from drawings by James Stewart, with engraved port. and text illus. Pl. 8: White Spoonbill (*Platalea leucorodia*). ▪ *Ref: Anker, 224, 227; Nissen, 252; Zimmer 1:324–28, 330–31.*

———. *Birds of Great Britain and Ireland.* Vol. 3, *Natatores.* The Naturalist's Library. Edinburgh: Lizars, 1860. 6½ × 4¼″. ▪ 31 hand-colored steel-plate etchings by William Lizars from drawings by James Stewart, with engraved ports. and text illus. Pl. 10: Red-breasted Merganser (*Mergus serrator*).* ▪ This volume includes a table of all the naturalists whose portraits and biographies appear in the forty-volume Naturalist's Library series. ▪ *Ref: Anker, 224, 227; Nissen, 252; Zimmer 1:324–28, 330–31.*

JONSTON, JOHN. *Historia naturalis de avibus.* . . . Frankfort, 1650–62(?). 14 × 8½". ▪ 62 copperplate engravings by Matthaus Merian. Pl. 55: 5 Birds of Paradise (*fam. Paradisaeidae*); imaginary Bird of Paradise.* ▪ John or Johannis Jonston based much of his writings not on personal observation, but on the earlier work of Aldrovandi and especially Gesner, and perpetuated many of the myths about such monsters as griffins and harpies that they had recorded. Jonston's work was immensely popular; Matthaus Merian's engravings had been based on woodcuts found in previously published books. ▪ *Ref: Anker, 234; Balis, 12; Nissen, 260; Zimmer 1:341–42.*

KITTLITZ, FRIEDRICH HEINRICH, FREIHERR VON. *Über Einige Vögel von Chili.* St. Petersburg, 1830–34. 10½ × 8½". ▪ 17 hand-colored, partly colored, and uncolored engravings. Pl. 1: Chilean Plantcutter (*Phytotoma rara*). ▪ Early, little-known study of the birds of Chile, unusual because of its Russian imprint. Kittlitz traveled extensively and published additional works on the natural history of the Pacific islands and the coasts of Alaska.

KÖRNER, MAGNUS PETER. *Skandinaviska föglar. Tecknade efter naturen.* . . . Lund, 1839–46. 9½ × 7½". ▪ 62 hand-colored lithographs by Körner, printed by Körner. Pl. 57: Goosander (*Mergus merganser*); King Eider (*Somateria spectabilis*).* ▪ M. P. Körner, who held the post of artist at the University of Lund, described 270 species of birds found in Scandinavia in this important regional study, which was issued in ten parts. ▪ *Ref: Anker, 271; Nissen, 286.*

LATHAM, JOHN. *A general history of birds.* 10 vols. Winchester, 1821–28. 11 × 8¼". 2d ed. of *A general synopsis of birds.* 3 vols. in 6. 1781–85. ▪ 193 hand-colored copperplate etchings by Latham from his own drawings, mostly from the 1781–85 ed. Vol. 3, pl. 47: Arfak Astrapia (*Astrapia nigra*). Vol. 7, pl. 110: New Zealand Tit (*Petroica macrocephala*).* ▪ Latham's final English-language edition of his ornithological writings and illustrations, including the *General synopsis* . . . of 1781, various supplements, and the *Index Ornithologicus* . . . of 1790. German translations also were issued during this period. ▪ *Ref: Anker, 277, 279; Nissen, 290; Zimmer 2:376–77.*

LATHAM, SYMON. *Latham's Faulconry; or The Faulcons Lure and Cure . . . with Latham's New and Second Book of Faulconry.* . . . 2 vols. in 1. London: Thomas Harper, 1633. 7¼ × 5¼". ▪ Woodcut vignettes. p. 30: probably Goshawk (*Accipiter gentilis*). ▪ The subtitle describes the scope of this early and still authoritative manual: ". . . ordering and training up of all Hawks . . . teaching approved Medicines for the cure of all Diseases in them . . . published for the delight of noble mindes and instruction of young Faulconers in things pertaining to this princely art. . . ."

LAYARD, EDGAR LEOPOLD, and RICHARD BOWDLER SHARPE. *The birds of South Africa.* Rev. ed. London: Quaritch, 1875–84. 10 × 6¼". ▪ 12 hand-colored lithographs by John Gerrard Keulemans. Pl. 6: Rufous Rockjumper (*Chaetops frenatus*). ▪ Sharpe revised and added material to Layard's work, which originally appeared in 1867. This new edition described 812 species. ▪ *Ref: Anker, 281; Zimmer 2:378.*

LEAR, EDWARD. *Illustrations of the family of Psittacidae, or parrots.* . . . London, 1830–32. 21½ × 14". ▪ 42 hand-colored lithographs by Edward Lear, printed by Hullmandel. Pl.: Blue and Yellow Macaw (*Ara ararauna*).* ▪ Lear's . . . *Parrots,* drawn from live models, is one of the great ornithological works. ▪ *Ref: Anker, 283; Nissen, 293; Zimmer 2:380, 381.*

LEMBEYE, JUAN. *Aves de la isla de Cuba.* Havana: Imperanta del tiempo, 1850. 10¼ × 7". ▪ 1 uncolored and 19 hand-colored lithographs by L. Marquier from drawings by Lauro Ferrod. Pl. 2: Osprey (*Pandion haliaetus*). ▪ An early record of the ornithology of Cuba, and probably the first published there. Ferrod copied Audubon in many of his illustrations, but usually changed the backgrounds. He did not credit his source. ▪ *Ref: Nissen, 296; Zimmer 2:384.*

LESSON, RENÉ PRIMEVÈRE. *Histoire naturelle des oiseaux-mouches.* . . . Paris: Bertrand, 1829–30. 9½ × 6¼". ▪ 86 color-printed and hand-finished copperplate engravings, with etching, by J. L. D. Coutant from drawings by Antoine-Germaine Bévalet, Jean-Gabriel Prêtre, Vautier, and others. Pl. 7: Horned Sungem (*Heliactin cornuta*). Prêtre, artist.* ▪ In contrast to the many large-format illustrated bird books popular at this time in France, Lesson chose to issue his works on hummingbirds and birds of paradise in small sizes, both to make them more affordable, and also because this seemed appropriate for his subject. ▪ *Ref: Anker, 291; Balis, 65; Nissen, 297; Zimmer 2:386–87.*

————. *Histoire naturelle des colibris, suivie d'un supplément à l'histoire naturelle des oiseaux-mouches.* Paris: Bertrand, 1830–32. 9½ × 6½". ▪ 66 color-printed and hand-finished copperplate engravings, with etching, by J. L. D. Coutant and Teillard from drawings by Bévalet and Jean-Gabriel Prêtre. Pl. 2: Crimson Topaz (*Topaza pella*). Prêtre, artist.* ▪ *Ref: Anker, 293; Balis, 66; Nissen, 298; Zimmer 2:388.*

————. *Histoire naturelle des oiseaux de paradis et des épimaques.* . . . 2 vols. Paris: Bertrand, 1834–35. 9½ × 6½". ▪ 43 color-printed and hand-finished copperplate engravings, with etching, by Massard and others from drawings by Jean-Gabriel Prêtre and Paul-Louis Oudart. Pl. 14: Superb Bird of Paradise (*Lophorina superba*). Oudart, artist.* ▪ *Ref: Anker, 296; Balis, 67; Nissen, 300; Zimmer 2:390.*

LEVAILLANT, FRANÇOIS. *Histoire naturelle d'une partie d'oiseaux nouveaux et rares de l'Amerique et des Indes.* . . .

Paris: Dufour, 1801–2. 20 × 18″. ▪ Extra-illustrated edition. 49 uncolored and 49 color-printed and hand-finished copperplate engravings, with etching, by Langlois from drawings by Jacques Barraband (uncredited). Pl. 49: Capuchin Bird (*Perissocephalus tricolor*).* ▪ Levaillant intended this study of new species of birds found in tropical America, chiefly hornbills and cotingas, to form a supplement to his 1796 pioneering study of the birds of Africa. ▪ *Ref: Anker, 300, 301; Balis, 54; Nissen, 309; Zimmer 2:392.*

————. *Histoire naturelle des oiseaux de paradis.* . . . 2 vols. Paris: Denné le Jeune, 1801–6. 22½ × 16½″. ▪ Extra-illustrated edition. 114 uncolored and 114 color-printed and hand-finished copperplate engravings, with etching, by Bouquet, Gremilliet, Pérée, and Langlois from drawings by Jacques Barraband. Vol. 1, pl. 1: Greater Bird of Paradise (*Paradisaea apoda*). Pérée, engr.* Vol. 1, pl. 16: Twelve wired Bird of Paradise (*Seleucidis melanoleuca*). Pérée, engr.* ▪ François Levaillant's illustrated large-plate books devoted to the birds of paradise, the parrots, and the birds of Africa and tropical America are considered among the most beautiful bird books of Napoleonic France. ▪ *Ref: Anker, 304; Balis, 58; Nissen, 311; Zimmer 2:393.*

LEWIN, WILLIAM. *The birds of Great Britain, systematically arranged, accurately engraved, and painted from nature.* . . . 8 vols. in 4. London, 1795–1801. 14 × 10½″. ▪ 336 hand-colored copperplate etchings by Lewin from his own drawings. Vol. 1/2, pl. 22: Merlin (*Falco columbarius*). ▪ Lewin, a self-taught artist and etcher, enlisted the help of his large family in the enormous task of printing and coloring this important early British ornithology. ▪ *Ref: Anker, 306; Nissen, 314; Zimmer 2:395.*

MARSCH [or MARSH], OTHNEIL C. *Odontornithes: A monograph on the extinct toothed birds of North America.* Vol. 7 of United States Engineer Bureau. Professional papers, no. 18. *U.S. geological exploration of the Fortieth Parallel.* Washington, D.C. 1880. 11½ × 8¾″. ▪ 34 lithographs and 40 text wood engravings. Pl. 20: *Hesperornis.* Lith. by E. Crisand from drawing by F. Berger. 17¾ × 23¼″. ▪ Highly technical descriptions and illustrations of the fossil remains of *Hesperornis* and *Odontornithes.* Cited as an example of the outstanding scientific documentation and art issued under the aegis of the U.S. government.

MARSIGLI, LUIGI F. *Danubius Pannonico-Mysicus.* . . . 6 vols. Vol. 5, *Aves.* The Hague, 1726. 23 × 17″. ▪ 74 copperplate engravings and vignettes by J. Houbraken from drawings by Raimondo Manzini. Pl. 3: Gray Heron (*Ardea cinerea*).* Pl. 12: White Spoonbill (*Platalea leucorodia*).* ▪ An ambitious six-volume study of the natural and applied sciences, as well as the geography, of the Danube regions. Count Marsigli used his own extensive collections as his sources, later donating

them to the city of Bologna where they formed the core of the municipal museum. ▪ *Ref: Anker, 326; Nissen, 327.*

MICHELET, JULES. *L'Oiseau.* 14th. ed. Paris: Hachette, 1881. 10½ × 7¾″. ▪ 210 engraved text illustrations by Berweiller, Laplante, and others from drawings by H. Giacomelli. p. 110: Great Northern Diver (*Gavia immer*). p. 111: Frigatebird (*Fregata* sp.). ▪ This extremely popular work went through many editions.

MORRIS, BEVERLY ROBINSON. *British game birds and wildfowl.* 3rd ed. London: Nimmo, 1891. 12¾ × 10″. ▪ 60 hand-colored wood engravings by Benjamin Fawcett, printed by Fawcett. Pl. opp. p. 185: Barnacle Goose (*Branta leucopsis*).* ▪ A popular work reissued several times, from 1855 to 1895. The artist, engraver, and printer, Fawcett, made notable technical advances in the fields of both wood engraving and chromolithography. ▪ *Ref: Anker, 345; Nissen, 351.*

NILSSON, SVEN. *Illuminerade figurer till Skandinaviens fauna.* . . . 2 vols. Lund: Berling, 1832–40. 10½ × 7″. ▪ 200 hand-colored lithographs by Magnus Körner and W. V. Wright, printed by Körner & Co. and Gjothstrom & Magnusson. Vol. 2, pl. 123: Garganey (*Anas querquedula*). Körner, artist. ▪ Important study of the birds and mammals of Scandinavia, whose principal illustrator, Körner, issued his own study of Scandinavian birds in 1839. ▪ *Ref: Anker, 365; Nissen, 396.*

NOZEMAN, CORNELIUS, and MARTINUS HOUTTUYN. *Nederlandsche vogelen.* . . . 5 vols. Amsterdam, 1770–1829. 21¾ × 14¾″. ▪ 255 hand-colored copperplate engravings, with etching, by Christian, Jan Christian, and Jan Sepp from drawings by C. Sepp and J. C. Sepp. Vol. 2, pl. 88: Great Crested Grebe (*Podiceps cristatus*).* Vol. 4, pl. 189: Lapwing (*Vanellus vanellus*).* Vol. 5, pl. 244: Common Peafowl (*Pavo cristatus*).* Vol. 5, pl. 246: Great Northern Diver (*Gavia immer*).* Vol. 5, pl. 250: Whooper Swan (*Cygnus cygnus*).* ▪ The first description of the birds of Holland, which was completed by Martinus Houttuyn after Cornelius Nozeman's death. Complete sets are rare since the publication extended over sixty years. ▪ *Ref: Anker, 369; Balis, 33; Nissen, 371; Zimmer 2:469.*

ORBIGNY, ALCIDE D'. *Voyage dans l'Amérique méridionale.* . . . 9 vols. Vol. 4, *Oiseaux;* Vol. 9, *Atlas zoologique.* Paris: Bertrand, 1826–33. 14½ × 12″. ▪ 67 color-printed and hand-finished copperplate engravings, with etching, by various engravers from drawings by Edouard Traviès. Vol. 9, pl. 62: White-fronted Woodpecker (*Melanerpes cactorum*); Andean Flicker (*Colaptes rupicola*). ▪ Under the auspices of the Musée d'Histoire Naturelle in Paris, the ornithologist Orbigny traveled in South America from 1826 to 1833. Among the many specimens he brought back were eight hundred birds, 332 species of which were discussed in the

ornithological section of his extensive reports. ▪ *Ref: Anker, 382; Nissen, 378.*

PALLAS, PETER SIMON. *Spicilegia zoologica.* . . . Berlin: Lange, 1767–72. 10¼ × 8″. ▪ Copperplate engravings by C. B. Glassbach and I. F. Schuster from drawings by Decker, C. Hiller, Aert Schouman, and others. Fasc. 6, pl. 1: Crested Oropendola (*Psarocolius decumanus*). Schouman, artist.* ▪ Pallas reused earlier published writings in this important work of systematic description, which was subsequently translated into Dutch and German, from the original Latin. ▪ *Ref: Anker, 385.*

PENNANT, THOMAS. *The British zoology.* 4th ed. 4 vols. London: White, 1776–77. 8¾ × 5″. ▪ Copperplate etchings by Peter Mazell and R. Murray from drawings by Desmoulins, G. Edwards, M. Griffith, P. Paillou, S. Parkinson, and others. Vol. 1, pl. 19: Gyrfalcon (*Falco rusticolus*). Peter Paillou, artist.* Vol. 2, pl. 97: Mallard (*Anas platyrhynchos*).* ▪ Even though Pennant was a well-known naturalist, his name was not listed as the author until the fifth edition. ▪ *Ref: Anker, 392; Balis, 41; Nissen, 385; Zimmer 2:487–89.*

PERSIAN BOUNDARY COMMISSION. *Eastern Persia: an account of the journeys of the Persian Boundary Commission.* . . . 2 vols. Vol. 2, *Zoology* . . . by William T. Blandford. London: Macmillan & Co., 1876. 8¾ × 6″. ▪ Text illus., 28 hand-colored lithographs (10 of birds) by Mintern Bros. from drawings by John Gerrard Keulemans. Pl. 14: Purple Sunbird (*Nectarinia asiatica*). ▪ *Ref: Anker, 45.*

PISO, WILLIAM, and GEORGES MARCGRAVE. *Historia naturalis brasiliae auspicio et beneficio illustratis.* . . . 2d ed. Amsterdam, 1658. 16 × 10″. ▪ Woodcuts. p. 200: Wood Stork (*Mycteria americana*).* p. 201: Jabiru (*Jabiru mycteria*). p. 192: 3 birds, unidentifiable.* p. 193: 3 birds, unidentifiable. ▪ Early, and for some time the only, study of the natural history of Brazil, based on explorations in the then Dutch colony in 1637. Its coauthor, Marcgrave, died before publication of the first edition in 1648. ▪ *Ref: Balis, 22; Nissen, 589.*

———. *De indiae utriusque re naturali et medica* . . . by Guilielmus Pisonus, bound with: *Tractatus topographicus et meteorologicus Brasiliae.* . . . by Georgii Marcgravii. Amsterdam: Elzevier, 1658. 14½ × 9½″. ▪ Copperplate engravings from original woodcuts. [Marcgrave] p. 70: Dodo (*Raphus cucullatus*). p. 71: Double-wattled Cassowary (*Casuarius casuarius*). ▪ A variant later edition of the same authors' *Historia naturalis brasiliae* . . . , which itself was reissued under its original title in a second edition, also dated 1658. ▪ *Ref: Balis, 22; Nissen, 589.*

PLESKE, THEODOR D. *Ornithographia Rossica.* St. Petersburg: Eggers, 1889–92. 13 × 9½″. ▪ Text illus., folding tables, 4 hand-colored lithographs by Gustave Mützel, printed by C. Bölm. Pl. 2: Arctic Warbler (*Phylloscopus borealis*); Green

Willow Warbler (*P. nitidus*); Greenish Warbler (*P. trochiloides*); Pale-legged Willow Warbler (*P. tenellipes*); Large-crowned Willow Warbler (*P. occipitalis*).* ▪ The only volume ever published of an ambitious proposed study of the birds of Russia, based on the collections held in the zoological museum of St. Petersburg. The text is in German and Russian. ▪ *Ref: Zimmer 2:493.*

QUOY, JEAN-RENÉ, and JOSEPH-PAUL GAIMARD. *Zoologie du voyage de l'Astrolabe.* . . . Vols. 8–11 (text) and 17–18 (atlas) of: Dumont-D'Urville, Jules S. C. *Voyage de la corvette Astrolabe.* . . . 21 vols. Paris: J. Tastu, 1830–35. Atlas, 21¼ × 14½″. ▪ 31 color-printed and hand-finished copperplate engravings of birds by various engravers from drawings by Jean-Gabriel Prêtre, Alphonse Prévost, and Paul-Louis Oudart. Pl. 13: Papuan Frogmouth (*Podargus papuensis*). Prêtre, artist. ▪ Ornithological reports based on the round-the-world voyage of the *Astrolabe* from 1826 to 1829. ▪ *Ref: Anker, 410; Balis, 49; Nissen, 394; Zimmer 1:184–85.*

RAY, JOHN. *L'Histoire naturelle, éclaircie dans une de ses parties principales, l'Ornithologie.* . . . Translated by François Salerne. Paris: Debure, 1767. 12 × 8½″. Originally pub. as *Synopsis methodica avium* . . . , 1713. ▪ 31 etchings by François Nicholas Martinet from his own drawings. Pl. 5: 1. Eagle Owl (*Bubo bubo*); 2. Tawny Owl (*Strix aluco*); 3. European Nightjar (*Caprimulgus europaeus*).* ▪ A posthumous translation of Ray's description of one hundred species of birds. Together with Francis Willughby, Ray established the foundations of pre-Linnaean zoological and botanical classification in the seventeenth century. ▪ *Ref: Anker, 414; Balis, 32; Nissen, 397; Zimmer 2:501–2.*

RICHARDSON, JOHN. *Fauna Boreali-Americana; or the zoology of the northern parts of British America.* . . . 4 vols. Vol. 2, *Birds*, by William Swainson and Richardson. London: John Murray, 1829–37. 10¾ × 8½″. ▪ Text illus., 50 hand-colored lithographs by William Swainson. Pl. 30: Great Horned Owl (*Bubo virginianus*).* Pl. 34: Great Gray Shrike (*Lanius excubitor*). ▪ Among the 238 species of birds described in this study were many new to science. The British government gave a grant toward its publication, making this the first zoological work to be sponsored in this manner. ▪ *Ref: Anker, 493; Zimmer 2:520–21.*

RIESENTHAL, OSKAR VON. *Die Raubvögel Deutschlands und des angrenzenden Mittel-Europas.* . . . 2d ed. Cassell: Fischer, 1894. 16 × 12″. ▪ 60 chromolithographs by Thedor Fischer from paintings by Riesenthal. Pl. 19: Gyrfalcon (*Falco rusticolus*).* ▪ Descriptions and illustrations of birds of prey, including owls, of Germany and neighboring countries. ▪ *Ref: Anker, 422; Nissen, 407; Zimmer 2:525–26.*

RUSS, KARL. *Voegel der Heimat.* Vienna, 1886–87. 9½ × 6″. ▪ 40 chromolithographs by August. Pl. 26: a. Goldfinch (*Car-*

duelis carduelis); b. Siskin (*C. spinus*); c. Serin (*Serinus serinus*). ▪ Little-known study of the birds of Germany. Russ also wrote on German breeds of poultry, and cage birds. ▪ *Ref: Nissen, 426.*

SAGRA, RAMON DE LA. *Histoire physique, politique et naturelle de l'Île de Cuba.* 20 vols. in 17. Vol. 3, *Ornithologie* (text, atlas) by Alcide d'Orbigny; (atlas, 1839–40). Paris: Bertrand, 1839–61. 16 × 11″. ▪ 33 hand-colored copperplate engravings with etching from drawings by Edouard Traviès and Jean-Gabriel Prêtre. Pl. 23: West Indian Red-bellied Woodpecker (white var.) (*Melanerpes superciliaris*). Traviès, artist.* Pl. 30: Wood Duck (*Aix sponsa*). Traviès, artist.* ▪ Sagra brought many zoological specimens back to Paris from his travels in Cuba. As an associate of Paris's Musée d'Histoire Naturelle, Alcide d'Orbigny also wrote the bird sections of Baron Cuvier's monumental *Règne animal . . .* of 1836–49. ▪ *Ref: Anker, 383; Nissen, 379; Zimmer 2:538–39.*

SALVIN, OSBERT, and FREDERICK DU CANE GODMAN, eds. *Biologia Centrali-Americana.* 59 vols. Vols. 3–6, *Aves* (1879–1904). London: Porter, 1879–1915. 12¼ × 10″. ▪ 84 hand-colored lithographs by M. and N. Hanhart, and Mintern Bros. from drawings by John Gerrard Keulemans and Edward Neale. Vol. 6, pl. 33: Orange Oriole (*Icterus auratus*); Streak-backed Oriole (*I. pustulatus*). Keulemans, artist. ▪ Salvin died before the completion of the bird volumes of this enormous work. Godman, assisted by others, completed the study of over 1,100 species. ▪ *Ref: Anker, 437; Nissen, 184; Zimmer 2:541–42.*

SAVIGNY, JULES-CÉSAR. *Histoire naturelle et mythologique de l'ibis.* Paris: Allais, 1805. 8¾ × 5¼″. ▪ 6 copperplate engravings with etching by Bouquet from drawings by Henri-Joseph Redouté and Jacques Barraband, printed by Perroneau. Pl. 4: Glossy Ibis (*Plegadis falcinellus*). ▪ The first illustrated monograph on the ibis, based on Savigny's travels with the Napoleonic expeditions, 1798–1801. It was later included with the ornithology portion of the complete report, 1809–28. ▪ *Ref: Nissen, 432.*

SCHAEFFER, JACOB CHRISTIAN. *Elementa ornithologica iconibus vivis coloribus espressis illustrata.* 2d ed. Regensburg, 1779. 11 × 9″. ▪ 70 hand-colored engravings by Jacob Eisenmann, Johann Friedrich, Andreas Hoffer, and Sebastian Leitner from drawings by John Joseph Rothermundt. Pl. 38: Domestic Fowl (*Gallus domesticus*). ▪ Schaeffer describes birds then known in Germany, with Latin text and Latin, French, and German nomenclature. A detail of each bird's tongue is included for further ornithological information. ▪ *Ref: Anker, 439; Nissen, 433; Zimmer 2:550.*

SCHINZ, HEINRICH RUDOLF. *Naturgeschichte und Abbildungen der Vögel-Gattungen. . . .* 24 parts. Zurich: Brodtmann,

1830. 14½ × 10¼″. ▪ 144 hand-colored lithographs by K. J. Brodtmann after Susemihl, Audebert, Lesson, and others. Pl. 14: 1. Abyssinian Ground Hornbill (*Bucorvus abyssinicus*); 2. White-headed Hornbill (*Aceros leucocephalus*); 3. Celebes Hornbill (*Aceros cassidix*); 4. Rufous Hornbill (*Buceros hydrocorax*). Pl. 34: 1. Wire-tailed Manakin (*Pipra filicauda*); 2. Striped Manakin (*Machaeropterus regulus*); 3. Lesser Green Broadbill (*Calyptomena viridis*); 4. Guianan Cock-of-the-Rock (*Rupicola rupicola*). Pl. 87: 1. Owlet-Nightjar (*Aegotheles cristatus*); 2. Grand Potoo (*Nyctibius grandis*); 3. Javan Frogmouth (*Batrachostomus javensis*); 4. Oilbird (*Steatornis caripensis*). ▪ This illustrated treatise used the plates from many well-known bird books as models. The sources are credited in the text. ▪ *Ref: Nissen, 435.*

SCLATER, PHILIP LUTLEY, and OSBERT SALVIN. *Exotic ornithology. . . .* London: Quaritch, 1866–69. 21½ × 14″. ▪ 100 hand-colored lithographs by Joseph Smit, printed by M. and N. Hanhart. Pl. 15: Andean Cock-of-the-Rock (*Rupicola peruviana*).* Pl. 24: Streak-backed Oriole (*Icterus pustulatus*). Pl. 66: Sharpbill (*Oxyruncus cristatus*). ▪ *Ref: Anker, 450; Nissen, 447; Zimmer 2:560–61.*

SEBA, ALBERT. *Locupletissimi rerum naturalium thesauri. . . .* 4 vols. Amsterdam: Janssonius, 1734–65. 22 × 14½″. ▪ 449 copperplate etchings. Vol. 1, pl. 63: Greater Bird of Paradise (*Paradisaea apoda*); Flowerpecker? (*Dicaeidae?*); probably Common Kingfisher (*Alcedo atthis*).* ▪ Dutch apothecary Albert Seba enlisted the aid of artists and writers in the production of the book. ▪ *Ref: Anker, 454; Balis, 43.*

SHARPE, RICHARD BOWDLER, and CLAUDE W. WYATT. *A monograph of the Hirundinidae, or family of swallows.* 2 vols. London: Sotheran, 1885–94. 12½ × 10½″. ▪ 103 hand-colored lithographs by C. W. Wyatt, printed by Mintern Bros. Vol. 1, pl.: (American) Barn Swallow (*Hirundo rustica*).* Vol. 1, pl.: (Eastern) Barn Swallow (*Hirundo rustica*). ▪ Each species of swallow is shown in its habitat. This travelogue of birds and regions includes a Japanese temple, an American log cabin, the Fort at Agra, and an Australian plain complete with kangaroos. ▪ *Ref: Nissen, 463; Zimmer 2:578–79.*

SHELLEY, GEORGE ERNEST. *A monograph of the Nectariniidae, or family of sun-birds.* London, 1876–80. 14½ × 12″. ▪ 121 hand-colored lithographs by John Gerrard Keulemans, printed by M. and N. Hanhart. Pl. 53: Yellow-bellied Sunbird (*Nectarinia jugularis*).* ▪ Still the authoritative work on this bird family, in which the author describes nearly 140 of its members. Only 250 copies were issued. ▪ *Ref: Nissen, 466; Zimmer 2:588.*

SIEBOLD, PHILIPP FRANZ VON, COENRAAD JACOB TEMMINCK, and HERMANN SCHLEGEL. *Fauna Japonica. . . .* 5 vols. Vol. 5, *Aves* (1844–50). Leyden, 1833–50. 15⅞ × 12″. ▪ 120

hand-colored lithographs by Josef Wolf and H. Schlegel(?). Pl. 71: Japanese Crested Ibis (*Nipponia nippon*).* ▪ The first great Western study of the fauna of Japan. Twenty of the illustrations are signed by Wolf; the balance are unsigned. ▪ *Ref: Anker, 504; Balis, 76; Nissen, 469; Zimmer 1:356–58, 2:625–26, 628.*

SONNERAT, PIERRE. *Voyage aux Indes Orientales et à la Chine....* 2 vols. Paris: Dentu, 1782. 10½ × 8½″. ▪ Copperplate engravings, principally by Avril, from drawings by Sonnerat. Vol. 2, pl. 94: Wild Fowl (*Gallus gallus*). ▪ Sonnerat made this journey to the Far East under the sponsorship of King Louis XVI. The work was issued in an expanded edition in 1806 and also appeared in German translation. Sonnerat has been accused of presenting others' work as his own, as evidenced by his 1776 book *Voyage à la Nouvelle Guinée*...—not only did he depict a penguin as an inhabitant of the region, which it is not, but Sonnerat never even traveled to New Guinea. ▪ *Ref: Anker, 478; Nissen, 473; Zimmer 2:597.*

STRICKLAND, HUGH EDWIN, and ALEXANDER GORDON MELVILLE. *The Dodo and its kindred....* London: Reeve, Benham and Reeve, 1848. 12½ × 10″. ▪ 18 plates consisting of lithographs and anastatic printing by various artists. Pl. 3: Dodo (*Raphus cucullatus*). Strickland, artist. ▪ This exhaustive monograph discusses the Dodo, Solitaire, and other extinct birds of Mauritius, Rodriguez, and Bourbon islands. Strickland invented the process of papyrography, which is basically an offshoot of lithography; very little use was subsequently made of it. ▪ *Ref: Anker, 486; Zimmer 2:606.*

STUDER, JACOB HENRY. *The birds of North America.* New York, 1881. 15 × 11½″. ▪ 119 chromolithographs by Theodore Jasper. Pl. 29: Passenger Pigeon (*Ectopistes migratorius*). ▪ This popular work, which describes and pictures some seven hundred species, was reissued several times. ▪ *Ref: Nissen, 482; Zimmer 1:334.*

STURT, CHARLES. *Two expeditions into the interior of southern Australia....* 2d ed. 2 vols. London: Smith, Elder, 1834. 9⅛ × 5¾″. ▪ Maps, 7 uncolored lithographs, and 4 hand-colored lithographs of birds. Vol. 2, pl. opp. p. 219: Gray-crowned Babbler (*Pomatostomus temporalis*); White-browed Babbler (*P. superciliosus*). ▪ Little-known study of the natural resources of the then Colony of New South Wales.

SWAINSON, WILLIAM. *The natural arrangement and relations of the family of flycatchers.* The Naturalist's Library, edited by William Jardine. Edinburgh: Lizars, 1838. 6¾ × 4¼″. ▪ 33 hand-colored steel-plate etchings by William Lizars from drawings by Swainson, with engraved port. and text illus. Another ed., 1843. (Naturalist's Library.) Pl. 16: Rufous-crowned Tody-tyrant (*Poecilotriccus ruficeps*). ▪ *Ref: Anker, 224; Nissen, 492; Zimmer 1:324–27, 330–31, 2:615.*

———. *A selection of the birds of Brazil and Mexico.* London: H. Bohn, 1841. 9⅜ × 6″. ▪ 78 hand-colored lithographs by Swainson. Pl. 55: Slaty Bristlefront (*Merulaxis ater*). ▪ Revised edition of Swainson's 1834–36 *Ornithological drawings, being figures of the rarer and most interesting birds of Brazil....* ▪ *Ref: Anker, 494; Nissen, 490; Zimmer 2:615–17.*

TEMMINCK, COENRAAD JACOB, and MME KNIP (PAULINE DE COURCELLES). *Les pigeons....* 2d ed. 2 vols. Paris, 1838–43. 21½ × 14¼″. ▪ 146 plates, most color-printed and hand-finished copperplate engravings, with etching, by César Macret, Dequevauviller, and Guyard; the balance, hand-colored lithographs by Bineteau, all from the drawings by Mme Knip. Vol. 1, pl. 12: Rock Dove (*Columba livia*). ▪ The partnership between the author, Temminck, and the artist, Mme Knip, ended in acrimony, and depending upon the sympathies of the bibliographer, either Temminck *or* Knip is listed as the author in numerous sources. The illustrations in the first volume are all engravings; lithography was used in the second volume. ▪ *Ref: Anker, 261; Balis, 72; Nissen, 505; Zimmer 2:625, 626.*

———, and M. LAUGIER DE CHARTROUSE. *Nouveau recueil de planches coloriées d'oiseaux....* 5 vols. Paris: Levrault, 1820–39. 13¾ × 10″. ▪ 600 hand-colored copperplate engravings, with etching, from drawings by Nicolas Huet and Jean-Gabriel Prêtre. Vol. 1, pl. 10: Black Baza (*Aviceda leuphotes*). Prêtre, artist. Vol. 2, pl. 159: Javan Frogmouth (*Batrachostomus javensis*). Prêtre, artist.* Vol. 4, pl. 426: Lappet-faced Vulture (*Torgos tracheliotus*). Huet, artist.* Vol. 4, pl. 464: Comb-crested Jacana (*Irediparra gallinacea*). Prêtre, artist.* ▪ Intended as a sequel to the Buffon-Daubenton *Planches enluminées....* The artists Huet and Prêtre included depictions of newly discovered species from the English colonies, Africa, South America, and other distant places. ▪ *Ref: Anker, 502, 503; Balis, 75; Nissen, 506; Zimmer 2:626–28.*

VOSMAER, ARNOUT. *Natuurkunde beschryving eener uitmuntende versameling van zeldsaame gederten.* Amsterdam: Elwe, 1804. 11¾ × 8¼″. ▪ 33 hand-colored copperplate engravings (dated 1766–87) from drawings by Vosmaer, Aert Schouman, and others. Pl. 8 (bird section): Secretary Bird (*Sagittarius serpentarius*). Schouman, artist.* ▪ As advisor to the Dutch prince William V, Vosmaer had access to the birds and animals in the zoological cabinet and menagerie at the royal palace in Apeldoorn. A first edition, accompanied by these plates, was published, 1766–87 under a different title.

WILHELM, GOTTLIEB TOBIAS. *Unterhaltungen aus der Naturgeschichte.* 12 vols. Vols. 4, 5, *Vögel* (1795). Augsburg: Engelbrecht, 1792–1802. 6⅞ × 4″. ▪ 90 hand-colored copperplate engravings. Vol. 4, pl. 3: 1. Crowned Eagle (*Stephanoaetus coronatus*); 2. Peregrine Falcon (*Falco per-*

egrinus); 3. Secretary Bird (*Sagittarius serpentarius*).* Vol. 5, pl. 22: 78, 79. Golden Oriole (*Oriolus oriolus*); 80. Yellow-rumped Cacique (*Cacicus cela*); 81. Oriental Green Barbet (*Megalaima zeylanica*).* ▪ A small-format German natural history encyclopedia, enlivened with excellent hand-colored illustrations. ▪ *Ref: Nissen, 533.*

WILSON, ALEXANDER. *American ornithology.* . . . 9 vols. in 3. Philadelphia: Bradford and Inskeep, 1808–14. 14 × 10½″ (plate size). ▪ 76 hand-colored copperplate engravings, with etching, by A. Lawson, J. G. Warnicke, G. Murray, and Alexander B. Tanner from drawings by A. Wilson, colored by A. Rider. Pl. 10: Northern Mockingbird (*Mimus polyglottus*); Ruby-throated Hummingbird (*Archilochus colubris*); Rufous-sided Towhee (*Pipilo erythrophthalmus*).* Pl. 11: Common Cardinal (*Cardinalis cardinalis*); Scarlet Tanager (*Piranga olivacea*).* Pl. 36: American Bald Eagle (*Haliaeetus leucocephalus*).* Pl. 50: Barn Owl (*Tyto alba*); small flycatcher (? *sp.*); Great Horned Owl (*Bubo virginianus*); Hawk Owl (*Surnia ulula*).* ▪ Wilson's book was sold by subscription. Those who signed up received the volumes as they were completed. Wilson had almost finished the eighth volume when he died. His friend, George Ord, finished it and published a ninth volume based largely on Wilson's notes. ▪ *Ref: Anker, 533; Balis, 123; Nissen, 535; Zimmer 2:679–80.*

WILSON, SCOTT B., and ARTHUR H. EVANS, *Aves Hawaiienses: the birds of the Sandwich Islands.* London: R. H. Porter, 1890–99. 12½ × 10″. ▪ Photogravure plates, map, 64 hand-colored lithographs by Frederick Frohawk, printed by West, Newman. Pl. 1: Hawaii O-o (*Moho nobilis*). ▪ An important work on the ornithology of Hawaii. ▪ *Ref: Anker, 536; Nissen, 537; Zimmer 2:686–87.*

WORM, OLE. *Museum wormianum, seu historia rerum rariorum.* . . . Leyden, 1655. 14¼ × 9″. ▪ Copperplate engravings, many after woodcuts. p. 301: Great Auk (*Pinguinus impennis*).* ▪ A catalogue of the Danish doctor Ole Worm's private museum, or "cabinet of curiosities." His was one of the first natural history collections and a model for many later ones, some of which evolved into national museums.

YARRELL, WILLIAM. *A History of British Birds.* 4th ed. rev. and ed. by Alfred Newton and Howard Saunders. London: Van Voorst, 1871–85. 9 × 5½″. ▪ 564 wood-engraved text illus. by many engravers from drawings by Alexander Fussell, Edward Neale, J. Thompson, J. G. Keulemans, Charles Whymper, and others. Vol. 2, p. 89: House Sparrow (*Passer domesticus*).* ▪ The influence of Thomas Bewick is apparent in this extremely popular work by his disciple William Yarrell. ▪ *Ref: Nissen, 553; Zimmer 2:699–700.*

This book and the exhibition it accompanies are the result of the efforts of many people and the vast holdings of The New York Public Library. Three colleagues at the Library deserve special praise: Rodney Phillips, Associate Director for Public Services; Bernard McTigue, Curator of the Arents Collections; Richard Newman, Manager of Publications. Each has offered much encouragement and help along the way. ▪ To the many other co-workers at the Library much credit is due: Elizabeth Diefendorf, Chief of General Research; Richard Hill, Chief of the Annex Collections; Donald Anderle, Associate Director for Special Collections; Francis O. Mattson and the staff of the Rare Book Room, especially John Rathé; Robert Rainwater, Curator of the Spencer Collection; the staff of The Miriam and Ira D. Wallach Division of Art, Prints and Photographs; my colleagues in the General Research Division. Diantha Schull and members of the Exhibitions Program all merit recognition, especially Jeanne Bornstein, Project Coordinator, who serenely guided me through the preparation of the exhibition and book, and Barbara Bergeron for her assistance with the manuscript. Thanks, also, to Susan F. Saidenberg, Assistant Manager; Myriam de Arteni, Exhibitions Conservation

Specialist; Jean Mihich, Registrar, Lawrence Murphy, and their assistants in the Registrar's Office; Lou Storey, Installation Specialist, and Jill Entis; and Edward Rime, Exhibitions Assistant. Others who provided special assistance include Gregory Long, Harold Snedcof, and Susan Rautenberg in the Development Office; Betsy Pinover, Shellie Goldberg, and Lydia Voles in the Public Relations Office; Marilan Lund and Rebecca McClellan in the Graphics Office; and Myrna Martin in the Friends Office. ▪ Outside the Library invaluable assistance was given by Mary LeCroy of the Ornithology Department of the American Museum of Natural History for ornithological identification and verification of scientific and popular nomenclature. Also, thanks to Katherine Boyd, for her bibliographic skills. It was a special honor to work with Joseph Kastner, whose own books have given me pleasure and taught me much. Our editor, Ruth Peltason, merits my gratitude and admiration, and Elissa Ichiyasu, the designer of the book, has beautifully presented the illustrations. ▪ Finally, thanks are due my husband, David, who has borne patiently and with good humor my tribulations and joys while working on the exhibition and book. —*Miriam T. Gross*

ACKNOWLEDGMENTS